Gainsborough
at Gainsborough's House

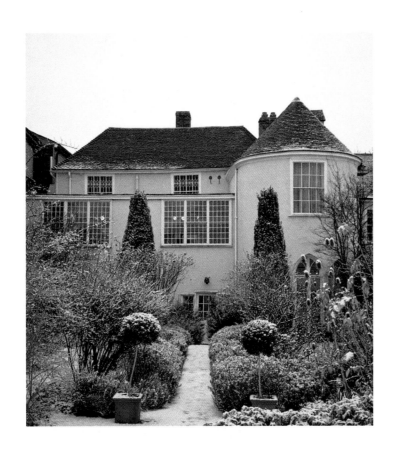

Gainsborough at Gainsborough's House

HUGH BELSEY

Paul Holberton publishing
2002

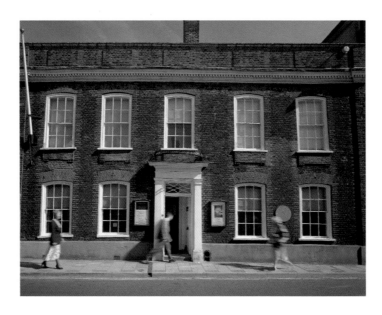

Fig. 1 Gainsborough's House, Sudbury, street façade
Photograph by Adrian Arbib

This catalogue accompanies an exhibition at Thos. Agnew & Sons Ltd,
43 Old Bond Street, London W1X 4BA, 22 January to 21 February
2003, and subsequently at Gainsborough's House, 46 Gainsborough
Street, Sudbury, Suffolk CO10 2EU

First published October 2002 by Paul Holberton publishing for
Gainsborough's House (www.gainsborough.org)

Produced by Paul Holberton publishing
37 Snowsfields, London SE1 3SU, www.paul-holberton.net

Designed by Roger Davies
daviesdesign@onetel.net.uk

ISBN 1 903470 06 4 (hardcover)
1 903470 05 6 (paperback)
Cataloguing in Publication Data
A catalogue record for this book is available from the British Library

Distributed in the UK and Europe by Greenhill Books
Distributed in the United States of America and Canada by
University of Washington Press

Jacket/ cover
Thomas Gainsborough, *Peasants going to Market, ca.* 1780 (cat. 20)

Half title
Gainsborough's House, rear façade with garden, under snow
Photograph by Rosemary Woodward

Contents

Most of the collection at Gainsborough's House has been acquired in the past twenty years during my curatorship. It has been an exhilarating, though often exacting, task. Forming the character of the collection has been a great privilege and this catalogue provides me with a unique opportunity to thank many people who have had faith in my abilities and whose responses and remarks have helped me so much.

Working in a small museum without the opportunity to exchange ideas with colleagues regularly, occasional or chance conversations with friends from other institutions take on greater importance. However, *Gainsborough's House Review* has helped keep the House in the vanguard of research and I am especially grateful to Dr Susan Sloman and David Tyler for choosing to publish so much of their new findings within its pages. Remarks from John Hayes, Judy Egerton, Duncan Robinson, Brian Allen, Michael Rosenthal, David Mannings, Alex Kidson, Hamish Miles, the late Francis Hawcroft and Elizabeth Einberg have all helped formulate the contents of this catalogue, and I am grateful for them.

For the formation of the collection I am especially indebted to the donor of a painting by Canaletto which provided the means for a small museum to compete in an international art market. Heather Wilson and Gerry McQuillan of Re:source and Sir Peter Wakefield of the National Art Collections Fund helped with the finer details of the 1984 Finance Act and the acceptance-in-lieu system; Lindsay Stainton fought for the Society's acquisitions with particular tenacity; finally, the administrators and the advisors of various national funds have always been very willing to listen to any new request for support.

Jane McAusland has conserved most of the works on paper in the collection, and has provided sterling advice over the years. The late Sarah Spicer encouraged me to think about the presentation of works of art and Michael Gregory, of Arnold Wiggins Ltd, has continued to make me realise its importance. I have had valued conversations with painting conservators: Ian McClure at the Hamilton Kerr Institute, Rica Jones of the Tate, Ruth Bubb and John Mitchem. Dealers, especially Bill Drummond, Lowell Libson, Andrew Wyld, Anne George, Andrew Clayton-Payne, Andrew Edmunds, Norman Blackburn, Nigel Talbot, Joscelyn McDiarmid and the late Sidney Sabin, and auctioneers, at Sotheby's headed by David Moore-Gwyn and Henry Wemyss, at Christie's by Hattie Drummond and John Stainton, have all provided kindness and support.

Julian Agnew and his fellow directors greeted with warmth the suggestion to stage this exhibition at Agnew's. Stephen Deuchar and the Trustees of the Tate have kindly cooperated and allowed us to include the painting we own jointly. It gives me great pleasure to acknowledge the generosity of a private benefactor and a grant from the Paul Mellon Centre for Studies in British Art, which have made a considerable contribution to the production of this book. My thanks, too, to the publisher, Paul Holberton, and the designer, Roger Davies, for their patience and professionalism. Finally I am grateful to my colleagues in Sudbury, who have been so supportive during the fight for acquisitions. They have worked hard to move these paintings to London and to ensure that as many people as possible see this exhibition.

HUGH BELSEY
July 2002

Suffolk evokes many positive images in the minds of those who have been fortunate enough to be touched visually and emotionally by the character of its countryside, buildings and people. It is a 'quiet secret' amongst the English shires.

It is no surprise to us that the Stour Valley, constituting Suffolk's southernmost border, inspired the creativity of two of England's most appreciated artists, Gainsborough and Constable, whose landscape paintings are at the heart of English art in the eighteenth and early nineteenth century and a precursor of later nineteenth-century Impressionism.

Gainsborough's *Cornard Wood*, depicted from the grounds of Abbas Hall at Great Cornard, a Suffolk aisled hall dendro-dated to 1290, was completed when he was twenty-one. The picture now hangs in the National Gallery as unequivocal evidence of his prodigious genius. This tradition of setting standards for others to follow is now being perpetuated by those entrusted with the responsibility for preserving and enhancing our appreciation of this greatness.

Gainsborough's House is located in the picturesque market town of Sudbury, an Icenian settlement first recorded in the eighth century in connection with the bishop of Dunwich, Aelfhun. The House is unique as the only museum in the birthplace of a great British artist to have more of his paintings on show than any other institution in the world. Run by the Trustees of the Gainsborough's House Society, it is supported by an active Friends group, chaired by Glynis Wash, with a membership totalling nearly eight hundred.

Recognition of youthful talent was echoed with the appointment, at the age of twenty-seven, of Hugh Belsey, Curator for the last twenty-one years. With grit and determination, he has created a unique centre of excellence which deserves special recognition in the museum world. He has done this with unrivalled dedication, commitment and enthusiasm in the face of severe economic constraint and a host of other difficulties. In his role as 'chief executive', with his gentle obstinacy and hard work, he has combined the characteristics of a maverick and a leader. Success has also come from the team he has put together being anchored firmly in their local community.

Importantly, Gainsborough's House is not a retrospective institution frozen in time. Hugh has the skill to present the relevance of Gainsborough in lay terms to groups of all ages throughout Great Britain. Sudbury enjoys contemporary exhibitions, notably of sculpture and state-of-the-art printmaking, which are actively encouraged here and support the presentation of Gainsborough's works *in situ*.

This is the first time this splendid collection has been exhibited outside Sudbury. I hope that all of those who view it and enjoy it will recognize the hard work that has brought it into being. It is also a time to reflect upon how much could be achieved in the future with more funding. Collectors and the art world at large are increasingly valuing Gainsborough, witness the recent sale of a painting for £2.6 million.

The local councillors at Babergh District Council have preserved from development Gainsborough Country for future generations by designating it an Area of Outstanding Natural Beauty and a Special Landscape Area. It is our collective responsibility to preserve and promote the artistic traditions and landscape located in this special piece of England. Visiting Sudbury, travelling on to East Bergholt via Lavenham, is a voyage of discovery among perhaps more historic buildings than anywhere in England.

I can make no better conclusion than to quote Constable's view of Gainsborough, as expressed in a lecture given to the Royal Institution of Great Britain in 1836, the year before he died: "The landscape of Gainsborough is soothing, tender, and affecting. The stillness of noon, the depths of twilight, and the dews and pearls of the morning, are all to be found on the canvasses of this most benevolent and kind-hearted man. On looking at them, we find tears in our eyes, and know not what brings them."

I hope this may inspire you to visit Gainsborough's House, Sudbury and the Stour Valley.

STEFAN AND TAKAKO KOSCIUSZKO
Abbas Hall, September 2002

Introduction

Thomas Gainsborough was, in his own words, "liberal, thoughtless and dissipated", "the most inconsistent, changeable being, so full of fitts & starts".[1] For his contemporaries he was "a kind-hearted, good Fellow", "his conversation was sprightly, but licentious" and he "had two faces, his studious & Domestic [as well as] His Convivial one".[2] He was obviously more energetic than his slight frame should reasonably have allowed and his mercurial intelligence made one commentator consider that "there certainly was only a very thin membrane which kept this wonderful man within the pale of reason".[3] He was modest, witty, empathetic and loathed pomposity and humbug. Although he did not suffer fools gladly, he ensured that he enjoyed life to the full: "Recollect how many hard featured fellows there are in the world that frown in the midst of enjoyment, chew with unthankfullness, and seem to swallow with pain instead of pleasure".[4] As an artist "he was irregular in his application, sometimes not working for 3 or 4 weeks together, and then for a month wd. apply [himself] with great diligence".[5] He said himself that "Painting & Punctuality mix like Oil & Vinigar, & that Genius & regularity are utter Enemies, & must be to the end of Time".[6] He accepted the religious faith of his upbringing and said that he generally viewed his "Works of a Sunday, 'tho never touch".[7]

This extraordinary man was born the youngest of nine children to John and Mary Gainsborough in a house in Sepulchre Street in the market town of Sudbury in Suffolk. He was baptized in the Independent Meeting House in Friars Street on 14 May 1727 and remained in the town until about 1740, when, encouraged by a small legacy towards his apprenticeship from his rich uncle Thomas Gainsborough, he moved to London (see cat. 52 and 53). There, in an artistic world dominated by William Hogarth, he was soon taken up by Francis Hayman (cat. 61 and 62), with whom he may have lodged. He assisted Hayman to paint some of the supper-box pictures for The Grove at Vauxhall Gardens. He subscribed to drawing lessons at the St Martin's Lane Academy, where he learnt much from the French draughtsman and engraver Hubert-François Gravelot (cat. 54–59) and his fellow students (cat. 60). Indeed he may have helped Gravelot design some of the surrounds for Jacobus Houbracken's *Heads of Illustrious Persons* (cat. 57 and 58). In 1746 he married an illegitimate daughter of Henry, 3rd Duke of Beaufort, Margaret Burr (cat. 11), who was probably carrying his child. The newly weds moved to a house in Hatton Garden. By this time Gainsborough was painting with imagination and energy (cat. 1) and must have set up his first studio soon after he married (cat. 2 and 3). He sometimes collaborated with his contemporaries (cat. 2 and 4) and, at this time, was considered something of a landscape specialist. The child, a little girl called Mary, died, and after the death of the artist's father (cat. 13) in October 1748 the couple moved to Sudbury.

In Sudbury Mrs Gainsborough gave birth to two daughters, another Mary and Margaret (cat. 18), but the town provided few opportunities for an aspiring artist and in 1752 the family moved to Ipswich. A larger town, Ipswich enjoyed more of an intellectual life than Sudbury, with a music club (cat. 48), a library, lively theological debate (cat. 5), and a range of prospective clients. He must also have had access to a press, as he began to investigate etching, with the help of Thomas Major and Joseph Wood (cat. 33 and 34). Although Gainsborough continued to paint 'conversation pieces' (cat. 4), that format was beginning to look old-fashioned, and he started to apply himself with some energy to full-scale portraiture (cat. 5). In October 1758 he decided to try his newly developed skills in Bath. The experiment was successful, and he took his family to the West Country the following year, renting the largest house available in the city, where he could accommodate his young family, paint portraits and take in lodgers.

He opened a 'Shew' room for prospective clients to see his work (cat. 17 and 51) and commissions began to pour in. He worked unremittingly, drawing in the evenings for relaxation. Bath not only had the advantage of being visited by clients who had time on their hands, it also had a developed print trade, which sustained Gainsborough's imagination, and picture collections, which provided further inspiration. The work of Van Dyck (cat. 7 and 8) was especially important to him. Rubens (cat. 9) and Claudean landscape were also to play their part (cat. 10), and an increasing number of varied sources have been identified recently (cat. 10, 20, 28 and 31). By the time of the inaugural exhibition of the Royal Academy in 1769 Gainsborough had assimilated the grandeur of the Old Masters with his ability to catch a likeness and had distilled them into eloquent compositions without equal (see cat. 20). In 1772 he took on Gainsborough Dupont, his nephew, as an apprentice (cat. 41, 42, 44, 50 and 65–69). The rigours of the Royal Academy, the dictates of official taste and the lack of subtlety demanded by the competitive nature of its annual exhibitions did not suit his temperament. He stopped exhibiting in 1773, perhaps in preparation for a move to London the following year.

The lease on the large house in Bath expiring in June 1774, he rented the western third of Schomberg House in Pall Mall in London. There he built a studio in the garden, to which he added a

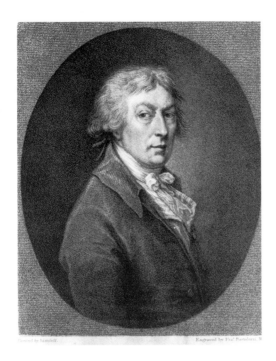

Fig. 2
FRANCESCO
BARTOLOZZI
(1727–1815) after
THOMAS
GAINSBOROUGH
Self-portrait
Stipple engraving,
25.6 × 20.3 cm
(10⅛ × 8 in.)
Gainsborough's
House, Sudbury
(1988.025)

second storey later on. He was persuaded to exhibit again at the Academy in 1777 and the impact of his contribution must have made his rivals uneasy. There was time enough to experiment with soft-ground etching and aquatint (cat. 35–38) and in 1780 he nearly published three prints which showed the range of his landscape work (cat. 36). He was taken up by George III in 1781, painting both the king and his wife Queen Charlotte. By 1782 he was torn between producing ponderous landscapes that attempted to interpret a classical theme in his own terms (cat. 10) and more transient observations that were fed by his remarkable visual recall (cat. 30 and 32). In the following year he made an exceptional group of portraits of the royal family that were unsympathetically displayed at the Academy; indeed his submissions altogether had been so late that the hanging committee had no alternative but to omit one from the catalogue and show it in the fireplace. He declared that "he never more, whilst he breaths, will send another Picture to the Exhibition".[8] He did, however, send paintings to the 1784 exhibition, requesting special hanging conditions for a full-length portrait of the *Eldest Princesses*, but the hanging committee was no longer able to accommodate his wishes and he removed his pictures. Instead he held exhibitions at Schomberg House.

One of the paintings he displayed at the 1781 Academy exhibition was *A Shepherd* (cat. 39–40), the first of a series of 'fancy pictures', as Sir Joshua Reynolds was to call them, which culminated in *The Woodman* (cat. 32), a painting which Gainsborough felt was his greatest achievement. After turning his back on the Academy Gainsborough was able to indulge himself in travel. In 1783 he went to the Lake District with his Ipswich friend

Samuel Kilderbee (cat. 27) and to Antwerp. He continued to paint landscapes and subject pictures, selecting the sitters whom he wished to paint (cat. 42, 44 and 65). In May 1788 he caught a chill which developed into a cancer of the neck, and he died on 2 August. He was buried at Kew beside his old friend Joshua Kirby (cat. 63). In the following December his rival, Sir Joshua Reynolds, attempted to define his genius in a lecture to the Royal Academy students and wrote: "If ever this nation should produce genius sufficient to acquire to us the honourable distinction of an English School; the name of Gainsborough will be … among the very first …".[9]

It was not until 10 June 1913 that the national memorial to the artist was unveiled on Market Hill in Sudbury. The sculpture, by the Australian sculptor Bertram Mackennel, was commissioned by a special committee who raised £10,000, and a proud town welcomed Princess Louisa to officiate at the ceremony. Forty years later £5,250 was raised (half came from the gift of a painting by Sir Alfred Munnings) to purchase Gainsborough's House at the foot of Market Hill in what was now called Gainsborough Street.

The house, parts of which date back to the fourteenth century, is much altered, incorporating an amalgam of styles. Presumably it originally comprised a hall to the east, with a screens passage dividing it from a small room looking on to the street – perhaps a shop – with a buttery behind. In the first half of the sixteenth century the fine ceiling in the parlour was installed and a pair of chimney stacks were inserted.

John Gainsborough (cat. 13) appears to have bought the house from John Thompson of Pebmarsh for £230, and added a brick façade to the street frontage, a common development of medieval buildings in the area.[10] The elder Gainsborough overstretched himself, for he was declared bankrupt in 1733. His nephew, also called John (cat. 53), purchased the house for a generous £500, which released the artist's father from debt and enabled his family to live in the House until the death of the artist's mother in 1755. The property was then let.

In 1792, after the death of the last Gainsborough owner, the property was sold to the tenant, Peter James Bennett, a silk manufacturer. The auctioneer described the property as "consisting of a most excellent Brickt Mansion … replete with every convenient Accommodation for a genteel Family, or principal Manufacturer, having upon the Premises two Buildings, (now used as Weaving-shops in the Silk Line,) 147 Feet long, with an Orchard, well planted with Fruit Trees in a high state of Perfection, which with a Flower Garden, paved Yard, and Scite of the Buildings, contain about two Acres …".[11] Mr Bennett made considerable improvements to the house, building the present staircase and the upper and lower bow rooms at the back. He may also have added, or altered, the Weaving Room.

The house continued to be connected with silk manufacture. In the nineteenth century it passed to the Kemp family, who sold it in 1920 to the builder James McQuae. McQuae built his yard at the

north end of the garden and sold off sections of the property. He leased the main building to Miss Ward and Miss Spencer to run as a guest house, the bedrooms of which were named after Gainsborough's most famous paintings. In December 1951 the House was being let as flats, but on enquiry C.G. ('Micky') Doward, an art dealer based in America, discovered to his surprise that the property was for sale. He bought it; it did not suit his wife, and the property soon appeared in the advertising pages of *Country Life*. Letters were written to national newspapers and by September 1956 the local community had decided to buy the house and began raising the money to complete the purchase.[12] The sum was raised early in 1958 and an impatient Mr Doward was paid by a fledgling Gainsborough's House Society. Fundraising continued and the restoration began a year later. Gainsborough's House opened its doors to the public on 12 April 1961, exhibiting an exceptional collection of paintings by Gainsborough borrowed from national collections and private owners in East Anglia.[13] The Society also persuaded the Arts Council to extend the tour of an exhibition of drawings by Gainsborough to show in Sudbury at the same time.[14]

After the end of the inaugural exhibition the Society and their devoted curator, Frank Rees, who, at the time, was given accommodation but no remuneration, fought hard to find loans and organize suitable displays. Money was tight and expectations were high. The first Curator was succeeded by William Fell, and after his resignation in 1968 the distinguished painter Rowland Suddaby (cat. 80) took up the mantle. He died suddenly in 1972.

In February 1964 Cavendish Morton became Chairman of the Society's Managment Committee. He was keen to establish an endowment for the Society to ensure its future, and there were enquiries whether the House could be vested in the National Trust. During the same period the quality of exhibitions improved, with the appointment of younger curators. Robert McPherson started in 1973, and in 1976 he was succeeded by David Coke (1976–79). Stephen Jones (1979–81) followed and, since September 1981 the present author, Hugh Belsey, has held the post.

Despite its hand-to-mouth existence in the early days, Cavendish Morton was keen for the Society to start a collection. Some exhibits had been given to the Society when it first opened in 1961: notably Kenneth Gainsborough Waring, a descendant of the artist's sister Sarah Dupont, had donated the artist's swordstick (cat. 46) and a book of engravings by Wells and Laporte (see cat. 26); others had given pieces of eighteenth-century china and annotated catalogues of the Society of Artists' exhibitions in the 1760s.[15] In 1967 ownership of Gainsborough's studio cabinet (cat. 47) was transferred from the Victoria and Albert Museum and in 1968 two letters by Gainsborough to the publisher James Dodsley were purchased at auction and two small drawings by Gravelot were bought.[16] Gifts came in, too. Norman Baker gave the Society some Gainsborough family mourning rings and a rummer presented to his ancestor John Baker in 1818.[17] Another drawing by Gravelot was donated by Sidney Sabin (cat. 57), a long-term supporter of

the Society, and the late Charles Warren gave fine drawings by George Frost, Thomas Churchyard (cat. 77) and Sir George Beaumont.[18] An appeal to members of the Society provided funds for another Gainsborough letter in 1973 (cat. 49) and for a print (cat. 37), and in 1979 another appeal provided the money for the Articles of Apprenticeship between Gainsborough and his nephew (cat. 50). During his chairmanship, as the Society was in no position to buy works of art itself, Cavendish Morton bought prints after the artist's work, a rare impression of the *Suffolk Plough* (cat. 33) and a copy of *The New Bath Guide* which contains Dorothy Richardson's illuminating account of her visit to Gainsborough's studio in 1770 (cat. 51). They were all given to the Society, with characteristic generosity, in 1987. But although paintings by Gainsborough were lent to the Society, none was owned by it.

In 1981 a second charity, Gainsborough's House Society Development Trust, was founded to raise funds for capital improvements to the building and provide money for acquisitions. The first purchase was controversial: the fragmentary portrait of a boy painted when Gainsborough was in his teens (cat. 1). It was secured with the help of the Purchase Grant Fund and the newly established National Heritage Memorial Fund. Next, when the small-scale portrait of *Revd John Chafy* was offered for sale at auction, the Society raised £100,000 from various national bodies to buy the piece. At the eleventh hour, however, the Tate Gallery decided that the painting was of national importance, and the funds raised by the Society were transferred to the Tate, which made a successful bid for the painting.[19]

The opportunity to purchase the large landscape of 1782 (cat. 10) arose after the painting failed to reach its reserve at auction and was offered as a private treaty sale. The terms of the 1984 Finance Act prevented independent museums from purchasing works by private treaty and so they were unable to benefit from the remission of capital tax. However, after consultation with the capital taxes office and the Museums and Galleries Commission it was established that the painting could be bought by an agency listed in the Finance Act – in this case Suffolk County Council – and ownership could then be transferred to the Society. Since then this system has been used frequently to benefit the museum and, with varying degrees of success, by a number of other independent institutions.

The year 1988 was a remarkable one for Gainsborough's House, for in the summer its exhibition, *Gainsborough's Family*, attracted loans from both sides of the Atlantic and from both public and private lenders. It did much to introduce the Society's work to people who were subsequently to sell or give to the Society (cat. 11, 13 and 18). Fundraising in the town during the year made possible the purchase of a rare print, *Peasant reading a tombstone* (cat. 36). At the same time an unexpected event transformed the ability of the Society to purchase works of art.

On a Sunday in July 1988 a man who had a house close to Sudbury, and felt that London had more than enough, offered the Society a Canaletto to "swap for a Gainsborough in another

gallery". Naturally he was anxious to avoid paying capital tax and so the National Art Collections Fund agreed to sell the painting on behalf of the Society and to pass on the funds, to enable it to buy works of art, conserve them and re-frame them. What surprised everyone was that the painting sold for eight times its estimate, so that its auction on 5 July 1989 made the acquisition fund richer by a handsome £869,000. This happy event gave Gainsborough's House the opportunity to buy, without recourse to other funding sources, medium-priced objects such as prints after Gainsborough (cat. 39, 42–45), works by his teachers (Gravelot, cat. 54–59, and Hayman, cat. 61 and 62) and by close associates (Grignion, cat. 60, and Kirby, cat. 63). Work by Gainsborough's descendants (Gainsborough Dupont, cat. 65–69, and R.J. Lane, cat. 78 and 79) were also added to the collection, and paintings, drawings and prints by lesser Suffolk figures such as Henry William Bunbury (cat. 70–73) and George Frost (cat. 74 and 75) were also purchased to round out the collection. Topographical views were also within the purview of the collecting policy (cat. 76).

A fine drawing by Gainsborough dating from the mid 1770s had been given to the Society in the summer of 1988 by Miss Maud Wethered (cat. 21), which whetted the appetite to make the collection more representative of Gainsborough's work as a landscapist. A unique impression of *The Gipsies* (cat. 34) was purchased, a landscape drawing from the group formerly at Barton Grange (cat. 22) and, with the help of national funding bodies, an early painting, one of a pair, which had been acquired by Revd Thomas Rackett in the late eighteenth century (cat. 3). The artist's work as a portraitist is represented thanks to the gift of *Revd Tobias Rustat* (cat. 5), the happy conclusion to an enquiry from the public, and following the purchase, at a reasonable price, of the three-quarter-length of *Lady Tracy* (cat. 7) sixteen months later. Its generous acquisition fund also enabled the Society to purchase cheaply a further fragment of the double portrait of a boy and girl (cat. 1). However, the great late drawing of a woman and child walking in a landscape, now in the Getty Museum, proved to be far beyond the Society's resources.[20] There have been other setbacks, too. The Society attempted to acquire a *Self-portrait* in 1994, and was outbid at auction for the portrait of *Philip Dupont* in 1997. Both these are now in private collections in England.[21]

In 1992 Gainsborough's monumental drawing *Peasants going to market* was stopped from export and, with the help of many agencies, acquired by the Society early the following year (cat. 20). Rather too soon afterwards it was confirmed that the Muilman conversation piece (cat. 2) would be sold at auction in the summer. After negotiations with funders, and in the light of the Society's failure to secure the portrait of *Revd John Chafy*, discussions began with the Tate Gallery. It was decided by the funders that the painting could be shared, the first time such an agreement has been made between a national and an independent museum. Fortunately the painting was purchased for less than anticipated and the acquisition fund was not decimated.

Smaller acquisitions were made in 1994. A large jug from Worcester dating from about 1765, with transfer prints by Robert Hancock, one of which was after François Vivares's print after Gainsborough's *Rural Lovers*, was purchased and set the agenda for collecting objects which used Gainsborough's work as a decorative motif and showed the rise and fall of his popularity.[22] Amongst them was the most complete extant copy of Thomas Rowlandson's *Imitations of Modern Drawings* (cat. 45), which contains several soft-ground etchings after Gainsborough's drawings, one of which, from Holker Hall, was added to the collection later in the year (cat. 31). This drawing, among others that had recently been purchased, joined an early landscape drawing which had passed for many years as a George Frost (cat. 12). Interesting and varied drawings were appearing on the market: the best of them, the *Study for Diana and Actaeon* (cat. 28), was withdrawn from auction and entered the collection in 1996, and a *Study of the artist's daughters* (cat. 18), which had been on loan since 1988, was purchased later that year with the support of the Heritage Lottery Fund. While both these acquisitions were significant purchases, more modest drawings, which make specific points, were purchased at auction for quite low prices. A drawing first recorded in the Michael Salaman collection was purchased in April 1998 (cat. 15) and three months later a drawing from the Tillotson collection which is closely related to one of Gainsborough's soft-ground etchings (cat. 24). This was especially relevant as the collection of prints by Gainsborough had been enlarged the previous year with the purchase of two prints in soft-ground etching and aquatint which had been identified through a public enquiry in 1989 (cat. 35 and 38). In 1997 the print collection had been transformed by the acquisition of fifty-eight prints from the collections formed by the Marquesses of Bute. They included exceptionally rare impressions by, amongst others, Gainsborough Dupont, of *Mrs Sheridan*,[23] *Revd Sir Henry Bate-Dudley* and *Sir John Skynner* (cat. 42 and 44).

The Society had purchased Gainsborough's head-and-shoulders copy of Van Dyck's *Lord Bernard Stuart* (cat. 8) in 1995, but the opportunity to borrow the artist's moving copy of Rubens's *Descent from the Cross* (cat. no. 9) was an exceptional one. The loan was transferred from the Ashmolean Museum. The painting soon became available for purchase and was acquired with a second grant from the Heritage Lottery Fund. Replacing the unsuitable frame, which dated from the 1950s, with a fine eighteenth-century Carlo Maratta frame with its original gilding transformed the painting's appearance.

The Cobbold conversation piece (cat. 4) was a painting indigenous to Suffolk which had frequently been lent to the House. The sudden death of Patrick Cobbold placed its future in question. It seemed that the family could best meet their capital tax obligations by parting with it, and in July 1995 the family were advised that the painting should go to auction, where it was bought in. Fortunately the reserve indicated the value and served as the basis for the acceptance-in-lieu procedure. The painting was

allocated to the Society in June 1998. The year ended with the exceptionally generous donation to the Society of the late small-scale portrait of *Margaret Gainsborough* (cat. 11) and a drawing from the late 1770s (cat. 25).

In September 1997 the Society purchased a pair of cottages which adjoin the garden of the House and the Trustees were keen to make an application to the Heritage Lottery Fund to restore them, which prevented any approach to the Lottery for more expensive acquisitions. Nonetheless, with the continuing support of both the Purchase Grant Fund and the National Art Collections Fund, the Society purchased at auction a drawing from the series Gainsborough made in preparation for the 1787 painting of *The Woodman* (cat. 32). Its condition may have discouraged other bidders, but in the hands of the paper conservator Jane McAusland the buff colour of the paper was restored, so that the white highlights receded and began to complement the black chalk rather than compete with it.

In 2001 two other drawings were offered to the Society. Unexpectedly a study for Gainsborough's Lake District landscape in Munich became available (cat. 27) and a study, though in unexceptional condition, for the important portrait of *Ann Ford* was also on offer (cat. 17). Both were purchased by the Society with contributions once again from the Purchase Grant Fund and the National Art Collections Fund. The Society was also fortunate in securing two prize pieces from the Christopher Lennox-Boyd collection: Gainsborough's corrected copy of Richard Earlom's mezzotint of *A shepherd* (cat. 40) and Dupont's preparatory drawing for his mezzotint of *Revd Sir Henry Bate-Dudley* (cat. 41). In addition, one of the paintings that had been lent to the Society since it first opened in 1961 was purchased with grants from the same sources. After cleaning, *Lambe Barry* (cat. 6) has been revealed as an exceptional portrait dating from Gainsborough's early months in Bath.

Earlier in 2002, to cap a remarkable group of acquisitions of works on paper which relate to paintings, a drawing relating to a landscape in the collection of the Duke of Rutland was offered by e-mail from a private source and was eventually purchased with the support of the Purchase Grant Fund (cat. 23).

The collection in Sudbury now amounts to over two thousand objects, which enables the Society to illustrate the majority of Gainsborough's moods and styles and to provide a wide-ranging display of work associated with the St Martin's Lane Academy and of artists as diverse as Henry William Bunbury, William Gilpin and Rowland Suddaby. With a necessarily prescribed collecting policy, the ever diminishing availability of suitable work on the art market and increasing prices, it is unlikely that the collection can – or should – expand with such energy in the future. Nonetheless, the existing collection in the artist's birthplace is already one of distinction and one which can serve the local population well. The Society needs now to ensure that its exceptional holdings become better known.

NOTES

1. First quotation: Gainsborough's words when dying to Samuel Kilderbee (*GM*, MDCCCXXXV, February 1835, p. 130); second quotation: letter to William Jackson, 14 September 1767 (Hayes 2001, p. 43).

2. First quotation: letter from William Jackson to his son Thomas, from Exeter 6 September 1788 (*GHR* 1996/97, p. 125); second quotation: William Jackson, *The Four Ages*, London 1798, p. 160; third quotation: conversation between Gainsborough's daughter Margaret and Joseph Farington, recorded on 5 February 1799 (Farington, IV, p. 1152).

3. Thicknesse 1788, p. 18.

4. Hayes 2001, p. 117.

5. From a conversation with Margaret Gainsborough recorded on 29 January 1799 (Farington, IV, p. 1149).

6. Letter from Gainsborough to Hon. Edward Stratford, 1 May 1772 (Hayes 2001, p. 101).

7. Hayes 2001, p. 99.

8. Hayes 2001, p. 150.

9. Reynolds, p. 248.

10. A series of seventeenth- and eighteenth-century title deeds existed in 1853 but are now lost. Extracts were read out at a meeting of the Bury and West Suffolk Archeological Institute on 25 September 1850, when the House was in the possession of a Mr. Hill (*Proceedings …*, I, 1853, p. 222).

11. Quoted from the sale particulars in the possession of Oliver's Auctioneers in Sudbury. I am grateful to James Fletcher for providing me with a photograph of the document.

12. For further information about the Society and a synopsis of the achievements of the various curators see Kinross 1995, pp. 38–49. Many of the Society's papers are preserved in the Suffolk Record Office (Bury St Edmunds Branch) GB 560. The minutes of the Society and newspaper cuttings continue to be preserved in the House.

13. Interestingly, both the Muilman and the Cobbold conversation pieces, which now form part of the collection (cat. 2 and 4), were lent to the House at that time (Kinross 1995, p. 42, repr.).

14. Cat. 26 and 28 were included in this display.

15. The china was given by Desmond MacCarthy and the Society of Artists' catalogues for 1761 and 1763–67 were given by R.G. Townend (1961.006–011).

16. 1968.018 and 019 (Hayes 2001, pp. 44–46).

17. 1978.002–006 (see Sudbury 1988, nos. 45–47, repr.).

18. The Frost is of Freston Tower (1975.005) and the Beaumont (1975.003) was included in Sudbury 1991, no. 37, repr.

19. See Jones 1997, p. 19, repr. col. (Waterhouse 1958, no. 127).

20. Hayes 1970a, no. 63, and N. Turner, *The J. Paul Getty Museum: European Drawings 4*, Los Angeles 2001, pp. 274–76, repr. col.

21. Christie's, 15 April 1994, lot 23, repr. col., and Sotheby's, 12 November 1997, lot 71, respectively (Waterhouse 1958, nos. 295 and 224).

22. This section of the collection has not been included in this exhibition and catalogue, but is examined in H. Belsey and C. Wright, *Gainsborough Pop*, exh. cat., Sudbury 2002.

23. 1997.088 (Horne 1891, no. 61, and Russell 1926, no. 10a).

24. New acquisitions are listed in *GHR* and it is hoped to dedicate a future issue to a comprehensive catalogue. See also Belsey 1991 and Belsey 1997.

Paintings by Thomas Gainsborough

THOMAS GAINSBOROUGH

Portrait of a Boy and Girl (fragments), ca. 1744

Oil on canvas, 133.3 × 72.4 cm (52½ × 28½ in.) and 44.8 × 33.5 cm (17⅝ × 13⅛ in.)

FRAMES (Boy) English carved Carlo Maratta frame with husk sight moulding, alternating acanthus leaf and shield in the hollow and pin and ribbon ornament, 2nd half 18th century. (Girl) English carved half Maratta frame with alternating acanthus leaf and shield on the sight edge, *ca.* 1760

PROVENANCE (Boy) perhaps Lady Sarah Gordon Lennox (died 1826), who married, as her second husband, George Napier (1751–1804); by descent to her granddaughter, Elizabeth, Countess of Arran (died 1899) [ownership is recorded on a label dated 1886]; by descent to her son-in-law, Walter, 8th Lord Ruthven (1838–1921) in whose possession it is recorded by 1901; Christie's, 28 July 1922, lot 162 [as Hogarth], bt Mrs F.L. Evans (died 1969); her executors' sale, Christie's, 13 July 1984, lot 95, repr. col., bt McEwan Gallery; bought by Oscar and Peter Johnson on behalf of the Society in August 1984 with generous contributions from the National Heritage Memorial Fund, the Victoria and Albert Museum (Purchase Grant Fund) and Gainsborough's House Society Development Trust (1984.005)

(Girl) with Aitken Dott, Edinburgh; Murray Usher; his executors' anonymous sale, Sotheby's, 10 April 1991, lot 105, repr. [as attributed to George Beare], bought by Historical Portraits Ltd for the Society (1991.011)

LITERATURE Farson 1990, pp. 148–50, repr.; Belsey 1991, pp. 112–14, repr. col.; *BM* 1991, p. 581, repr.; Owen 1992, pp. 106–07, repr. col.; Mould 1995, pp. 195–97, fig. 40 col.; Postle 2002, forthcoming

EXHIBITED (Boy) Glasgow 1901, no. 1033 [as Hogarth]; Sotheby's 1988, no. 53, repr. col.

This large portrait of a brother and sister in a landscape was an ambitious canvas for an artist to paint in his teens. Gainsborough must have felt able to accept the commission only after having assisted Francis Hayman paint some of the 'Supper box' canvases for The Grove at Vauxhall Gardens in 1743. Apart from a couple of landscape paintings, Gainsborough did not attempt to paint anything else as large until the late 1750s.

Conservation at the Hamilton Kerr Institute (University of Cambridge) revealed that the painting of the boy had been cut at the top and the bottom as well as the left-hand side, and included a blue skirt, previously covered over. The girl in the second fragment is wearing a stomacher of the same colour, and the background in this smaller fragment includes lichen on the tree trunk and heads of wheat which match those in the larger one.[1] The portrait originally

would have shown the girl seated on a bank with an assortment of flowers gathered in her apron, while her younger brother, conscious of his superior status, looked on with protective assurance. Child portraits, especially double portraits of siblings, seem to have enjoyed particular popularity in the 1740s and the format is perhaps best paralleled in a painting ascribed to George Beare which appeared at Christie's in 1981 (fig. 3) and the more sophisticated portrait of Edward and Sarah Harley which has been attributed to Dandridge and to Pickering – the latter seems more likely.[2]

Before the Christie's sale in 1984, the portrait was ascribed to William Hogarth and related to his double portrait of William and Elizabeth Mackinen in the National Gallery of Ireland.[3] Indeed the resemblance of the boy in the Hogarth to the figure in the Sudbury portrait encouraged commentators

Fig. 3
Attr. GEORGE BEARE
(active 1744–49)
Portrait of a Boy and Girl
Oil on canvas,
151.7 × 124.5 cm
(59¾ × 49 in.)
Christie's, 20 November
1981, lot 108
© Christie's Images

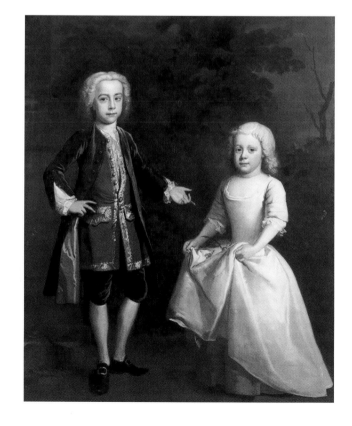

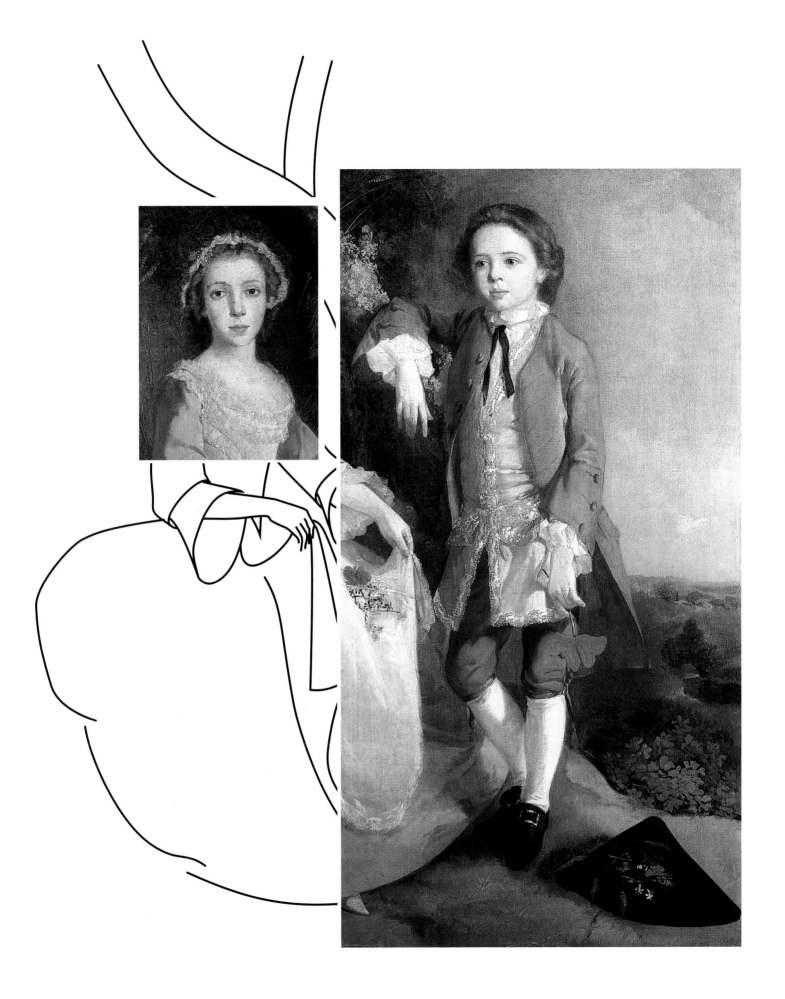

to give the figure the same identity. Perhaps thinking of the portrait of *Sir Frederick Evelyn as a Boy* (Salisbury and South Wiltshire Museum),[4] Sir Ellis Waterhouse favoured an attribution to George Beare, who would later also be associated with the smaller fragment of the girl's head.[5] However, several features make the attribution to Gainsborough preferable: the light which unites the figures with the landscape is wholly Gainsboroughesque and the grey-green landscape beyond the precipitous fall in the ground behind the boy has parallels in the dog portrait, *Bumper*, of 1745 and the portrait of *Clayton Jones* in the Yale Center for British Art.[6] The foreground – in handling like clumps of cotton wool – slopes dangerously towards the beholder in all three canvases. The Yale portrait shares certain anatomical awkwardnesses with the Sudbury fragment such as the overlarge hands and the unresolved difficulty Gainsborough experienced with the boy's right ankle. Despite all these caveats, the portrait has a purity of colour and shows a remarkable ability to render the textures of fabrics which, as an affirmation of quality, does much to explain the earlier attribution to Hogarth.

NOTES

1. The two fragments were associated by a number of scholars, including Brian Allen, Lindsay Stainton and Michael Liversidge. See also *The Sunday Times Magazine*, 16 June 1991, pp. 30–32.

2. Einberg 1987, no. 150, repr.

3. M. Webster, 'From an Exotic Home: Hogarth's Portrait of the Mackinen Children', *Country Life*, 28 September 1989, p. 151.

4. Surry 1989, no. 3, repr.

5. Waterhouse's thoughts were recorded in *The Guardian* on 24 September 1984 and John Hayes's attribution of the smaller fragment to the same artist is given in Sotheby's 1991 sale catalogue.

6. See especially Hayes 1982, pp. 34–35, 39.

THOMAS GAINSBOROUGH

Group Portrait of Charles Crokatt, William Keable and Peter Darnell Muilman, ca. 1748

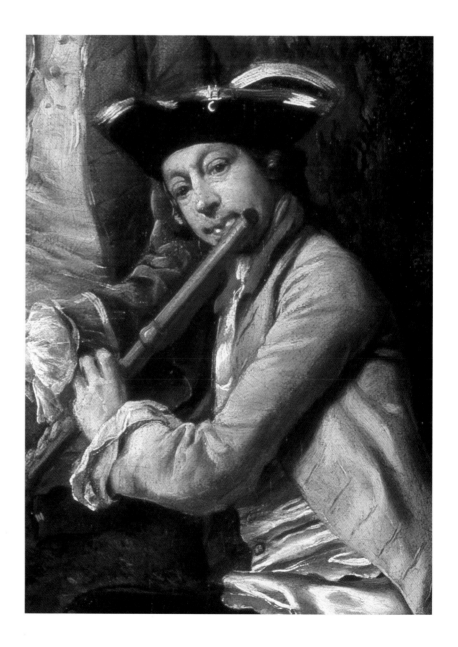

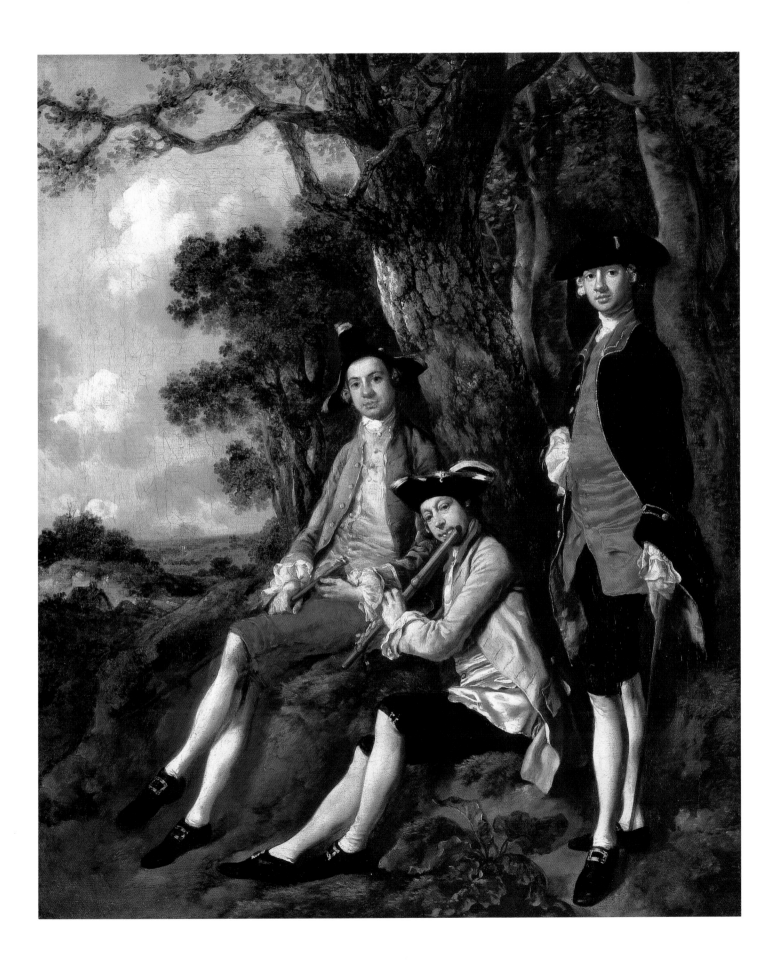

Oil on canvas, 76.3 × 63.5 cm (30 × 25 in.)

FRAME English carved Rococo frame with simplified leaf and shield moulding, a serpentine top rail between stylized left-centre ornaments and acanthus-leaf corner ornaments with leaf tendrils extending along the rail and floral tendrils extending along the hollow, mid-18th century

PROVENANCE perhaps commissioned by Henry and/or Peter Muilman; by descent to Peter Muilman's daughter Anne Crokatt; by descent to her younger daughter Emilia Boucherett; by descent to her son Ayscoghe Boucherett (1792–1857); by descent to his daughter Mary Barne (died 1861); by descent to her great-great-great grandson Miles Barne; his (anonymous) sale, Sotheby's, 14 July 1993, lot 49, bought by Hazlitt, Gooden & Fox for Gainsborough's House and the Tate Gallery with generous contributions from the National Heritage Memorial Fund and the National Art Collections Fund (1993.025)

LITERATURE Waterhouse 1953, pp. 116–17; Waterhouse 1958, no. 747, repr. pl. 19; Stainton 1977, fig. 2; Hayes 1982, I, p. 35; Allen 1987, p. 40, repr. fig. 21; Belsey 1997, p. 55, repr. col.

EXHIBITED Norwich 1948, no. 19; Arts Council 1949, no. 6; Arts Council 1953, no. 12, repr. pl. IV; RA 1956, no. 211; Sudbury 1961, no. 4; Norwich 1961, no. 9; Ferrara 1998, no. 3, repr. col.; Charleston 1999, no. 1, repr. col.; Tate 2002, no. 21, repr. col.

The arrangement of the landscape with the wood, the track on the left and a fortuitously shaped bank on which the three friends disport themselves are echoed in a small drawing (fig. 4) which was probably the field sketch that provided Gainsborough initial thoughts for the composition. Worth noting are the slightly naïve aspects of the painting – the extension of the three branches of the trees in the clouds and the lack of a middle ground to the left – and the energy Gainsborough exerted in the painting of some of the individual features of the composition such as the veristic detail of the oak trunk in the background.

There has been some confusion about the identity of the figures. Waterhouse thought the seated figure playing a flute was Gainsborough himself.[1] However, since the appearance of a self-portrait (fig. 5), there can be little doubt about the identification of the figure in the centre as the artist and amateur musician, William Keable (1714–1774). The clear delineation of the features and the purplish tinge of the head has encouraged the likely suggestion that Keable contributed his own head himself.[2]

The relationship between Keable and the other sitters is unclear. As he is shown playing the flute, he presumably shared some of his family's musical ability; he is recorded as painting small-scale portraits similar to those by Edward Penny and Arthur Devis[3] and head-and-shoulder portraits in a style like that of George Beare (for example, the self-portrait at Yale). Arguably the best of these portraits is that of *Mrs Benjamin Smith* (Gibbes Art Gallery, Charleston),[4] which shows that he was a competent artist whose work deserves closer scrutiny. In 1754 he is recorded working in the Second St Martin's Lane Academy, but by 1765 he had settled in Bologna, where he became a member of the Accademia della Clementina in 1770. He may have travelled to Italy for his health as his will was written at Ischia in 1764, ten years before he died. He is buried at Livorno.

Peter Darnell Muilman (1730–1766) is probably the figure in the red waistcoat on the right, who appears to be somewhat younger than the other sitters. Muilman was baptized at St Botolph's, Bishopgate, on 9 April 1730. His father Henry (died 1772), who was a South Sea director in 1734 and 1742, had emigrated from Amsterdam with his younger brother Peter (1713–1790), who became a distinguished London merchant.[5] Both brothers, who were business partners, appear to have retired to the Essex countryside in 1749. In that year Henry purchased Dagenhams at Romford,[6] and Peter purchased the manor of Great Yeldham in the north of the county. The figure's pose has an elegance close to one of Gravelot's fashion engravings of 1744 (fig. 6); indeed it is so close that it appears as though Gravelot's figure has turned forty-five degrees to his right to pose for Gainsborough.

Peter Darnell Muilman's sister, Anna, married Charles Crokatt in 1752.[7] Crokatt had purchased Luxborough Hall at Chigwell in Essex three years earlier and it is tempting to assume that he, too, was associated with the business interests of the Muilman brothers.[8] Crokatt committed suicide in 1769. In his will he describes himself as of St Botolph's, Bishopsgate, London, with an estate of £10,000. His elongated posture must be based on studies from a lay figure.

Despite such disparate influences and unusually mixed levels of concentration, Gainsborough unites the composition with colour, exploiting the optical opposite of the landscape's green with the scarlet of Muilman's waistcoat, the vermilion of Keable's velvet collar and the crimson of Crokatt's breeches.

NOTES
1. Waterhouse 1953, pp. 116–17.
2. Andrew Wilton first made the suggestion.
3. An anonymous portrait is illustrated in Waterhouse 1981, p. 203.
4. Charleston 1999, no. 2, repr. col.
5. *GM*, LX (I), 1790, p. 183.
6. *VCH: Essex*, VII, p. 66.
7. Essex County Record Office D/DNe T3. Interestingly this information exists amongst the deeds for the Peter Muilman property, Dagenhams.
8. Morant 1768, p. 169, erroneously says that a James Crokatt purchased the house and that he was married to a daughter of Peter Darnell Muilman.

right Fig. 4
THOMAS GAINSBOROUGH
Landscape with trees by a road
Pencil, 14.5 × 19 cm (5¾ × 7½ in.)
Private collection, United States

left below Fig. 5
WILLIAM KEABLE (1714–1774)
Self-portrait, 1748
Oil on canvas, 76.2 × 63.5 cm (30 × 25 in.)
Yale Center for British Art, Paul Mellon
Collection

right below Fig. 6
LOUIS TRUCHY after HUBERT-FRANÇOIS
GRAVELOT (1699–1773)
Study of a man's costume, published 1744
Engraving, 27 × 18 cm (10⅛ × 7⅛ in.)
Victoria and Albert Museum, London or British
Museum, London????

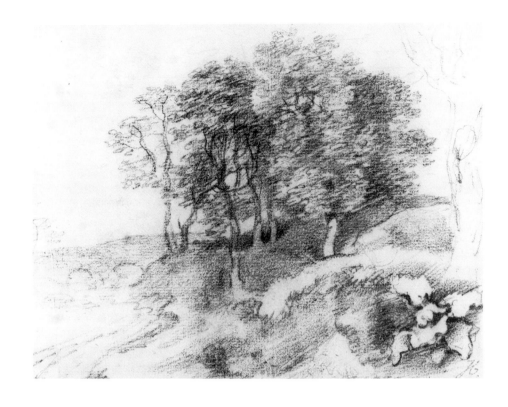

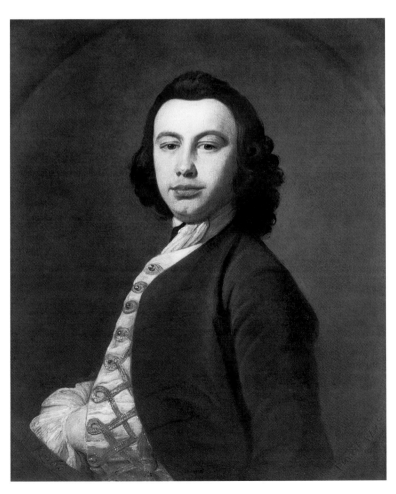

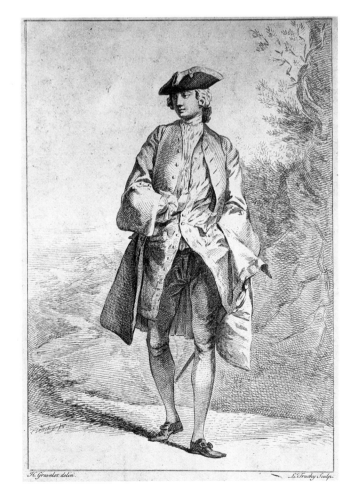

19

THOMAS GAINSBOROUGH

Wooded Landscape with Herdsman seated, ca. 1748

Oil on canvas, 49 × 65.5 cm (19¼ × 25¾ in.)

FRAME English carved half Maratta frame with alternating acanthus leaf and shield on the sight edge and a rope decoration in the hollow with a bead-decorated knull, 20th century

PROVENANCE ... Revd Thomas Rackett (1757–1841); by descent to his daughter Dorothea Solly; by descent to Col. R.J.N. Solly; his descendants' sale, Christie's 25 April 1985, lot 54, bt private collection; anonymous sale, Sotheby's, 19 July 1986, lot 76, bt private collection; on loan to the Ashmolean Museum, Oxford; on loan to Gainsborough's House from March 1989 and sold to the Society through Robert Holden Ltd in December 1990 with contributions from the National Art Collections Fund, the MGC/V&A Purchase Grant Fund, the Esmée Fairbairn Charitable Trust and the Godington Trust (1990.087)

LITERATURE Waterhouse 1958, no. 869; Hayes 1982, pp. 48, 336–37, no. 11, repr.; *BM* 1991, p. 579, repr.; Cormack 1991a, p. 30–37, repr.; Belsey 1991, p. 112; Egerton 1998, p. 77, repr. col.

EXHIBITED Arts Council 1949, no. 1; Bath 1951, no. 6; Ferrara 1998, no. 28, repr. col.; Colchester 2000

While the composition of this small landscape uses the age-old principle of the golden mean in the location of the clump of trees, the effect of the painting depends on the tranquil cloudscape that mottles the landscape beneath with pools of sunlight. The landscape itself is peppered with unrelated incident such as the two cows, who ignore one another, and the indolent herdsman lounging in the centre. A sense of progression is created by the track on the left, marked by a white gate, and the pathway which emerges in the middle ground and leads on to the cluster of buildings in the distance. Placed prominently on the horizon is a church with a brooch spire reminiscent of St Mary's, Great Henny, or St Andrew's, Great Cornard. The serenity of the scene gives extra impetus to the suggestion that the prominence of the church is not purely circumstantial and that it provides a spiritual presence in the landscape.

Another canvas originally of similar size (fig. 7) was also owned by the antiquarian Revd Thomas Rackett and his descendants, and the two paintings must have hung as pendants in Spetisbury Rectory in Dorset.[1] The cloudscapes in the two landscapes mirror each other, and have a common horizon which is broken in both cases by a single clump of foliage and a church spire.

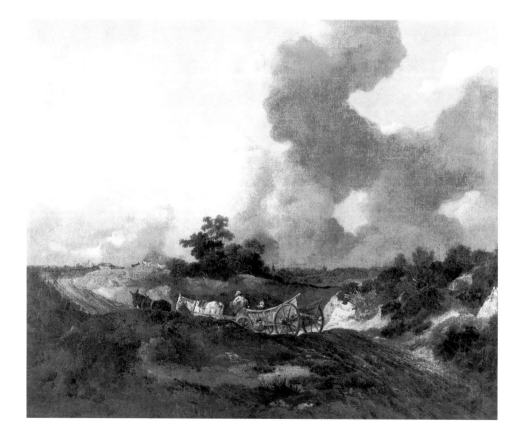

Fig. 7
THOMAS GAINSBOROUGH
Landscape with a Country Wagon, ca. 1748
Oil on canvas, 49.3 × 60.5 cm (19⅜ × 23¾ in.)
Rothschild Trust, Canada Inc.

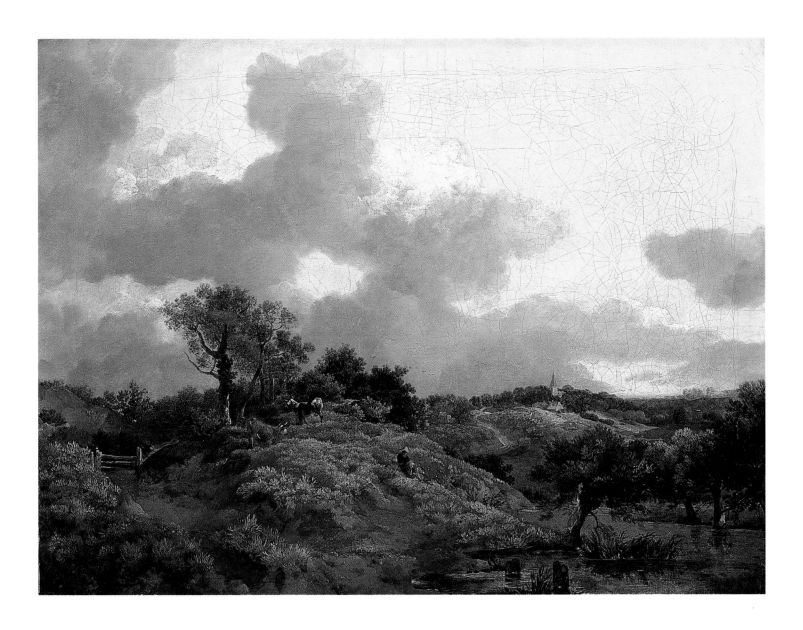

Whereas the Sudbury painting is verdant and includes cows, water and a calm sky, the other canvas is more gaunt and has horses drawing a wagon over a sandy track. Malcolm Cormack has suggested that the two canvases deliberately convey a contrasting mood, "a sort of *L'Allegro* and *Il Penseroso* of classical landscape translated into his [Gainsborough's] own more naturalistic forms".[2]

John Hayes felt the composition showed some advance from Gainsborough's earliest landscapes, the "imations of little Dutch landskips", as Gainsborough was to call them many years later,[3] and dated it about 1746–47, making it a little earlier than the

large landscape in the Philadelphia Museum of Art which is signed and dated 1747. Malcolm Cormack suggests a date of *ca.* 1747–48,[4] and Judy Egerton sees a stylistic similarity to *Cornard Wood* (National Gallery), which the artist dated 1748, a date she favours for the Sudbury canvas.[5]

The landscape, with its lack of artifice, suggests a topographical view, one which is no longer recognizable after two hundred and fifty years of agricultural improvements. It recalls, however, Philip Thicknesse's report of Gainsborough's love for the landscape around Sudbury: " … not a Picturesque clump of Trees, nor even a single Tree of

beauty, no, nor hedgerow, stone or post, at the corner of the Lanes, for some miles around the place of his nativity that he had not so perfectly in his mind's eye, that had he known he could use a pencil, he could have perfectly delineated".[6]

NOTES

1. For Rackett see Dewar 1965, *passim*, and Neale 2000, pp. 11–12.
2. Cormack 1991a, p. 36.
3. Hayes 2001, p. 174.
4. Cormack 1991a, p. 35.
5. Egerton 1998, p. 77.
6. Thicknesse 1788, pp. 5–6.

THOMAS GAINSBOROUGH

Mrs Mary Cobbold with her Daughter Anne in a Landscape with a Lamb and Ewe, ca. 1752

Oil on canvas, 75.5 × 63 cm (29¾ × 24¾ in.)

PROVENANCE first recorded in the collection of John Dupuis Cobbold in 1898; by descent to Patrick Cobbold; his executors' sale, Sotheby's, 12 July 1995, lot 44, bt in; accepted by HM Treasury in lieu of inheritance tax by HM Government in January 1998 and allocated to Gainsborough's House in June 1998 (1998.075)

LITERATURE Armstrong 1898, p. 198; Waterhouse 1953, p. 117; Waterhouse 1958, no. 750; Egerton 1998, p. 86, repr.

EXHIBITED Ipswich 1927, no. 30; Park Lane 1936, no. 81, repr.; Norwich 1948, no. 17; Arts Council 1949, no. 5; Ham 1954, no. 143; Sudbury 1961, no. 3; Sudbury 1977, no. 4; Agnew 1980, no. 11; Carlisle 2002, no. 8, repr. col.

Until its sale in 1995, this conversation piece appears to have always been in the collection of the Cobbold family, first at Holywells Park in Ipswich (the subject of a recently identified landscape of about 1746)[1] and then, after 1923, at Glemham Hall in Suffolk. Despite considerable research, the identity of the sitters remains elusive. Perhaps the most likely candidates are Mary, the widow of Thomas Cobbold (1680–1752), a maltster of Bury St Edmunds, and their daughter Anne, who was to marry Robert Andrews, a Bury St Edmunds brewer.[2] This identity does not, however, explain why sheep should form such a prominent part of the composition.

Revd Edmund Farrer, the compiler of many catalogues of East Anglian picture collections, when studying this portrait at Holywells commented: "… the landscape is exceedingly good but the figures are stiff and poor",[3] an opinion which has been repeated frequently. The figures are shown beside three tree trunks; the farther two trees are crossed, a device frequently used in Gainsborough's 'conversation pieces' to indicate marriage, and the nearer trunk, which frames the head of the elder sitter, has a single leafless branch hanging with ivy silhouetted against the sky, a combination which would refer to the putative sitter's widowhood.

In the background a flock of sheep graze on the far bank of the stream but one of the ewes has wondered over the simple bridge to find its lamb. The contrast between the exceptional rendering of the ewe, anxiously bleating for its offspring, and the prosaic treatment of the lamb, which is struggling in the girl's arms, is very pronounced. The mother has a white rose pinned to her breast and holds a chained parakeet on her index finger, accessories that seem too fussy for Gainsborough's imagination. In comparison to the Gravenor conversation piece in the Yale Center for British Art, the figures are stiff, the draperies contrived and the faces dull.[4] So is this a collaborative painting between another artist and Gainsborough? There is one documented example of such practice, Gainsborough providing the background to a double portrait by Francis Hayman, and circumstantial evidence points to its being relatively common in Gainsborough's early years.[5] In this case, the most likely candidate as Gainsborough's collaborator is William Keable (see cat. 2).

Conservation in 1998 showed that the landscape was painted first, with spaces reserved for the figures of mother and daughter. On the other hand, modifications to the pink skirt, which have become increasingly transparent with age, were painted over the background. If the portrait was painted by two artists, they would have been working very closely together in order to determine the profile of the figures before painting the landscape.

NOTES
1. Ipswich Museums and Galleries. See Hayes 1982, no. 26, repr., and Ferrara 1998, no. 31, repr. col.
2. The identities were first proposed by John Hayes (see note 1).
3. In the manuscript catalogue of 'East Suffolk Portraits' (Suffolk Record Office (Ipswich) Q.S. 92c, f. 42, no. 14).
4. See the detailed illustrations in Jones 1997, pp. 20–22.
5. Allen 1987, pp. 8, 92–93, repr. col., and Belsey 2002b, pp. 14–18, 28, 35–36.

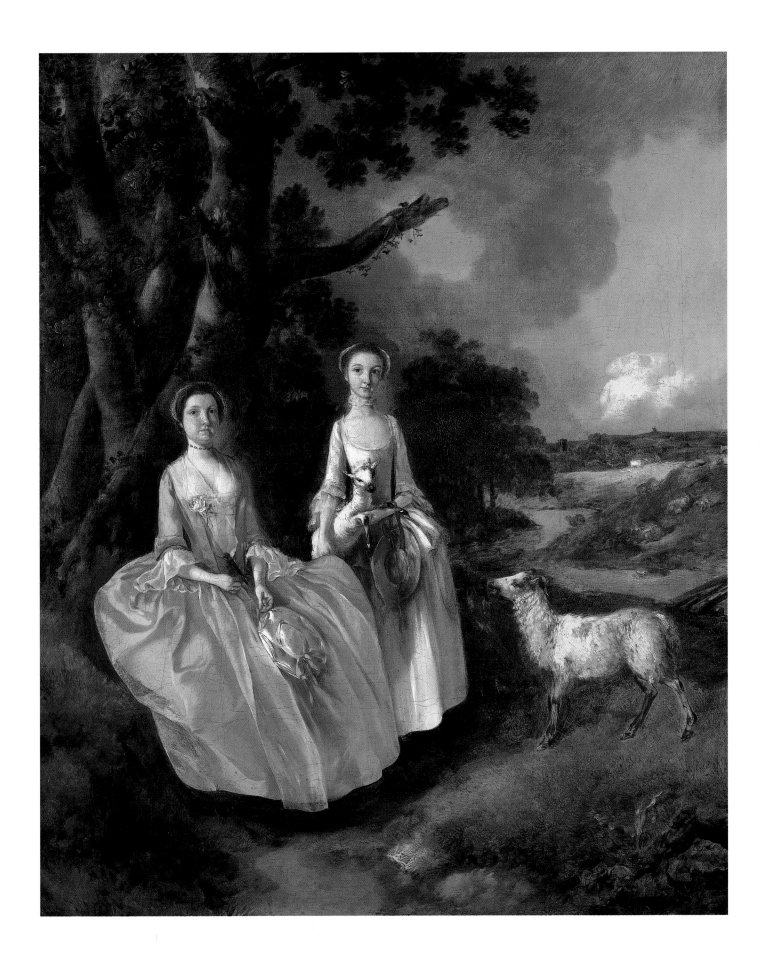

THOMAS GAINSBOROUGH

Portrait of Revd Tobias Rustat, ca. 1757

Oil on canvas, 75 × 62 cm (29½ × 24⅜ in.)

FRAME English neo-classical frame with composition ornament of acanthus-leaf sight moulding, flat frieze with anthemion corner ornaments, pearl cavetto section with scallop shells in the corners and alternating acanthus and shield knull, *ca.* 1810. The frame forms part of a suite which included the pendant portrait of Mrs Rustat and portraits by Henry Walton of members of the Crowfoot family[1]

PROVENANCE by descent to the sitter's nephew, Tobias Bowles, whose daughter, Mary (1779–1835), married William Henchman Crowfoot (1780–1848); by descent to W.M. Crowfoot, who presented the portrait to the Society in September 1989 (1989.062)

LITERATURE Lewin 1990, pp. 35–39, repr. col.; Belsey 1991, pp. 114–15; *BM* 1991, p. 580, repr.; Belsey 2002b, p. 66, 68–69, repr. col.

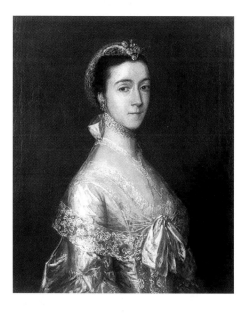

Fig. 8

THOMAS GAINSBOROUGH

Portrait of Sarah, Mrs Tobias Rustat, ca. 1757
Oil on canvas, 76.2 × 63.5 cm (30 × 25 in.)
Private collection, Australia

Tobias Rustat (1716–1793) was baptized on 22 May 1716 at St Mary's, Withersfield, in Suffolk, the son of Tobias Rustat (1668–1744) and his second wife Frances Tipping from Weston Colville just over the border in Cambridgeshire. On 24 December 1734 he was admitted to Jesus College, Cambridge, where, after completing his BA and MA, he served as a Fellow from 1743 until 1746. He was ordained deacon at Lincoln Cathedral on 23 September 1739 and was priested in February 1740. In 1745 he was appointed Rector of Fordham in Cambridgeshire, a position he retained until 1754. On 3 May 1748, through the presentation of his uncle Revd Thomas Tipping, who had obtained the advowson of the parish in 1713, he was appointed Rector of Stutton, south of Ipswich, with a living of £300 per annum, a post he retained until his death on 14 January 1793.[2] He inherited a considerable sum from his father, which enabled him to rebuild the Rectory (which became grand enough to be called Stutton House) and develop the grounds as an arboretum.[3] He erected a west gallery in the church "for the sole use of the singers".[4] On 25 October 1753 he married Sarah Paige of Exeter (fig. 8), who, in 1735, at the tender age of eleven, had inherited £12,000 from her father. On 19 June 1755 he was amongst the 127 members of the gentry and clergy who bought the Freedom of Ipswich for five guineas, and he is recorded as voting in the by-election on 17 December 1757. He also accepted the living of Capel St Mary from 1786 until 1791. His widow, Sarah, was buried with her husband in St Peter's, Stutton on 21 May 1801, aged seventy-five, and a simple memorial tablet decorated with the coats of arms of Rustat and Paige was installed in the chancel of the church.[5] The couple died childless and Rustat bequeathed £100 to the widows and orphans of Suffolk clergymen and made sizeable legacies to his nephews, Stephen Hemsted and Tobias Bowles, the sons of his sisters Susannah and Martha.[6] This portrait was presumably part

of the legacy, which passed through the Bowles family to the Crowfoots.

Gainsborough painted about ten Suffolk clergymen when he was in working in Ipswich in the 1750s. In 1757, presumably the date they were painted, Revd Henry Hubbard and Revd Richard Canning, who were lifelong friends, exchanged portraits. As John Hayes has noted, Canning's portrait of Canning is very similar to the portrait of Rustat.[7] These images are uncompromisingly direct and must have served as experiments in which Gainsborough honed his ability to catch a likeness. It was at this time that Gainsborough was trying out a "roughness of the surface" which, he explained, was "of use in giving force to the effect [of a portrait] at a proper distance". No doubt, too, he was considering how dappled candlelight would enliven the surface of the canvas and bring the portrait to life. At this stage in his career he was seeking ways to avoid the inherent difficulties of painting "a face, confind to one View, and not a muscle to move to say here I am" (see further cat. 49).[8]

NOTES

1. Bell 1999, p. 55, nos. 34–36.
2. This biographical information appears in Venn 1922–54, Part I, III, p. 501; *GM*, XIII, 1743, p. 52, and XVIII, 1748, p. 285; and letters in the Museum file from P.I. Lewin, the late John Bensusan-Butt and Dr John Blatchly.
3. After a fire in January 1984 the house, which had been Victorianized, was restored to its original eighteenth-century design (*EADT*, 23 January 1984 and 24 April 1985).
4. Rustat's improvements were swept away in the restoration instigated by his successor Revd Thomas Mills (*IJ*, 2 August 1862).
5. Crisp 1881 [unpaginated]. The plaque was moved to the north chapel during the nineteenth-century restoration.
6. Notice of the Executor's sale appears in *IJ*, 23 May 1901, p. 3, col. 1.
7. Hayes 1991, p. 88.
8. Hayes 2001, pp. 10, 90–91.

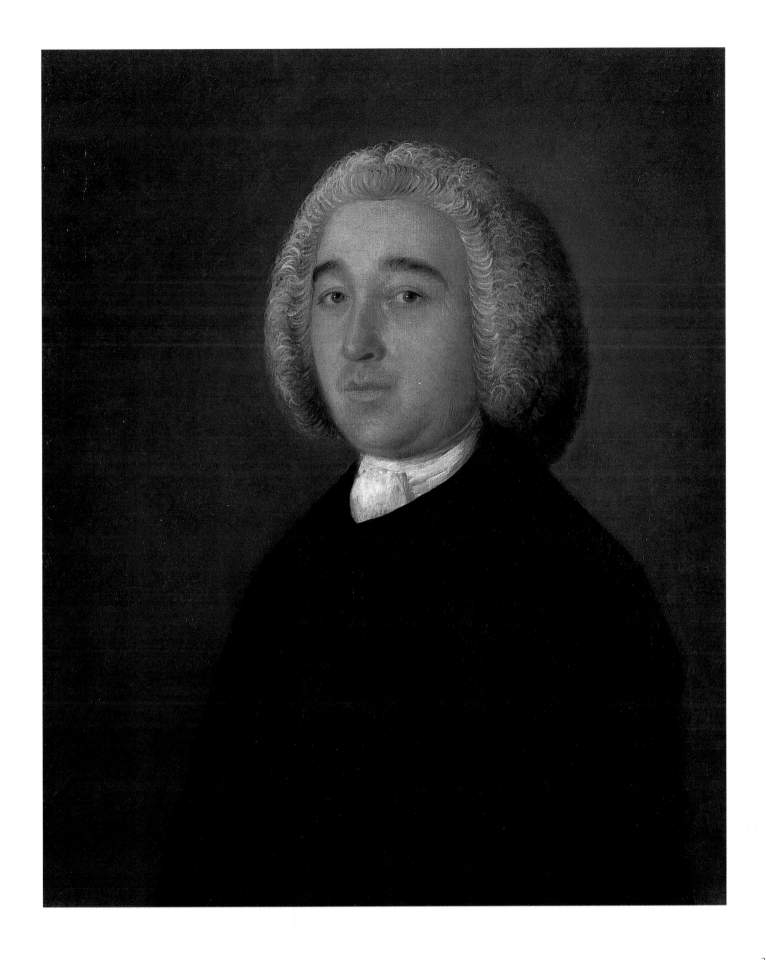

THOMAS GAINSBOROUGH

Portrait of Lambe Barry, ca. 1759

Oil on canvas, 75.5 × 63 cm (29⅞ × 24⅞ in.)[1]

FRAME English frame with reverse section and a raking gadroon knull with acanthus-leaf and flower back moulding, *ca.* 1700. Being a standard size, it was probably swopped with that of one of the other portraits in the family's collection in the nineteenth century

PROVENANCE by descent to the sitter's second daughter, Isabella (1738–1825); passed to her cousin Nathaniel Lee Acton (1757–1836) at Livermere Park, Suffolk; by descent to Jane Broke, who married 5th Baron de Saumarez; thence by descent; on loan to Gainsborough's House since 1961 and purchased in August 2001 from the Will Trust of the Sixth Baron de Saumarez with contributions from the National Art Collections Fund and Re:source/V&A Purchase Grant Fund (2001.140)

LITERATURE Farrer 1908, p. 241; Menpes and Greig 1909, p. 169 [as a miniature]; Hussey 1953, p. 1738, repr.; Waterhouse 1953, p. 6, no. 1; Waterhouse 1958, no. 41, repr. pl. 33

EXHIBITED Arts Council 1953, no. 20; Sudbury 1977, no. 13; Agnew 1980, no. 13; Tate 1980, no. 66, repr.

The sitter was born on 30 April 1704, the eldest son of Anthony Barry of Syleham, Suffolk, and his wife Isabella,[2] the daughter of John Lambe of Barham Hall[3] and his wife Susan, the daughter of John Acton (1587–1661). He married Susan Morse (*c.* 1710–1786) and they had two sons and three daughters.[4] Barry subscribed to a number of diverse publications[5] and was High Sheriff of Suffolk in 1748. In 1755 he was included in the list of Free-burgesses of Ipswich who were created to evict the existing Portmen of the borough.[6] He died on 24 November 1768 and was buried at Syleham on 1 December.

Barry is shown in a wig before a dark moody landscape which, with its thick foliage, has affinities with landscapes in Tate Britain and the Worcester Art Museum.[7] Opinion as to the date of the portrait varies. Waterhouse suggests "some years later than

1750" and Hayes prefers "about 1757–8". Interestingly, Barry appears in the visitor lists in Bath in September 1758 and April and October 1759, while the assurance of the composition points to a later date.[8] Another, smaller portrait of the sitter (fig. 9), dating from 1756, was probably painted in payment of a monetary loan.[9] The small-scale full-length portrait from Weston Underwood of a man with a dog of *ca.* 1746 has been wrongly identified as Lambe Barry.[10]

Like other portraits from the de Saumarez collection, this portrait was originally thought to represent a member of the Broke family.[11]

NOTES
1. When the canvas was relined it was placed on a larger stretcher and the original edges of the canvas were not removed. The stretcher size is 78.5 × 65.6 cm (30⅞ × 25¼ in.).
2. The identity is confirmed by an inscription on the back of the canvas noted, presumably before it was lined, by Farrer 1908, p. 241.
3. A tablet, presumably installed by the sitter, to the north of the altar on the east wall of St Margaret's, Syleham, commemorates Anthony Barry, "a Man of Exemplory Justice, Temperance, Piety and Charity to the Poor", and his wife Isabella.
4. For the Barry of Syleham pedigree see British Library, Add. Mss 19117, f. 66–69. The two surviving children, Isabella (1738–1825) and Anne (*ca.* 1750–1808), both unmarried, are commemorated in the chancel of Syleham Church. See obituary notices in *IJ* on 15 October 1808 and 12 March 1825.
5. Barry appears in the subscriber lists of Mary Masters, *Poems*, London 1733; Zachary Grey, *Hudibras*, London 1744; Joshua Kirby, *An Historical Account of the Twelve Prints of Monasteries*, Ipswich 1748; and John Conybeare, *Sermons*, London 1757.
6. Bensusan-Butt 1993, p. 62.
7. Hayes 1982, nos. 75 and 80 (exhibited at the Society of Artists in 1763).
8. As "Mr. Barry" (*Boddely's Bath Journal*, XV, no. 36, 4 September 1758; XVI, no. 17, 23 April 1759, and no. 41, 8 October 1759).

Fig. 9
THOMAS GAINSBOROUGH
Portrait of Lambe Barry, ca. 1756
Oil on canvas, 34.3 × 29.2 cm (13½ × 11½ in)
Private collection

9. Private collection (Waterhouse 1958, no. 40, pl. 32) and Hayes 2001, p. 6, repr.
10. Private collection on loan to Gainsborough's House (Waterhouse 1958, no. 756, pl. 18).
11. Hussey 1953, p. 1735.

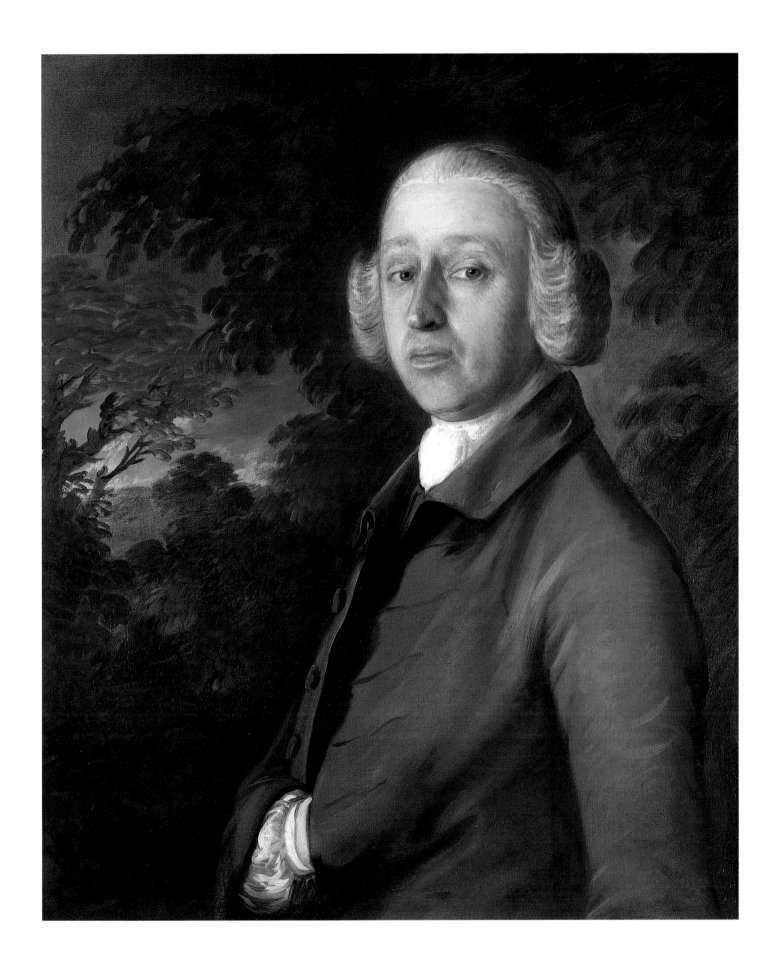

THOMAS GAINSBOROUGH

Portrait of Harriet, Viscountess Tracy, ca. 1763

Oil on canvas, 126.4 × 101 cm (49¾ × 39¾ in.)

FRAME English carved Rococo frame with husk sight moulding, a serpentine top rail of reeds bound by ribbons between pronounced and pierced scallop-shell centre ornaments and acanthus-leaf corner ornaments with leaf tendrils and flowerheads extending along the hollow, mid 18th century

PROVENANCE by descent to the 6th Viscount's half-brother, Henry, 8th Viscount Tracy; by descent to his daughter Henrietta Susanna, wife of Charles Hanbury-Tracy, 1st Baron Sudeley; thence to Charles, 4th Baron Sudeley; with S.T. Gooden; purchased by E.M. Denny in 1895; his executors' sale, 31 March 1906, lot 27, repr., bt Vokins; Ernest James Wythes, Copped Hall, Essex; his sale, 1 March 1946, lot 3, bt Spielman; with Newhouse Galleries, New York; purchased by Kay Kimbell and bequeathed to the Kimball Art Foundation; Kimball Art Museum, Fort Worth (ACF 49.2); deaccessioned and sold at Sotheby's, 13 November 1991, lot 51, repr. col., bt in; purchased by Historical Portraits Ltd for the Society in February 1992 with contributions from the MGC/V&A Purchase Grant Fund and the National Art Collections Fund (1992.001)

LITERATURE Armstrong 1898, p. 203; Menpes and Grieg 1909, p. 180; Waterhouse 1953, p. 107; Waterhouse 1958, no. 672; Sudeley 1970, pp. 152–53; Belsey 1992, pp. 6–8; Owen 1992, p. 106; Sloman 1996a, pp. 142–43, repr.; Belsey 1997, p. 56; Sloman 2002, pp. 86–87, repr. col.

The sitter was born on 20 September 1722, the second daughter of Peter Bathurst and his second wife Selina, the daughter of Robert Shirley, 1st Earl Ferrers. She was bought up at Clarendon Park near Salisbury and on 10 February 1755 she married Thomas Tracy, who, the following year, inherited an Irish peerage from his father and became 6th Viscount Tracy of Rathcoole. With the title the Tracys inherited Toddington Manor, a medieval house in Gloucestershire which had been extensively rebuilt in the 1620s by Sir John Tracy. Except

for the gatehouse near the church, the house was pulled down when Charles Hanbury-Tracy, later Lord Sudeley, built a new house in Gothick style on rising ground to the north-east. The appearance of the earlier house is known from an engraving by Jan Kip.[1] Lord Tracy commemorated his father with a monument in the church and in 1773 he received an honorary DCL from Oxford University, perhaps through the agency of his half-brother, John, the Warden of All Souls, who was to inherit the title from him in 1792.[2] After the sixth viscount's death, his widow moved to Pulteney Street, Bath, where she died three years later. She was buried on 8 August 1795 in St James's in Stall Street, a church demolished in 1957.

At the same time that this portrait was painted, Lady Tracy's sister Louisa, who had married George Byam, was sitting to Gainsborough for a large double portrait which was eventually to incorporate a portrait of their daughter Selina; and at a similar date her uncle John Shirley was sitting for a head-and-shoulders portrait.[3] A few years earlier her cousins, a son and daughter of her uncle Benjamin Bathurst, had also sat to the artist, and in 1778 her niece Selina, the daughter of her sister Elizabeth, sat to Gainsborough for a full-length portrait painted as a pendant to Gainsborough's canvas of her husband, Robert Thistlethwayte.[4] Tory politics – Lady Tracy's father and her two uncles all held seats in Parliament in the Tory interest – appears to be a common allegiance amongst his sitters during his early years in Bath.

In July 1764 Gainsborough wrote to his

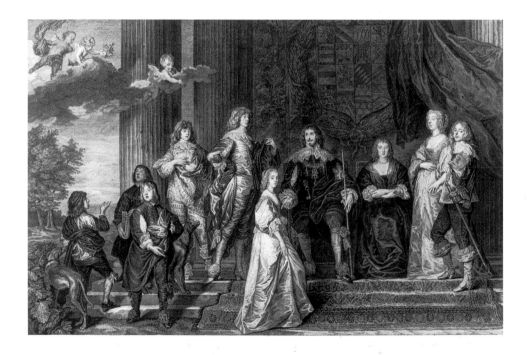

Fig. 10
BERNARD BARON (1696–1762) after SIR ANTHONY VAN DYCK (1599–1641)
The Pembroke Family, 1740
Engraving, plate size 47 × 67.6 cm (18½ × 26½ in.)
Gainsborough's House, Sudbury (1992.022)

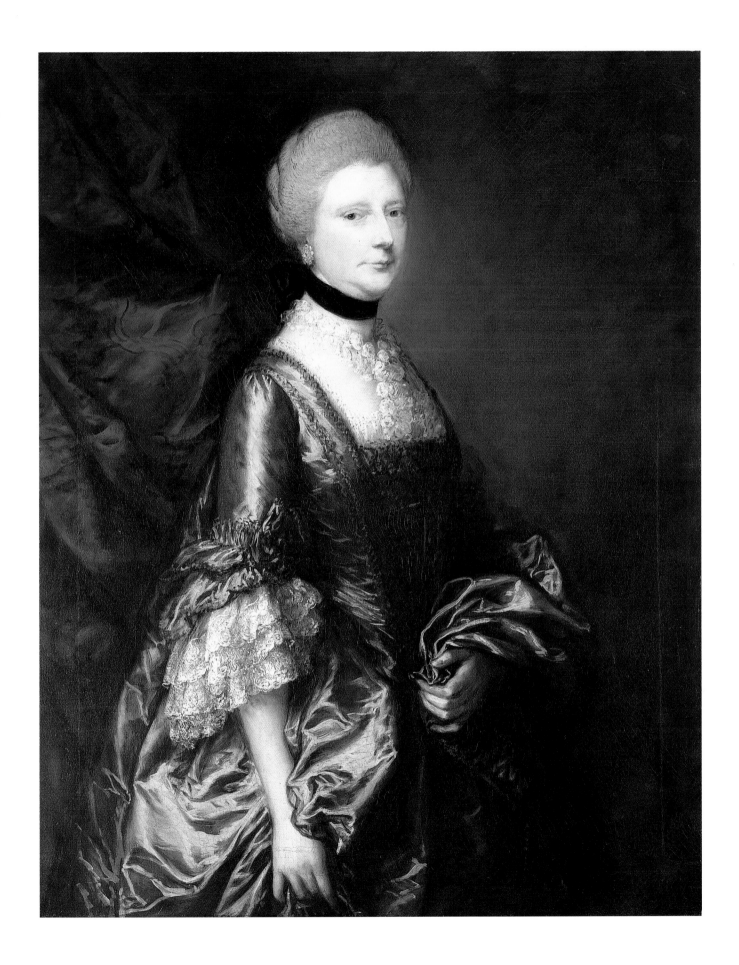

friend James Unwin saying that he had returned "from Wilton, where I have been about a Week, … for my Amusement".[5] His "amusement" may well have been to study the exceptional collection of Van Dycks in the house; and he is reputed to have painted a copy of the huge Pembroke Family there from memory.[6] He would have been aware of the composition through Bernard Baron's print published in 1740 (fig. 10). In the foreground of the great Van Dyck Lady Mary Herbert is shown in profile, lifting her skirts as she mounts the daïs, her head turned to face the beholder. Gainsborough adopts exactly the same pose in the canvas of Lady Tracy, and repeats it in portraits of Lady Carr and Mrs Leyborne Leyborne, amongst others.[7] Not only the pose but the handling of the paint betrays Gainsborough's source: the metallic folds of the blue satin dress with its strong highlights are more than redolent of the seventeenth-century master. The composition of the companion portrait of Lord Tracy (fig. 11),[8] repeated in portraits of Mr Leyborne Leyborne, Sir William Draper and Walter Barttelot, is a more formal eighteenth-century pose, with the sitter's right hand stuffed into his waistcoat, a gesture prescribed by contemporary fashion.[9]

Shortly after the sale in 1946 the head of the portrait was overpainted to give the sitter a more youthful appearance and thereby increase its saleability. The overpaint was removed in 1971 but, although the sitter's dress is in remarkable condition, the head has been damaged by these interventions.[10] Miniatures by James Scoular (1741–1812), still with the sitters' descendants, may show Lord and Lady Tracy a few years after the their portraits were painted by Gainsborough.[11]

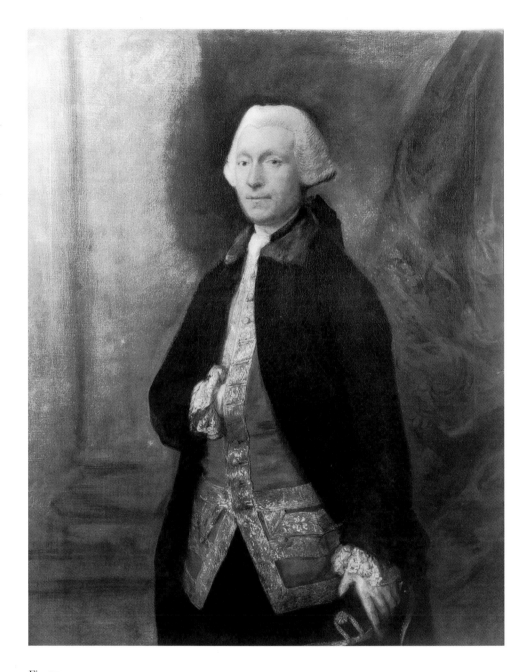

Fig. 11

THOMAS GAINSBOROUGH
Portrait of Charles Thomas, 6th Viscount Tracy, ca. 1763
Oil on canvas, 124.5 × 100.3 cm (49 × 39½ in.)
Private collection, Scotland

NOTES

1. Reproduced in Sudeley 1970, pl. I. An impression is at Sudbury (1992.027).
2. Foster 1891, Part 2, IV, p. 1432 [33].
3. See Belsey 2001, no. 9, and Waterhouse 1958, no. 614, respectively. The portrait of the *Byam Family* belongs to the Andrew Brownsword Foundation and is on loan to the Holbourne Museum of Art in Bath. The portrait of Shirley last appeared in the late Dr John P. Igini sale at Sotheby's, 12 April 1995, lot 60, repr. col.
4. See Belsey 2001, no. 7, and Waterhouse 1958, no. 661, respectively.

5. Hayes 2001, p. 28.
6. Tate 2002, no. 84, repr. col.
7. See Cormack 1991b, pp. 76–77, repr., and Waterhouse 1958, nos. 208 and 439, repr., respectively.
8. Another portrait of Tracy is recorded at Gregynog, attributed to Reynolds, although it is

not included in David Mannings's catalogue raisonné (Steegman 1962, II, p. 158, no. 17).
9. Waterhouse 1958, nos. 438, repr., and 43.
10. Lord Sudeley commented on the condition of the head (Sudeley 1970, pp. 152–53).
11. Courtauld Institute, neg. 607/25 (23a) and 607/25 (24a).

THOMAS GAINSBOROUGH

Portrait of Lord Bernard Stuart after Van Dyck, mid 1760s

Oil on canvas, 73.7 × 59.7 cm (19 × 23½ in.)

FRAME English carved Carlo Maratta frame with husk decoration at the sight edge and applied moulding of alternating acanthus leaf and shield and of ribbon moulding with a knull decorated with leaf tip, 2nd half 18th century

PROVENANCE the artist's posthumous sale, Christie's, 2 June 1792, lot 69, bt in; Gainsborough Dupont's posthumous sale, 10 April 1797, lot 34, bt for £3.5s by Bryan; ... Earl of Darnley; his sale, 1 May 1925, lot 21, bt Agnew; with Agnew until 1950s; Earl Newton, Connecticut, until 1994; with Historical Portrait Ltd; from whom purchased in November 1995 with a contribution from an anonymous trust (1995.066)

LITERATURE Waterhouse 1958, no. 1018; Belsey 1997, p. 56, repr.

EXHIBITED possibly Schomberg House 1789, no. 65;[1] Cincinnati 1931, no. 45, repr. pl. 16; Bath 1936, no. 187; Southampton 2001, no. 24, repr. col.

Van Dyck's portrait of Lord John Stuart (1621–1644) with his brother Lord Bernard Stuart, who was later Earl of Lichfield (1622–1645), was painted in about 1638 (fig. 12). The sitters were the younger sons of Esmé Stuart, 3rd Duke of Lennox and both died during the Civil War for the Royalist cause. The portrait descended to the sister of the last Duke of Richmond and Lennox (who died in 1672) and then to her granddaughter, the 1st Countess of Darnley. Subsequently the portrait hung at Cobham Hall in Kent.[2]

Gainsborough had some connection with the Darnleys of Cobham Hall: in 1765 he painted the granddaughter of the 1st Earl, the Countess of Clanwilliam (Ulster Museum, Belfast),[3] and twenty years later he painted the 4th Earl of Darnley (National Gallery of Art, Washington, D.C.).[4] This connection enabled Gainsborough to make several copies of Van Dyck's double portrait. The earliest appears to be the portrait under discussion, a head of Lord Bernard Stuart, which may have been pendant to a lost copy of his brother Lord John.[5] Stylistically the portrait of Lord Bernard can be associated with a date in the mid 1760s.[6] Gainsborough also copied the whole portrait less slavishly on a canvas exactly the same size as the original. This copy, which shows more of Gainsborough's personal style of brushwork, is now in St Louis.[7] Gainsborough's sitter, Lord Darnley, purchased both the St Louis copy and the head of Lord Bernard after Gainsborough's death.

NOTES
1. Described in the catalogue as "A man's portrait 26 × 21 in.".
2. Millar 1982, no. 44, repr. col. pl. IX. A contemporary version of the portrait, formerly in the Lucas collection, is also in the collection of the National Gallery (no. 3605).
3. Waterhouse 1958, no. 148.
4. Waterhouse 1958, no. 184. See Hayes 1992, pp. 100–01, repr.
5. "A Portrait, after Van Dyck" measuring

22¼ × 17¾ in. appeared in the 1789 Schomberg House sale as lot 94 and it is tempting to assume that this represents the other Stuart brother (Waterhouse 1958, no. 1019).
6. Robert Wark (Wark 1974, p. 45) associated the St Louis copy with the 1780s and the Darnley portrait.
7. Waterhouse 1958, no. 1017; Hayes 1975, p. 211, pl. 93. The painting is fully discussed by Wark 1974, pp. 45–53.

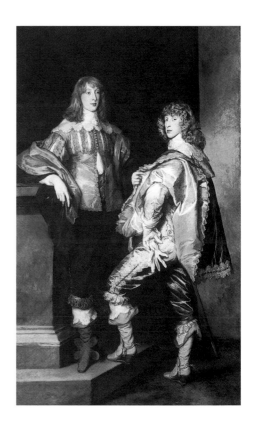

Fig. 12
SIR ANTHONY VAN DYCK
Portrait of Lord John Stuart and his Brother Lord Bernard, ca. 1638
Oil on canvas, 237.5 × 146.1 cm (93½ × 57½ in.)
National Gallery, London

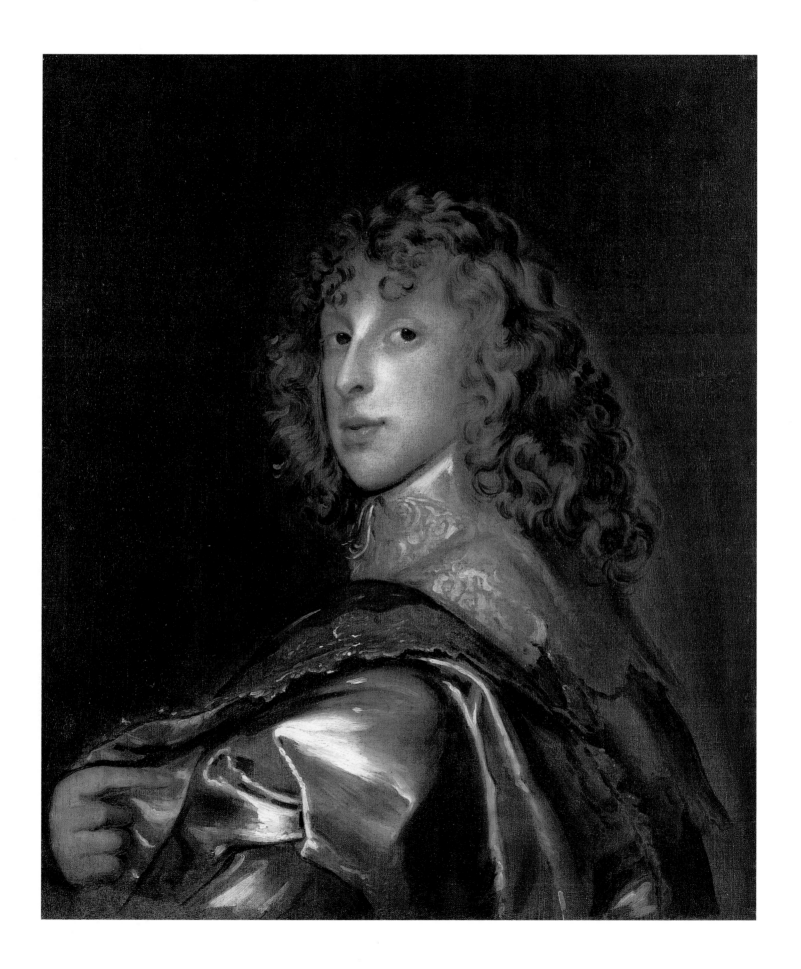

THOMAS GAINSBOROUGH

The Descent from the Cross after Rubens, later 1760s

Oil on canvas, 125.5 × 101.5 cm (49⅜ × 40 in.)

FRAME English carved Maratta frame with pearl sight moulding, alternating acanthus left and shield in the hollow and pin and ribbon twist. The frame retains its original gilding, 2nd half 18th century

PROVENANCE Mrs Gainsborough's sale, Christie's, 11 April 1797, lot 63, bt J. W. Steers as "unfinished, after the celebrated one of Rubens"; his sale, Christie's, 3 June 1826, lot 52 as "after Vandyke", bt Bond; W.R.G. Bond, Tyneham House, Dorset, by 1935;[1] his anonymous sale, Sotheby's, 30 April 1947, lot 149, withdrawn; re-offered, Sotheby's, 25 June 1947, lot 22, bt Sinclair; Hon. Michael Astor by 1950; lent to the Courtauld Institute Galleries, the Ashmolean Museum and Gainsborough's House before being purchased by private treaty from Astor's widow by the Society in November 1998 with contributions from the National Lottery (Heritage Lottery Fund), funds from the bequest of Miss Dorothy Elmer, the MGC/V&A Purchase Grant Fund and the National Art Collections Fund through Suffolk County Council (1998.126)

LITERATURE Waterhouse 1958, no. 1027, pl. 291; Hayes 1963, pp. 90–93, repr.; Hayes 1975, p. 211, pl. 75; Gordon 1981, pp. 18–19, repr.; Hayes 1982, pp. 107, 430, repr.; Belsey 1991, pp. 112–14; Belsey 1997, p. 56; Asfour, Williamson and Jackson 1997, pp. 28, 30; Asfour and Williamson 1999, pp. 253–55, repr. col.; Judson 2000, p. 163; Vaughan 2002, pp. 106–08, repr. col.

EXHIBITED Bath 1951, no. 33; Arts Council 1953, no. 58; Providence 1975, no. 63, repr.; Tate 1980, no. 107, repr.; Paris 1981, no. 39, repr.; Birmingham 1995, no. 8, repr. col.

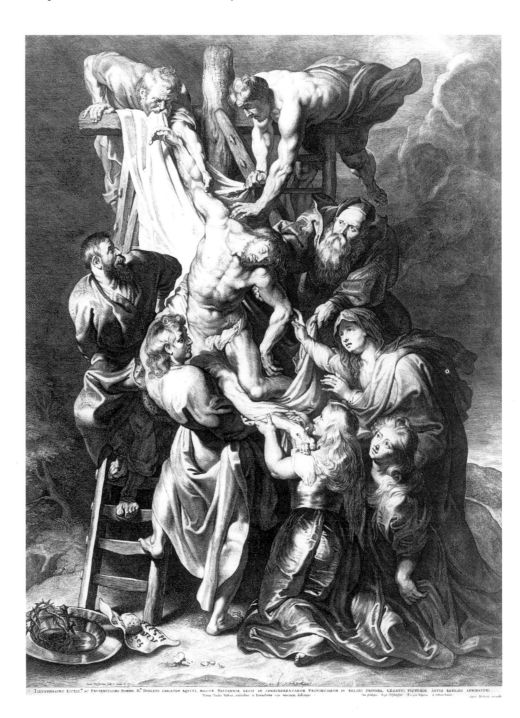

Fig. 13
LUCAS VOSTERMAN THE ELDER (1595–1675) after SIR PETER PAUL RUBENS (1577–1640)
The Descent from the Cross, 1620
Engraving, 58.5 × 43.5 cm (23 × 17⅛ in.)
The British Museum, London

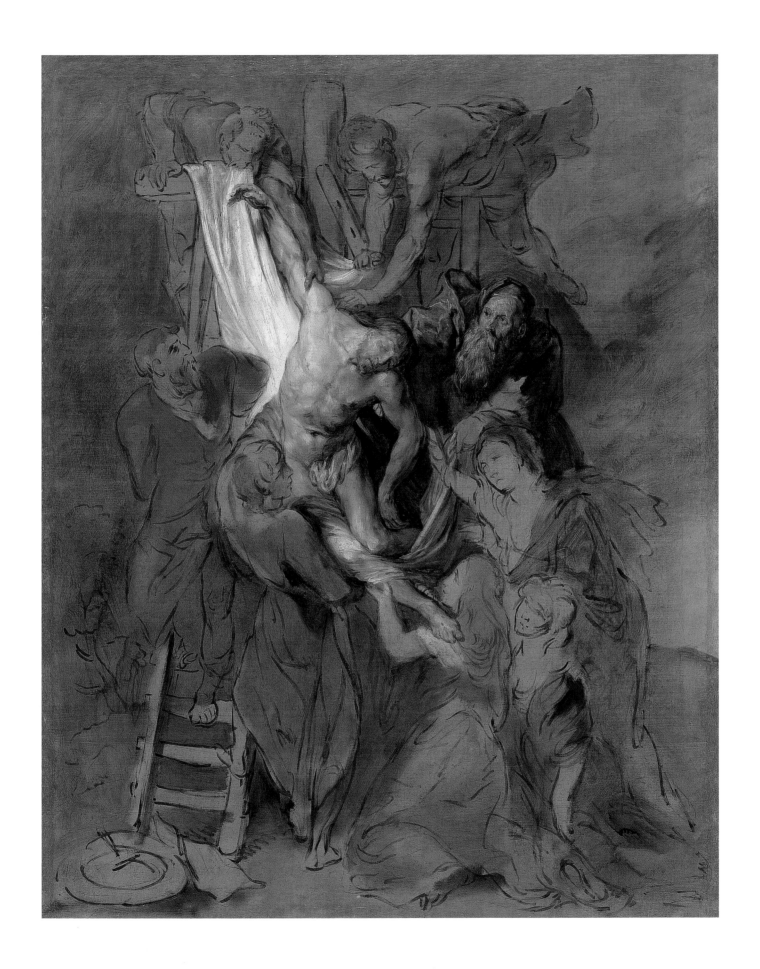

The cataloguer of the exhibition at Brown University in 1975 was the first to establish that Gainsborough used Lucas Vosterman's print of 1620 (fig. 13) as his source for this copy. Vosterman, in turn, was reproducing Sir Peter Paul Rubens's magnificent altarpiece of 1612 in Antwerp Cathedral.[2] Previously, Waterhouse had suggested that the copy was taken from the *modello* for the altarpiece, which was then close to Bath at Corsham Court and now forms part of the Lee collection in the Courtauld Institute Galleries.[3] However, Gainsborough's copy, like the print, reverses Rubens's composition and details such as the bowl at the foot of the ladder and some of the colouring differ from the Courtauld panel. Although they are treated in a summary manner, details such as the horizon, the dark areas of sky behind the figure of Nicodemus and the shading to the left of the group demonstrate incontrovertibly that the print is the prime source.

The copy was never finished and consequently provides evidence for the artist's working methods. Gainsborough appears to have used black chalk or pencil on the primed canvas as a guide before making a lightning drawing outlining the composition in thin brown paint. Presumably he followed his usual working method, as reported by Ozias Humphry, and blocked in the basic colours of the costumes in a darkened room before letting in more light and working up the detail.[4] In this particular canvas the detail is concentrated on the figure of Christ, the winding sheet and the bearded figure of Nicodemus.

But why would Gainsborough have made this copy? What did he learn by doing so? Why did he abandon the copy halfway through? In 1963 John Hayes first proposed that Rubens's example had helped Gainsborough design the pyramid of figures fighting over a cider keg in *The Harvest Wagon* (Barber Institute of Arts, Birmingham), though other authorities have found this connection too simplistic.[5] Rather than making no more than a formal study, Gainsborough rejects the operatic bravado of Rubens and replaces it with a lighter touch. The parallel arms which lower Christ and, in the Birmingham landscape, haul up the young girl are a quotation that Gainsborough adopted in the same way that he integrated elements from other pictures in his own compositions (see cat. 20 and 31). Just as he made sketches of the countryside around Sudbury and Great Cornard, so Gainsborough copied Rubens to increase his understanding and fix the forms into his memory for future use. Overall this copy is a demonstration of admiration and material evidence for the depth and quality of a lesson well learnt.[6]

On a flying visit in the autumn of 1783 Gainsborough was eventually to see Rubens's painting in Antwerp. Unfortunately his reaction is not recorded.[7]

NOTES

1. The painting is described as hanging above the chimney-piece in the dining room at Tyneham "in a magnificent contemporary frame" (Bond 1956, p. 10; I am grateful to William Drummond for this reference). The painting was presumably reframed in the late 1940s before the painting was acquired by Michael Astor (the frame was sold by Gainsborough's House at Bonham's, Chelsea, 18 November 1998, lot 640). The present frame was supplied by Arnold Wiggins & Sons on acquisition.

2. Providence 1975, no. 63. For Rubens's finished painting, a preparatory drawing and the oil sketch see Judson 2000, pp. 162–75, repr.

3. Waterhouse 1958, p. 125.

4. Whitley 1915, pp. 391–92.

5. Rosenthal 1982, p. 68, and Belsey reviewing Birmingham 1995 (*BM*, August 1995, p. 574).

6. See also *NACF Review* 1999, p. 87.

7. Asfour, Williamson and Jackson 1997, p. 28. Their implication that the copy may date from 1783 rather than the 1760s is stylistically untenable.

THOMAS GAINSBOROUGH

Wooded Landscape with Cattle by a Pool, 1782

Oil on canvas, 120.4 × 147.6 cm (47⅜ × 58⅛ in.)

FRAME Neo-classical 'Salvador Rosa' frame with acanthus leaf and shield decoration on the sight edge and a bold egg and dart design on the knull, late 18th century

PROVENANCE Joseph Gillott (1799–1872);[1] his sale, Christie's, 27 April 1872, lot 287, bt Agnew for Kirkham D. Hodgson; purchased from him by Sir Edward Guinness, later 1st Earl of Iveagh (1847–1927); by descent to Walter, 1st Lord Moyne; by descent to Hon. Jonathan Guinness; his sale, 15 July 1987, lot 89, repr. col., bt in; purchased by the Society by private treaty in December 1987–January 1988 with generous contributions from the National Heritage Memorial Fund, the National Art Collections Fund (The Wolfson Foundation and the Aileen and Vera Woodroffe Bequest), the MGC/V&A Purchase Grant Fund, the Pilgrim Trust, the Bryan Guinness Charitable Trust, the South Square Trust, the John S. Cohen Foundation, the Simon Whitbread Charitable Trust and other trust funds through Suffolk County Council (1988.001)

LITERATURE Morning Herald, 1 May 1782; London Courant, 8 May 1782; Fulcher 1856, p. 189; Armstrong 1898, p. 206; Whitley 1915, p. 185; Waterhouse 1958, pp. 31, 32, 33, 95, no. 939, repr. pl. 180; Hayes 1963, pp. 92–93, repr.; Hayes 1965a, p. 321; Hayes 1975, p. 222, repr. pl. 122; Hayes 1982, pp. 138, 141, 159, 499–500, no. 135, repr. pl. 181; Bermingham 1986, pp. 51–52, repr.; Belsey 1988, pp. 103–05, repr. col.; Braham and Bruce-Gardiner 1988, pp. 586–87, repr.; Cormack 1991b, pp. 29, 140–41, repr. col.; BM 1991, p. 580, repr.; Owen 1992, p. 106; Brenneman 1996, pp. 37–46; Rosenthal 1999, p. 195, repr. col.

EXHIBITED RA 1782, no. 166; Birmingham 1842, no. 241; RA 1903, no. 32; Bath 1951, no. 24; Paris 1953, no. 48, repr.; Nottingham 1962, no. 23, repr.; Paris 1981, no. 68, repr.; British Museum 1988, no. 68, repr. col.; Sudbury 1991, no. 15, repr. col.; RA 1998, no. 53, repr. col.; Ferrara 1998, no. 42, repr. col.; Tate 2002, no. 58, repr. col.

Gainsborough's obituary, published two days after his death by his great friend Sir Henry Bate-Dudley, analysed the artist's landscapes:

"His mind was most in its element while engaged in landscape. – These subjects he painted with a faithful adherence to nature; and it is to be noticed they are more in approach to the landscape of Rubens, than to those of any other master. At the same time we must remark, his trees, foreground, and figures, have more force and spirit; and we add, the brilliancy of Claude, and the simplicity of Ruysdael, appear combined in Mr. Gainsborough's romantic scenes."[2]

Subsequent critics, especially Sir Joshua Reynolds in the Discourse given in tribute to Gainsborough four months after his death, concentrated on the influence of Rubens's landscapes. In his eighth Discourse, given on 10 December 1778, he described a night-time landscape by Rubens, now in the Courtauld Institute Galleries,[3] which, as John Hayes has noted, has some similarity with the Gainsborough landscape in Sudbury, particularly in the trees on the right and in the relationship of the water with the rest of the composition. Nonetheless, the Claudean aspects of the landscape were increasingly in Gainsborough's mind as he developed the composition. Originally the horizon was filled with trees; and it was at a later stage that Gainsborough decided to overpaint them with a sunset sky and give his work something of "the brilliancy of Claude".[4] Indeed this aspect was noted by Bate-Dudley in his review of the 1782 exhibition:

"Mr. Gainsborough has exhibited but one Landscape – but that his Chef d'oeuvre in this line. It is an evening, at Sun-set, representing a wood land scene, a sequestered cottage, cattle, peasants and their children before the cottage, and a woodman and his dog in the gloomy part of the scene, returning from labor; the whole heightened by a water and sky, that would have done honor to the most brilliant Claude Lorain!"[5]

Perhaps Bate-Dudley had been told of a Claudean source for the painting. A drawing by the French master (fig. 14), which had been in England since the seventeenth century, may have been known to Gainsborough and the composition adapted for the Sudbury landscape.[6] Nonetheless, despite the visual evidence and opinions expressed by critics close to the artist, in order to place Gainsborough in a convenient pigeon hole and distance him from the edicts of the Academy, Reynolds was anxious to associate his rival with the naturalistic approach of the Flemish artist, rather than link him with the admired classicism of Claude Lorraine. Although he does not mention it, Reynolds may also have been aware of Gainsborough's debt to one of Salvator Rosa's Figurine for the pose of the figure of a young woman in the foreground – a source that Gainsborough is known to have used on other occasions (see cat. 20).[7]

This particular design was rehearsed in a drawing (fig. 15), which shows how Gainsborough first saw the shapes of the composition as patches of light and dark. This, the most important element of the painting, was then supplemented with the subject-matter of the kind listed by Bate-Dudley in his 1782 review, and used and re-used by the artist over the previous decade. On this occasion, however, Gainsborough was acutely aware of the need to be competitive and to paint a canvas as close to the Old Master tradition as he was able.[8]

NOTES
1. For his collecting activities see Chapel 1986, pp. 43–50.
2. Morning Herald, 4 August 1788. John Hayes was the first authority to connect this description to the Sudbury landscape. It has previously been associated with The Woodcutter's Return at Belvoir Castle (Hayes 1982, no. 120).
3. Hayes 1963, p. 92. For the Rubens see [Count Seilern], Paintings and Drawings at 56 Princes Gate London SW7, London 1955, p. 70, repr., and Braham and Bruce-Gardner 1988, passim.
4. Ruth Bubb, who cleaned the landscape in 1988, showed me the traces of green that can be seen in the valleys of the impasto at the horizon.

Fig. 14
CLAUDE LORRAINE
(1600–1682)
Watermill among trees,
1633
Pen and ink, brown wash
and chalk, 18 × 12.6 cm
(7⅛ × 5 in.)
The Ashmolean Museum,
Oxford

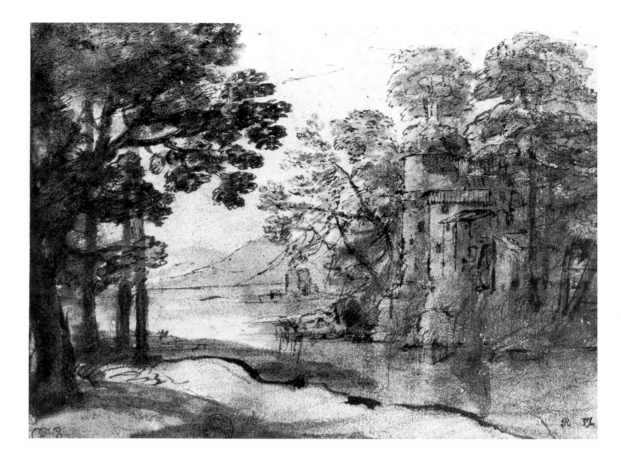

Fig. 15
THOMAS
GAINSBOROUGH
*Wooded landscape with
figures, cottages and cow*,
ca. 1782
Grey wash and black
chalk heightened with
white bodycolour,
26.7 × 38.9 cm
(10½ × 15¼ in.)
Yale Center for British
Art, Paul Mellon
Collection

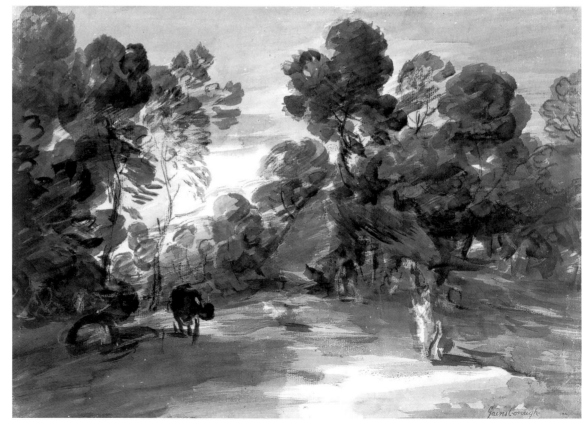

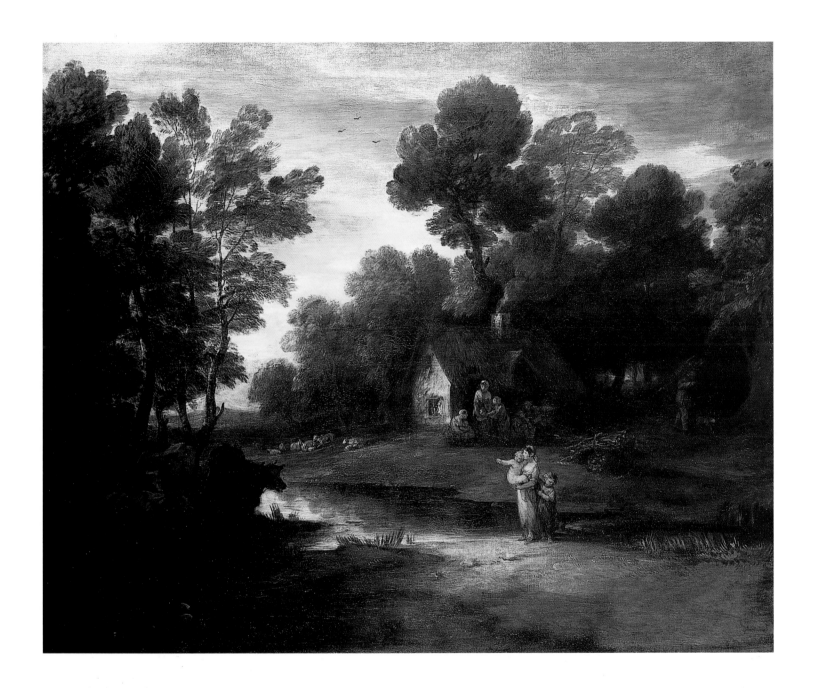

5. *Morning Herald*, 1 May 1782.

6. The drawing may have been in the Spencer
collection at the time. Gainsborough worked for
the family in the 1760s and 1780s (Whiteley
2000, pp. 81–82, no. 222, repr.)

7. Wallace 1979, no. 80, repr. These ideas are
developed by Brenneman 1996, *passim*.

8. The composition is simplified in the night
scene he was to paint on glass on few years later
(Hayes 1982, no. 134).

Portrait of Margaret, Mrs Thomas Gainsborough, ca. 1785

Oil on book board, 15.2 × 11.4 cm (6 × 4½ in.)

INSCRIBED [on reverse in a later hand]
*Margaret Burr / wife of / Tho*ˢ· *Gainsborough Esq*ʳ· /
*R.A. / London / Painted by M*ʳ· *Gainsborough.*
Three seals are also on the back: (1) crest of a
lion's head over the initials *JB* in script (2) with
the same lion's head with the initials *JB* in Gothic
(3) damaged

FRAME Simple frame of cavetto section with
pearl sight moulding, 2nd half 18th century

PROVENANCE perhaps owned by James Burr,
reputedly the brother of the sitter;[1] by descent to
his daughter, Mrs Scott; by descent to her son,
J. Scott (*ca.* 1810–1896); his posthumous sale,
Christie's, 20 June 1896, lot 81, bt Scott; … ;
W.A. Coats by 1904; … ; anonymous sale,
Sotheby's, 29 November 1978, lot 30, repr., bt
Anthony Reed; presented anonymously to the
Society in December 1998 (1998.131)

LITERATURE Coats 1904, pl. CXXI; Waterhouse
1953, p. 43; Waterhouse 1958, no. 796

EXHIBITED Suffolk Street 1927, no. 50;
Sudbury 1988, no. 16, repr. col.

This is perhaps the last portrait painted of
the painter's wife Margaret Burr (1728–
1797) and resembles a similar portrait now
in Christchurch Mansion, Ipswich (fig. 16),
which was painted at about the same time.
Both portraits were called portraits of the
artist's mother until they were published with
the correct identification by the present
author in 1988. There is a tradition that
Gainsborough portrayed his wife every year
to mark their wedding anniversary, though
the number of extant portraits hardly bears
this out.

The couple were married clandestinely on
15 July 1746 at Dr Keith's Mayfair Chapel,
where neither the permission of parents nor
the reading of banns were deemed necessary.
It is likely that Margaret Burr was pregnant
at the time with their first daughter, Mary,
who survived only eighteen months. The
family group, an ill-sorted couple with their

toddler, is recorded in a conversation piece
in the National Gallery.[2]

As the illegitimate daughter of the Duke
of Beaufort Mrs Gainsborough received an
annuity of £200, which gave her an
independence and encouraged her to
diminish her husband's profession.[3]
Gainsborough's illness in the autumn of 1763
brought them together and the artist paid
tribute to her concern: "My Dear Good Wife
… sat up every night til within a few and has

given me all the Comfort that was in her
power. I shall never be a quarter good
enough for her if I mend a hundred
degrees."[4] Eighteen months later, in a letter
to the same correspondent, James Unwin,
Gainsborough's banter with his wife
concerning an incomplete portrait of Mrs
Unwin shows that Gainsborough suffered
from being henpecked, although the episode
is related with considerable affection.[5] In
later life, following the trials of illness, despite

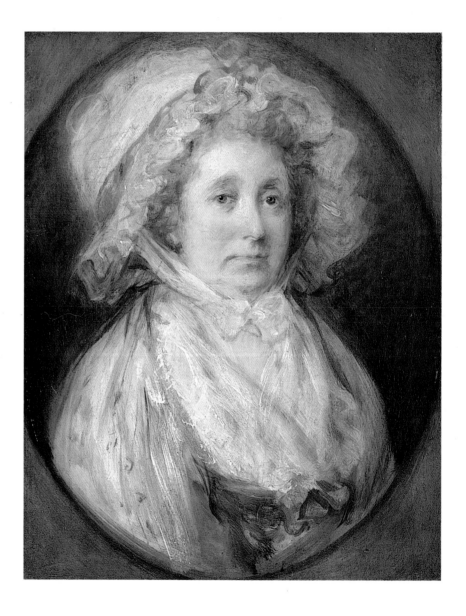

Gainsborough's propensity to be "deeply read in petticoats"[6] (other than those of his wife) and the worries of raising two difficult daughters, Gainsborough held his wife in great affection, as portraits such as this ably demonstrate.

NOTES

1. Gainsborough Dupont painted a portrait of James Burr, which was last recorded (1986) in the collection of Lord Craigmyle (Waterhouse 1953, p. 14). For the relationship see Tyler 1992, pp. 58, 64 n. 58.

2. Egerton 1998, pp. 64–71.

3. Sloman 1996b, *passim.*

4. Hayes 2001, p. 23.

5. Hayes 2001, p. 35.

6. Hayes 2001, p. 116.

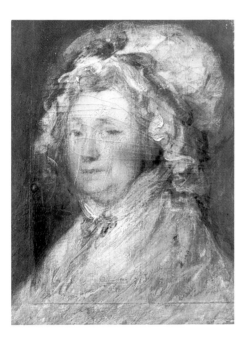

Fig. 16

THOMAS GAINSBOROUGH

Portrait of Margaret, Mrs Thomas Gainsborough,
ca. 1785

Oil on card, 11.2 × 8.5 cm (4⅜ × 3¼ in.)

Ipswich Museums and Galleries

Drawings and Prints

A pathway through a wooded landscape with a farm in the distance, ca. 1748

Pencil, 27 × 34.6 cm (10⅝ × 13⅝ in.)

PROVENANCE with Somerville & Simpson Ltd; their anonymous sale, Christie's, 14 July 1987, lot 31, bt in; with Stephen Somerville Ltd; purchased from them by the Society in July 1994 with generous contributions from MGC/V&A Purchase Grant Fund and the National Art Collections Fund (1994.084)

LITERATURE Rosenthal 1999, p. 183, repr. col. pl. 178

EXHIBITED Ferrara 1998, no. 62, repr.

This drawing comes from a group of five which were sold at auction as works by the Gainsborough devotee, George Frost (see cat. 74 and 75).[1] Each shows Gainsborough's exceptional dexterity in utilizing all the textures and shades of the pencil. Some of them include smudging with a cardboard roll to produce tone, known as stump. The chain lines of the paper used for each of these drawings have been analysed: they correspond with the less finished landscape drawing in the Bacon collection which John Hayes has dated independently to the "mid to late 1740s".[2]

The Sudbury drawing is arguably the most refined compositional study amongst this group of sheets. Using the same arguments for dating the early canvas at Sudbury (cat. 3), a date of about 1748 seems acceptable. Indeed the drawing has much in common with the Sudbury picture: both have a landscape made up of lilting curves with a strong horizon; both have a large expanse of sky and both have buildings pressed towards the horizon.

A small canvas by an imitator of Gainsborough in Gloucester Museum and Art Gallery (fig. 17) is based on the Sudbury drawing. The imitator, whose hand is also discernible in two other Gainsboroughesque landscapes,[3] has added to Gainsborough's design a log in the left foreground and a dark, dramatic sky. It is interesting that even at an early date Gainsborough's work was evidently valued highly enough for another artist to copy it.

NOTES
1. Two are illustrated in *Exhibition of Watercolours, Drawings and Paintings*, Stephen Somerville Ltd at Bernheimer's, London, June–July 1988, nos. 3 and 5, where John Hayes is quoted as dating both drawings *ca.* 1749/50. Another is in an English private collection.
2. Hayes 1970a, no. 71, pl. 391. The laid lines are 28 and 13.
3. John Hayes has suggested verbally to the author that the painting is by the same author as Hayes 1982, pp. 260–61, pls. 306–07.

Fig. 17
Imitator of THOMAS GAINSBOROUGH
Pathway through a Wooded Landscape, ca. 1750
Oil on canvas, 29.2 × 34.3 cm (11½ × 13½ in.)
Gloucester Museum and Art Gallery

Portrait of the artist's father, John Gainsborough, 1751

Pencil, 9.4 × 7.4 cm (3⅝ × 2⅞ in.)

INSCRIBED [on a label fixed to the back of the frame] *My Father Gainsborough's Picture, Drawn by my Husband three years after his Decease, and is extremely like him*

PROVENANCE by descent to the sitter's great niece, Mrs Edward Richard Poole (1804–1894), and first recorded in the collection in 1856; by descent to her great-great granddaughter, Mrs Catherine Dupré; purchased from her in November 1989 with a 50% contribution from the Museums Association (Beecroft Bequest) (1989.094)

LITERATURE Fulcher 1856, p. 206; Hayes 1970a, p. 39 [as lost]; Belsey 1991, pp. 114–15, repr.

EXHIBITED Sudbury 1988, no. 5, repr.

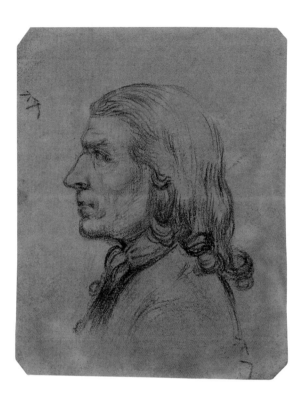

John Gainsborough was born in about 1683, the sixth child (the third of four sons) of Robert Gainsborough (1643–1748) and his first wife Frances Maynard (died 1689). On 6 July 1704 at St Andrew's, Great Cornard, he married Mary, the daughter of Henry Burroughs and his wife Mary Clark. They had nine children, the youngest of whom was the artist, Thomas. The artist's father appears to have had a varied career, working for the funeral trade as a crape maker, a weaver and an innkeeper. In 1733 he was made bankrupt and was helped by his brother Thomas's son, also called John (see cat. 53), who bought 46 Sepulchre (later Gainsborough) Street for a generous £500 to ensure that the family could continue to live in the house. He then became postmaster to the town, a position which was taken over by his wife after his death on 29 October 1748.

The artist's relationship with his father may have been tense, especially after his clandestine marriage to the illegitimate daughter of a duke (see cat. 11). Indeed it may be significant that Gainsborough only returned to Suffolk after the death of his father. Nonetheless, this drawing shows a sensitivity beyond the pure parlour game of drawing from memory. Parlour game or not, this sheet demonstrates Gainsborough's extraordinary visual recall.

THOMAS GAINSBOROUGH

Standing cow, ca. 1755

Pencil, 14.6 × 18.4 cm (5¾ × 7¼ in.)

PROVENANCE Sir Bruce Ingram; his sale,
Sotheby's, 17 March 1965, lot 904; private
collection, Kent; with Trim Bridge Galleries,
Bath, by October 1995; purchased from them by
the Society in January 1996 with a 50%
contribution from the Museums Association
(Beecroft Bequest) (1996.004)

LITERATURE Hayes 1970a, no. 871

There are a number of cow studies which
Gainsborough made between 1755 and
1757. They appear to have come from a
dismembered sketchbook.[1] One of them is a
preparatory study for one of the animals in
the early drawing from the Barton Grange
collection (see cat. 22) which is related to the
landscape formerly in the collection of Lord
Howe.[2] The Sudbury drawing is close to the
white cow in the same landscape.

NOTES
1. Two are in Tate Britain (Oppé collection;
Hayes 1970a, nos. 860, 861, and IEF 1983,
nos. 14 and 15); another is in a private collection
(Hayes 1970a, no. 862); a fourth, measuring 15.2
× 19 cm, was formerly with John Baskett. There
are also two drawings dating from the late 1760s,
of which one is in Jersey Museum (Hayes 1970a,
no. 870), while the other was last recorded in the
collection of Iolo Williams (Hayes 1970a,
no. 869).
2. For both drawing and painting see Hayes
1982, no. 62.

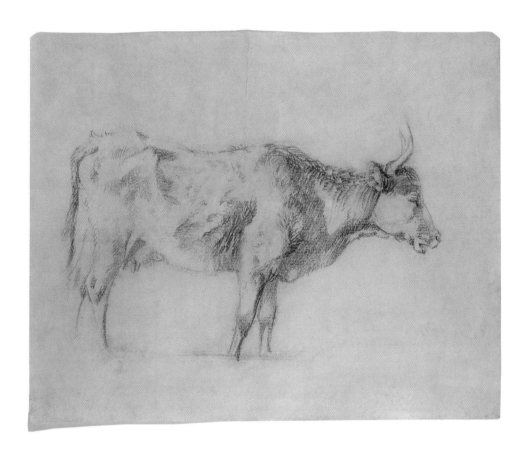

THOMAS GAINSBOROUGH

Wooded landscape with horse and boy sleeping; (Verso) Studies of trees, ca. 1757

Pencil and grey wash, 25.2 × 35.4 cm (9⁵⁄₁₆ × 13⁵⁄₁₆ in.)

PROVENANCE Michael Salaman before 1904; by descent; anonymous sale, Sotheby's, 21 November 1985, lot 83, bt John Morton Morris; private collection; his sale, Sotheby's, 8 April 1998, lot 39, bought by Agnew's for the Society with a contribution from the MGC/V&A Purchase Grant Fund (1998.056)

LITERATURE Woodall 1939, no. 288; Hayes 1983, no. 903

EXHIBITED Hazlitt 1990, no. 32, repr. col.

The dense foliage in the centre of this composition, with the spindly trees choked by ivy, anticipates the stylized drawings of imaginary landscapes that Gainsborough drew after he moved to Bath in 1759.[1] Scrapping out, in the centre of the sheet, may have permitted Gainsborough to change the left-hand profile of the trees. The sleeping peasant boy, silhouetted against the sky, is a favourite pose, best known from William Elliott's engraving of a drawing which has recently come to light.[2] For technique and design John Hayes compares the Sudbury drawing to the famous sheet which was formerly in the Witt collection.[3]

On the reverse there are a series of doodles testing the pencil and making sketches of odd tree branches. One of the branches, lower right, appears to be a rehearsal for the tree leaning at an angle to the right of the drawing on the other side of the sheet.

Verso: *Studies of trees*

NOTES

1. The best example is perhaps the damaged watercolour, dated 1759, now in a private collection in Ireland (Sotheby's, 15 June 2000, lot 17; Hayes 1970a, no. 243, repr.).

2. The drawing was unknown to Hayes (Hayes 1970a, no. 154). It was last recorded in a private collection in Virginia (*Drawings by Thomas Gainsborough (1727–88): A loan exhibition*, Davis & Langdale Company, Inc, New York, May–June 1987, no. 3, repr.).

3. Hayes 1970a, no. 233.

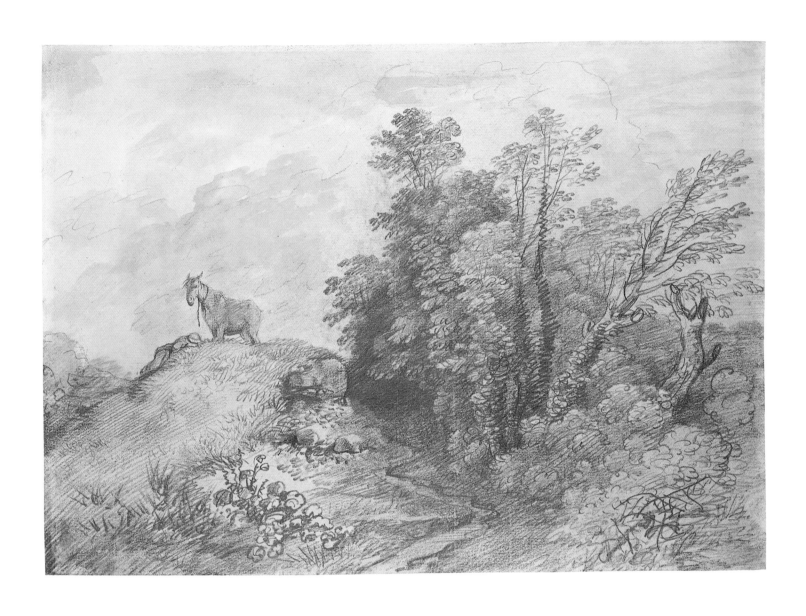

THOMAS GAINSBOROUGH

Two pack ponies, ca. 1758

Pencil, 14.3 × 19.1 cm (5⅝ × 7½ in.)

PROVENANCE Christie's South Kensington, 10 December 1997, lot 64 [as attributed to George Frost], bt Agnew; with Spink-Leger Galleries Ltd; purchased from them by the Society in August 1999 with a 50% contribution from the MGC/V&A Purchase Grant Fund (1999.107)

EXHIBITED: Agnew 1999, no. 3, repr. col.

This sheet shows two horses standing on a hill overlooking a distant landscape with a few lines on the right describing the head of a cloaked figure. One of the horses wears a saddle made of wood rather than leather (presumably for economy), which was used by riders or, with panniers, adapted to carry goods. Similar examples are shown in a number of the artist's landscape paintings of around 1770 at Kenwood, at Cincinnati and formerly at Holloway College.[1] As Susan Sloman has noted, this equipment is shown most clearly in a drawing dating from the 1760s.[2]

In his landscape paintings in the early and mid 1750s Gainsborough reflects agricultural activity in East Anglia, including cows and donkeys as a "little business for the eye". Horses that appear in his earlier work wear harnesses for pulling ploughs or carts. In contrast, pack ponies, which cope with the hilly terrain of Bath and its surroundings, were something of a novelty for the artist.

NOTES
1. Hayes 1982, nos. 95, 98 and 107.
2. Sloman 1998, p. 51, repr. The drawing was previously dated to the mid 1750s (Hayes 1983, no. 985).

THOMAS GAINSBOROUGH

Study for the portrait of Ann Ford, ca. 1760

Black and white chalk with stump on blue laid paper, 30.5 × 23 cm (12 × 9 in.)

PROVENANCE Private collection, England; anonymous sale, Christie's, 8 November 1994, lot 13, repr., bt in; with Andrew Clayton-Payne 2001; purchased in December 2001 with generous contributions from the National Art Collections Fund and Re:source/V&A Purchase Grant Fund (2001.164)

LITERATURE Ferrara 1998, under no 54, repr.; Rosenthal 1998, p. 656, repr.; Rosenthal 1999, pp. 172–73, repr.

On 24 June 1760 Gainsborough took a fourteen-year lease on a large house in Bath. The property was intended to provide him with space for his family, accommodation for lodgers, a studio and a room to display his paintings. Circumstantial evidence suggests that his portrait of *Ann Ford* (fig. 18) was painted specifically to hang in his show room; its purpose was to advertise Gainsborough's very special abilities. He chose a pose for Miss Ford which would exploit his skill in painting the ivory-coloured satin silk sacque dress. The pose is unusual and, as observed by Michael Rosenthal, matches that of the young woman in William Hogarth's painting, *The Lady's Last Stake* (Buffalo, Albright-Knox Art Gallery), which was exhibited to much acclaim in London in 1759.[1] The pose of both women and their dilemma in choosing vice over virtue (in Hogarth's case) or marriage over career (in Gainsborough's) would not have gone unnoticed. Perhaps the Hogarthian reference was known to Mrs Delany, who commented on Miss Ford's portrait when she wrote to her friend Mrs D'Elwes in 1760: "a most extraordinary figure handsome and bold; but I should be very sorry to have anyone I loved set forth in such a manner".[2]

Ann Ford's fulsome rejection of convention – her romantic involvement with Lord Jersey and her musical performances to the public – made her a topic of conversation in Bath. Controversy made her an apt choice

for Gainsborough's show room and it was of considerable commercial importance that the painting should make an impact on visitors to his studio. It is understandable that Gainsborough should lavish so much attention on the canvas. Indeed, if the painting has a fault, it could be that it shows some imbalance between the nervous energy of the painting, its airless quality and the somewhat contrived composition. The portrait might even be considered over-worked, and, judging by the uneven surface of the canvas, a number of pentimenti may be revealed by future X-ray photography. Presently the evolution of the design can be partially understood by examining the two extant preparatory drawings in the British Museum (fig. 19) and in Sudbury.

This study, the earlier of the two, was made to establish the fall of draperies over Miss Ford's unconventional pose. There are significant differences between the drawing and the painting. In the drawing, the sitter plays a Spanish guitar and in the painting an English guitar (or, less likely, a cittern) rests on her lap. In the drawing the sitter's left hand holds the fret of the guitar and in the painting her head rests on her hand. The London drawing shows the pose adopted in the painting, but there the cat is replaced by a patterned carpet, a landscape painting hanging on the back wall gives way to a viol da gamba and the sofa becomes a circular table piled high with books and sheet music.

NOTES

1. Sloman 1992, pp. 23–44.
2. Rosenthal 1998, pp. 654–55, repr.
3. *The Autobiography and Correspondence of Mary Glanville, Mrs Delany*, ed. Lady Llanover, London 1861, III, p. 605.

Fig. 19
THOMAS GAINSBOROUGH
Study for the portrait of Ann Ford, ca. 1760
Pencil and watercolour, 33.5 × 25.7 cm
(13⅛ × 10⅛ in.)
The British Museum, London

Fig. 18 THOMAS GAINSBOROUGH
Portrait of Ann Ford, 1760
Oil on canvas, 196.9 × 134.6 cm (77½ × 53 in.)
Cincinnati Art Museum, Bequest of Mary M. Emery

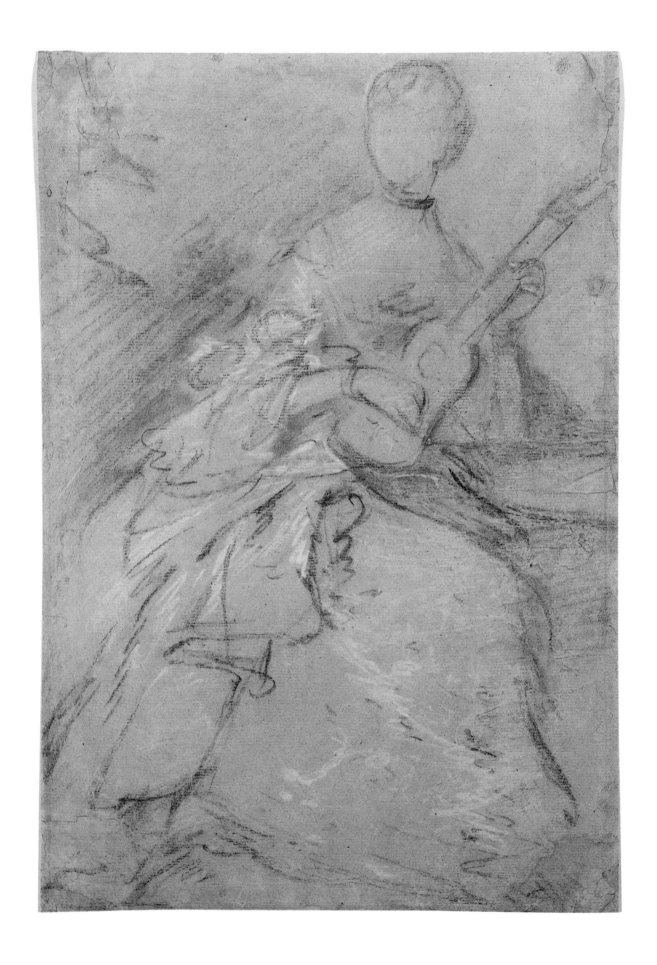

THOMAS GAINSBOROUGH

Study of the artist's daughters, ca. 1763

Black and white chalks on blue paper,
37.7 × 26.2 cm (14⅞ × 10¼ in.)

ENGRAVED in lithograph by Richard Lane and
published on 1 January 1825 in *Studies of Figures
by Gainsborough*

PROVENANCE by descent to the artist's
daughter Margaret and given by her to Henry
Briggs or Sophia Lane; presumably included in
their sale, Christie's, 25 February 1831, lot 95 or
97; . . . Henry J. Pfungst; his posthumous sale,
Christie's, 15 June 1917, lot 32, bt Sir George
Donaldson; purchased from him by Henry
Schniewind, Jnr, before 1925; his sale, Sotheby's,
25 May 1938, lot 137, bt Adams; C.R. Rudolf;
with Spink, from whom purchased by J.A.
Dewar; by descent to Viscountess Ward of Witley;
purchased from her executors in October 1996
by private treaty by the Society with generous
contributions from the National Lottery
(Heritage Lottery Fund) through Suffolk County
Council (1996.213)

LITERATURE Menpes and Greig 1909, p. 173;
Siple 1934, pp. 357–58; Comstock 1956, p. 141;
Hayes 1970a, pp. 116–17, no. 25, repr. pl. 90;
Gore 1974, p. 31; Belsey 1991, p. 114; Owen
1992, p. 107; Asfour and Williamson 1999, p. 91,
repr. col. pl. 51

EXHIBITED Cincinnati 1931, no. 54, repr.
pl. 59; IEF 1983, no. 31, repr.; Sudbury 1988,
no. 21, repr.

Mary, the elder daughter, shown seated in
this drawing, was baptized in All Saints',
Sudbury, on 3 February 1750, and Margaret
was baptized in St Gregory's, Sudbury, on
22 August 1751. Perhaps to mark their
education at Blackland's School, Chelsea,
their father painted a large-scale double
portrait of the two girls. The portfolio and
porte-crayon which Mary holds shows that
Gainsborough was eager, as we learn from
his letters, to provide them with a means to
earn money through drawing. For a brief
period the younger daughter, Mary, married
the oboist Johann Christian Fischer. After the
death of their parents 'Mol and the Captain',

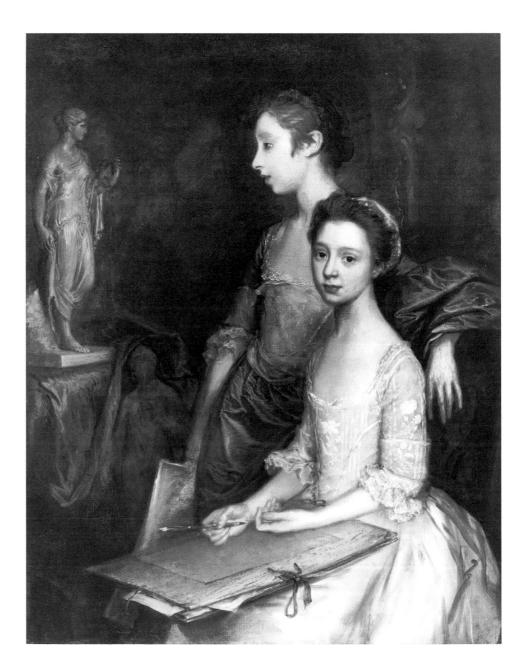

Fig. 20
THOMAS GAINSBOROUGH
Portrait of the Artist's Daughters, ca. 1785
Oil on canvas, 127.2 × 101.7 cm (49½ × 39½ in.)
Worcester Art Museum, Massachusetts

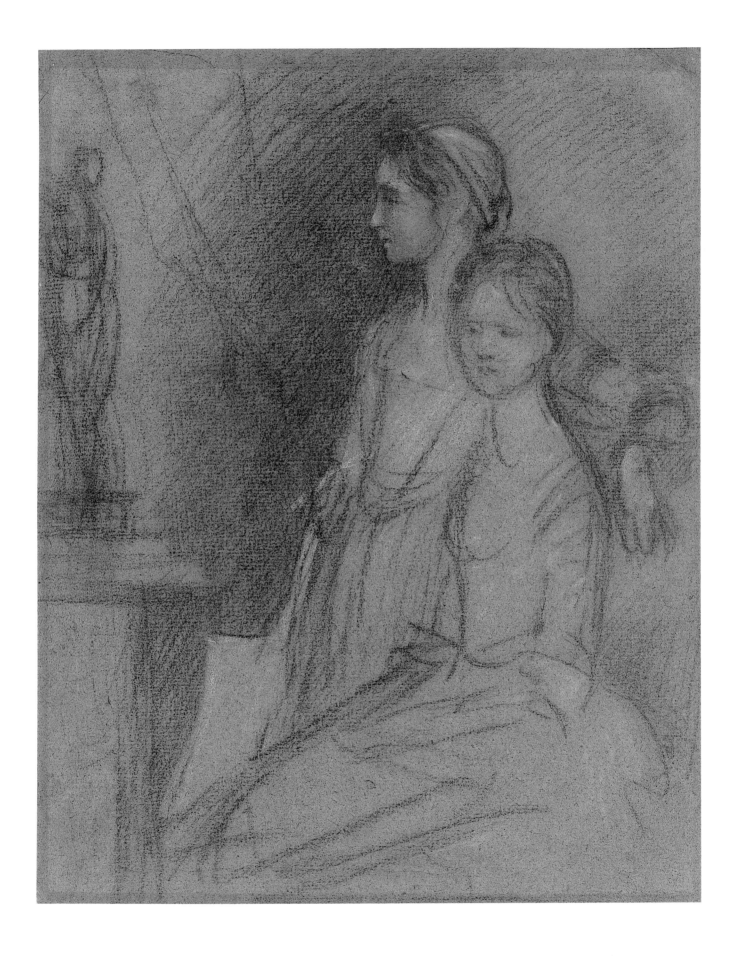

53

to use the artist's nicknames, lived in West London, where they became increasingly eccentric, and after the death of Margaret on 18 December 1820, Mary, who had become insane, was cared for by her cousin Sophia Lane until her death on 2 July 1826.[2]

This drawing is a study for the double portrait in Worcester Art Museum (fig. 20). The design of the painting caused Gainsborough some difficulty. X-rays reveal that he first considered posing the younger daughter, Margaret, in profile facing towards the right (fig. 21). The drawing postdates this alteration, though it still differs from the finished canvas. In the painting the pose of standing figure is more erect, a portfolio is placed on her sister's lap and a second statue appears. Similarly the swag of drapery in the background of the drawing is replaced by a picture frame which emphasizes the vertical elements of the composition.[3]

As we know from the lithographs made by Gainsborough's great-nephew Richard Lane (see cat. 78 and 79), more preparatory studies for portraits exist from the early 1760s than from any other period in Gainsborough's career. It was a time of stylistic transition and influence from, amongst others, Van Dyck (see cat. 7 and 8), which manifested itself in daring compositions and experimentation. Gainsborough often found the combination of figure groups particularly difficult: in this composition the problem of balancing two figures was solved by adding the statuary on the left which, as the X-ray shows, was subject to much adjustment during the painting of the picture. Classical allusions are unusual in Gainsborough's work; the statue of the Farnese *Flora* on the plinth was chosen as a personification of feminine beauty and the other figure, resting on the floor, may represent Hygiea, a goddess of health.

The authenticity of this drawing was doubted by St John Gore,[4] but all other authorities have accepted it without question.

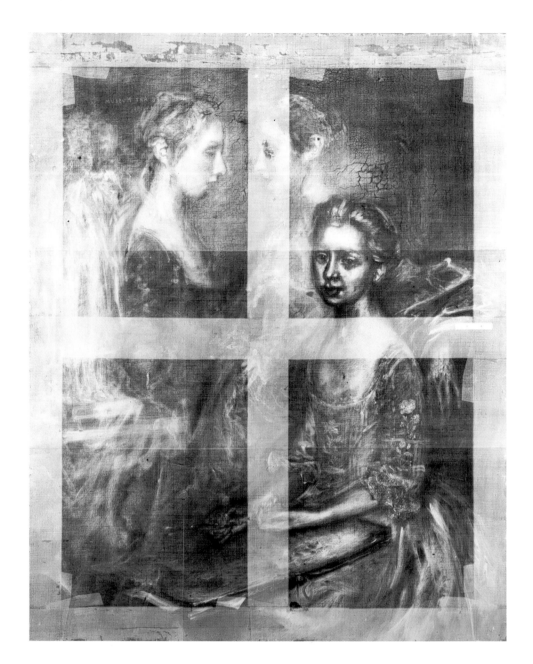

Fig. 21
X-ray of the portrait in Worcester Art Museum

NOTES

1. In the early 1780s Gainsborough appears to have given lessons to the royal children (Roberts 1987, pp. 70–72) and the daughters of the Earl of Leicester. He had a number of other pupils, including William Jackson (see cat. 64) and Lord Mulgrave, to whom he gave advice in a number of letters dating from 1771 and 1772 (see p. 58; Hayes 2001, pp. 92–96, 103–05).

2. Tyler 1992, *passim*.

3. Gore provides a detailed explanation of the development of the composition (Gore 1974, p. 31).

4. Gore 1974, p. 32 n. 6.

THOMAS GAINSBOROUGH

Study of a tree, ca. 1770

Pencil on laid paper, 9 × 6.2 cm (3 ½ × 2 ½ in.)

PROVENANCE perhaps Samuel Holme or his
son James Wilson Holme; their posthumous sale,
Christie's, 4 July 1906, lot 247; with Messrs
J. Pearson & Co; their sale, Sotheby's, 24 June
1924, lot 295 (3); ... with Maggs & Co. Ltd;
private collection 1998; purchased from them in
August 1998 (1998.084)

Studies of individual trees from this period
in Gainsborough's career are unusual; it is
tempting to assume that this sketch was cut
from a larger drawing that was aborted.

THOMAS GAINSBOROUGH

Peasants going to market, 1770–74

Black and white chalk, stump with grey and brown washes, extensively heightened with white chalk and gouache, on prepared brown paper, 41.4 × 53.8 cm (16¼ × 21⅛ in.)

FRAME English carved frame of cavetto section, 2nd half 18th century

PROVENANCE given to Henry Briggs by the artist's family; his sale, Christie's, 25 February 1831, lot 107, bt Johnson; Mr Loring?;[1] Walter, 4th Baron Northborne; his sale, Sotheby's, 12 December 1945, lot 45, repr., bt Cooper; with The Leger Galleries 1946; purchased by Sir Kenneth Clark (later Lord Clark of Saltwood); his sale, Christie's, 15 June 1982, lot 84, repr. col., withdrawn; by descent to the Trustees of Lord Clark's Settlement Trust; their sale, Christie's, 14 July 1992, lot 83, bt Timothy Clode; purchased following a export licence deferral through the generous co-operation of Timothy Clode, Esq. with grants from the National Heritage Memorial Fund, the MGC/V&A Purchase Grant Fund and the National Art Collections Fund in January 1993 (1993.001)

LITERATURE Hayes 1970a, pp. 50, 300, no. 826, repr. pl. 119; Belsey 1992, pp. 8–12, repr.; Asfour and Williamson 1999, pp. 259, 261, repr. col. pl. 165

EXHIBITED Leger 1946, no. 44; Arts Council 1949, no. 23; Arts Council 1951, no. 73, repr.; RA 1954, no. 545; RA 1998, no. 208, repr. col.; Ferrara 1998, no. 65, repr. col.; Tate 2002, no. 133, repr. col.

Fig. 22
REMBRANDT VAN RIJN (1603–1669)
The Flight into Egypt, 1651
Etching, plate size 12.6 × 11 cm (5 × 4⅜ in.)
Gainsborough's House, Sudbury (1995.096)

The drawing, described by the auction house in 1831 as "spiritedly touched, in a slight landscape", shows an assortment of people – resigned elder man, serene youthful woman, dejected teenager, squabbling toddlers and fractious babies – travelling along a track at sunset with two donkeys and a dog. Rather than illustrating a comprehensible narrative of a peasant family returning to, or coming from, market – so often the subject of his landscape paintings at this date – Gainsborough has combined a number of seventeenth-century sources to create one of

his most complex and ambitious drawings.

The basic composition derives from Rembrandt's etching of *The Flight into Egypt* dating from 1651 (fig. 22), which shows Mary full-face riding side-saddle and, leading the donkey, the careworn figure of Joseph in profile holding a lantern. The teenager, seated on the other donkey, comes from one of Salvador Rosa's *Figurine* (fig. 23), a rich source that, like several of his contemporaries, Gainsborough would use

again (see cat. 10).[2] The children's heads are close to those developed by François Duquesnoy, the Flemish sculptor working in Rome, whose cherubs became a generic type utilized in religious art throughout the seventeenth and eighteenth centuries. Duquesnoy's work, translated into plaster casts from which to draw, appears as models in a number of Gainsborough's portraits, such as those of Lady Rodney and of Lady Ligonier (fig. 24). Indeed in correspondence

Fig. 23
SALVADOR ROSA (1615–1673)
Figurina
Etching, 14.5 × 9.5 cm (5 ¾ × 3 ¾ in.)
The British Museum, London

Fig. 24
THOMAS GAINSBOROUGH
Portrait of Penelope, Viscountess Ligonier, 1770
Oil on canvas, 238.8 × 156.9 cm (94 ½ × 61 ¾ in.)
Henry E. Huntington Art Collections, San Marino, California

with the Hon. Constantine Phipps, in which he attempted to teach him drawing, Gainsborough remarks, "I can … examine and correct, your Drawings, as you send them to me by Letter; and this is by sending you some little Plaister Heads, of which I have duplicate Casts; so that you have nothing to do but stick them upon a wire & Draw for Life". He continues: "I shall still stick mine of the same upon a wire to examine your Outlines … and by return of post, after receiving your sketch, send you it corrected, with hints to go on".[3] A painting attributed to Cornelis de Wael, of which the early history remains unknown, has a striking similarity to the Sudbury drawing and may

also have caught Gainsborough's attention while he was preparing this drawing.[4] Curiously, the drawing never left Gainsborough's studio. Perhaps it was a piece that Gainsborough considered experimental and, like the late landscape in the collection at Sudbury (cat. 10), consciously in competition with Old Masters.

NOTES
1. A copy of the drawing in the Fogg Art Museum, Cambridge, Mass. (1943.707) is inscribed on the back: *Crayon Sketch for Picture in the Possession of Mr Loring 55 Upper Mary*[lebone] *Street P.P. by Thomas Gainsboro' from Mr Edridges Collection … Sept' 1853*

£*10.10–*.' I am grateful to Miriam Stewart of the Fogg for supplying a transcription and to Dr Kim Sloan for passing on her letter of 14 August 1992 (Museum files).
2. Wallace 1979, no. 22. See also J. Sutherland, 'Salvador Rosa in England in the Eighteenth Century', *BM*, CXV, 1973, pp. 785–89.
3. Hayes 2001, p. 96. See also S.M. Bennett, 'A Muse of Art in the Huntington Collection', in *British Art 1740–1820: Essays in Honor of Robert R. Wark*, San Marino 1992, pp. 57–80.
4. Phillip's, Bath, 27 April 1998, lot 96. I am grateful to Dr Susan Sloman for bringing this painting to my attention.

THOMAS GAINSBOROUGH

Wooded landscape with herdsman and cattle, ca. 1775

Pen and ink, traces of black chalk, grey and grey-black washes and white chalk, 26.7 × 35 cm (10½ × 13¾ in.)

PROVENANCE … ; C.H.T. Hawkins; his posthumous sale, Christie's 29 March 1904, perhaps lot 184, bt Shepherd; … ; Vernon Wethered; presented to the Society by his daughter Miss Maud L. Wethered in August 1988 (1988.012)

LITERATURE Woodall 1939, pp. 60, 62–64, repr. pl. 72; Hayes 1970a, no. 469; Belsey 1991, p. 114

EXHIBITED Sudbury 1991, no.12, repr.; Ferrara 1998, no. 69, repr. col.; Tate 2002, no. 138, repr. col.

Dr Mary Woodall, in her pioneering book about Gainsborough's drawings, associated this sheet with Gainsborough's painting *The Watering Place*, exhibited with great acclaim at the the Royal Academy in 1777.[1] Rather than being a formal study, this is an example of the rapid sketches Gainsborough made as an evening relaxation. The subtlety and certainty of line, the disregard for scale and detail (as John Hayes has noted),[2] enable the artist to make a pleasing composition with a restricted number of elements. Many of his drawings feature tracks, cows, herdsmen, pollarded trees and spindly saplings, continually rearranged to produce varied compositions.

NOTES

1. Woodall 1939, p. 62; the painting is Hayes 1982, no. 117.
2. Ferrara 1998, no. 69.

Wooded landscape with travellers, ca. 1777

Black chalk, white lead, ochre, red and green washes on prepared laid paper, dipped in skimmed milk and varnished,
21.5 × 31cm (8½ × 12¼ in.)

PROVENANCE probably given by the artist to Goodenough Earle (1699–1788/89) of Barton Grange in Somerset; by descent to Francis Wheat Newton; purchased by Agnew's in 1913; resold to Knoedler's, New York; purchased by G.D. Widener, Philadelphia; by descent to his son-in-law, Paul Carpenter Dewey; his anonymous sale, Christie's, 14 November 1989, lot 101, repr. col., bt Leger; purchased from them by the Society in August 1990 with contributions from the National Art Collections Fund (Aileen and Vera Woodroffe Bequest), the MGC/V&A Purchase Grant Fund and the Pilgrim Trust (1990.044)

LITERATURE Fulcher 1856 (2nd edn), p. 241; Hayes 1966, p. 92, repr.; Hayes 1970a, no. 410; Hayes 1971, pp. 57–58, repr.; Belsey 1991, pp. 114–15, repr.; BM 1991, p. 581, repr.; Stainton 1991, pp. 49–51, repr. col. on cover; Owen 1992, p. 106, repr. col.

EXHIBITED New York, Knoedler 1914, no. 16; lent to the Philadelphia Museum of Art from 1980 to 1989; Leger 1990, no. 2, repr. col.

This drawing is from a group of presentation drawings formerly in the collection at Barton Grange, near Taunton in Somerset, which were sold to Agnew's in 1913.[1] It uses a technique which is described in one of Gainsborough's letters to his friend the musician William Jackson (cat. 63);[2] more recently a technical analysis of the process has been initiated by Jonathan Derow.[3]

The artist was keen to keep his methods secret, especially "fixing the White Chalk previous to tinging the Drawing with water-Colours". He describes gluing sheets of paper together and stretching them on a frame like a drum, then making "the Effect [with] black & white … Indian ink shadows & your lights of Bristol made white lead" – emphasized because "the Bristol is harder and more the temper of chalk than the London" – and then "dip it all over in skim'd milk [and] let it dry". He explains that this process could be repeated until the design of the drawing was "to your mind". The technique he was especially keen to keep to himself was to "tinge in your greens your browns with sap green & Bistre, your yellows with Gall stone & blues with fine Indigo &c &c" over the areas of chalk. He continues: "When this is done, float it all over with Gum water, 3 ounces of Gum Arabic to a pint of water … let it dry & varnish it with Spirit Varnish". He reminds Jackson that this should be done on both sides to keep the sheet flat.

The Sudbury drawing is on a prepared red-brown paper and the purity of the green in the centre of the sky and the dash of red would not have been possible without a priming of white chalk, as described in the letter to Jackson. John Hayes has compared the density of the thicket and the strongly lit bank to similar features in Gainsborough's *Watering Place* of 1777, though he did not repeat this idea in later discussions of the painting.[4] The present author noted the similarity in this drawing's composition with a landscape by Poussin in the National Gallery (no. 6390); unfortunately the

eighteenth-century provenance of the Poussin is unrecorded and it does not appear to have been reproduced as a print – considerations which make this suggestion hypothetical.[5]

NOTES
1. Hayes 1966, *passim*.
2. Hayes 2001, pp. 110–11.
3. Derow 1988, *passim*.
4. Hayes 1971, p. 57. For the landscape painting see Hayes 1982, no. 117.
5. Reported in *Antique Collector*, LXI , no. 11, November 1990, p. 79.

THOMAS GAINSBOROUGH

Wooded landscape with cottage, peasant, cows and sheep, and cart travelling down a slope ('The Cottage Door'), 1777–78

Black chalk and stump heightened with white chalk on two pieces, one grey, the other washed to match, 37.9 × 31.6 cm (15 × 12½ in.)

PROVENANCE with Alfred Scharf; purchased from him by Nicholas Argenti; thence by descent to his daughter, Mrs Ann Conran; purchased by the Society by private treaty sale with a generous contribution from Re:source/V&A Purchase Grant Fund through Suffolk County Council, May 2002 (2002.079)

LITERATURE Hayes 1970a, pp. 33, 40, 207, no. 424, pl. 333; Hayes 1971, pp. 63–64, repr.; Hayes 1982, pp. 473, pl. 120a

EXHIBITED Bath 1951, no. 48

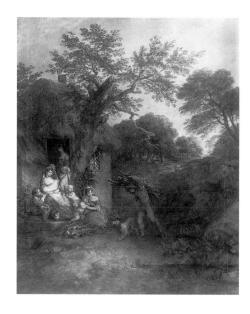

Fig. 25
THOMAS GAINSBOROUGH
Wooded Landscape with Rustic Lovers, Cows and Flock of Sheep, ca. 1778
Oil on canvas, 148.6 × 120.7 cm (58½ × 47½ in.)
Duke of Rutland, Belvoir Castle

It is unusual for Gainsborough to use two pieces of paper to make his drawings. The artist's invention, and enthusiasm, extended beyond the top edge of the lower sheet, and another piece of paper was attached to allow his imagination to take full rein. To match the larger sheet, the added one appears to have been prepared with a grey wash.

Before this addition was made, the composition would have been remarkably similar to a preparatory drawing (fig. 26)[1] for *The Cottage Door*, a painting now in Cincinnati Art Museum, which was probably shown at the Royal Academy in 1778.[2] A comparison of the two drawings shows something of the way Gainsborough juggled the limited vocabulary of his landscapes to form fresh compositional arrangements. In the present drawing the framing tree on the right of the sheet has become more substantial, and the window in the hovel has moved to the lateral wall. There is evidence that Gainsborough made some alterations to the roofline of the cottage.

The Sudbury drawing is closely related to

a canvas at Belvoir Castle which was acquired by Charles, 4th Duke of Rutland soon after it was painted (fig. 25). Like the Cincinnati canvas, this painting may also have been shown in the 1778 exhibition.[3] In the painting the landscape is arranged in exactly the same way as in the drawing but the staffage has changed. In the drawing two figures cower in the doorway of a very rustic cottage, another peasant tends two cows and a flock of sheep on the right and a cart disappears down a track on the left-hand side. In the painting the cows and sheep have been retained but instead of a single peasant tending them a couple, a cowherd and a young peasant woman in animated conversation, provides the subject for the piece. A peasant walking out of view replaces the cart on the track to the left.

NOTES
1. Hayes 1970a, pp. 18, 40, 44, 52, 79, no. 478, pl. 147.
2. Hayes 1982, pp. 473–77, no. 121.
3. Hayes 1982, pp. 471–73, no. 120.

Fig. 26
THOMAS GAINSBOROUGH
Study for The Cottage Door,
ca. 1778
Grey and grey-black washes, and white chalk,
27.1 × 34.6 cm (10⅝ × 13⅝ in.)
Private collection, United States

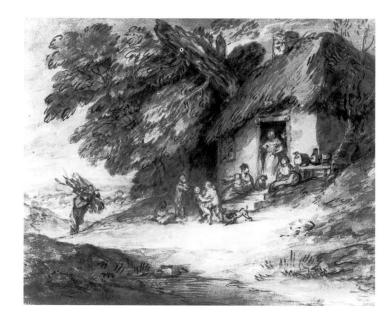

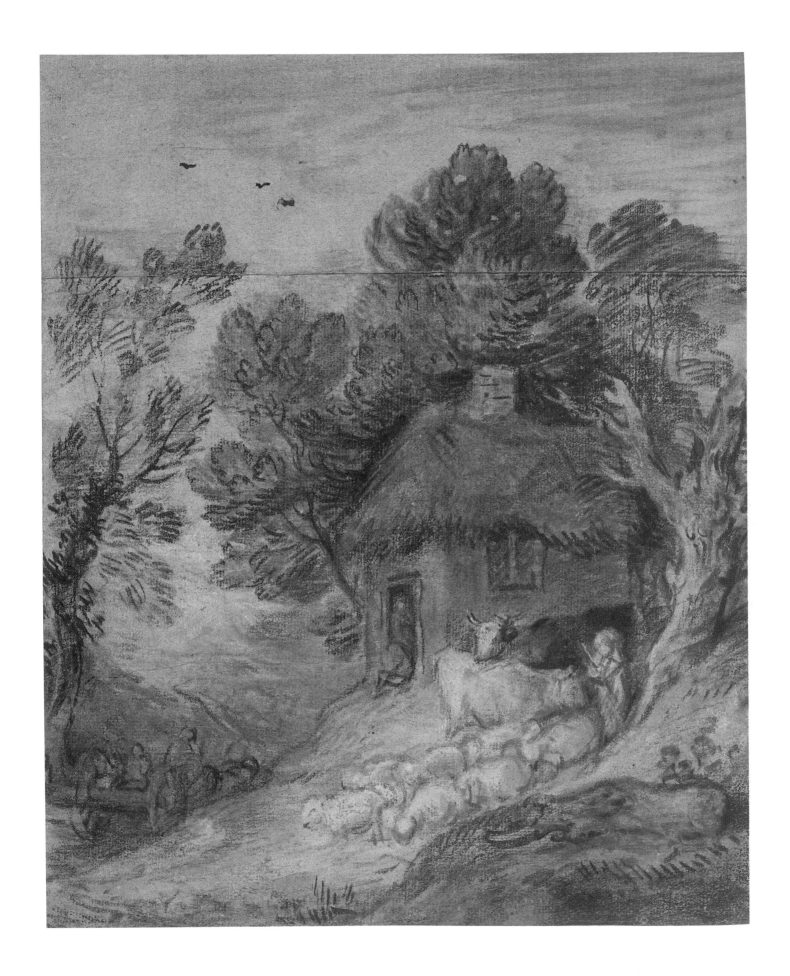

63

Wooded landscape with figures and cattle at a pool, ca. 1778

Black and white chalk with stump,
24.3 × 31.3 cm (9⅝ × 12¼ in.)

ENGRAVED in soft-ground etching and aquatint by Gainsborough and published by J. & J. Boydell as no. 4 in a series of twelve on 1 August 1797 (fig. 27)[1]

PROVENANCE with Terry-Engel Gallery; with John Manning Gallery; John Tillotson by 1958; his posthumous sale, Sotheby's, 21 November 1985, lot 69, bt John Morton Morris; private collection; the collector's posthumous sale, Sotheby's, 9 June 1998, lot 7, bt Andrew Clayton-Payne for the Society with a contribution from the MGC/V&A Purchase Grant Fund (1998.074)

LITERATURE *Illustrated London News*, 8 November 1958, p. 817; *The Manning Gallery 1953–1966*, London 1966, pl. 13; Hayes 1970a, no. 437; Hayes 1971, pl. 43

EXHIBITED: Manning 1958, no. 21; Hazlitt 1965, no. 30; displayed at Gainsborough's House in 1980; Hazlitt 1990, no. 33, repr. col.

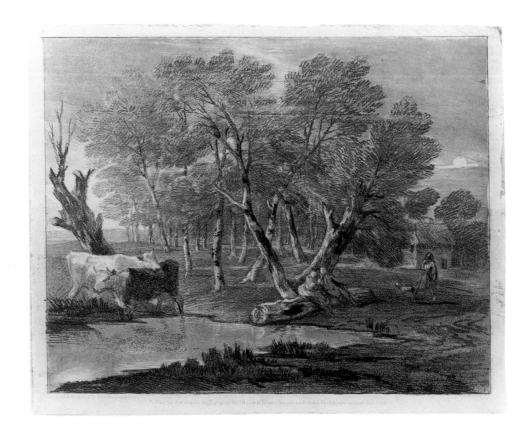

Fig. 27
THOMAS GAINSBOROUGH
Wooded landscape with figures and cattle at a pool, ca. 1778
Soft-ground etching and aquatint, plate size 27.5 × 34.5 cm
(10¾ × 13½ in.)
Private collection, London

This drawing is exactly the same size as the print although there are some amendments to the design. In the print the foreground has been simplified and the background on the extreme right has been strengthened with the addition of a cottage. There are differences in emphasis, too, which help to give the print greater clarity.

In the print the light-coloured cow rests its head on the back of the other in a pose often used in other landscape subjects. In the drawing, however, both cows are stiffer, and it is very likely that Gainsborough borrowed cow creamers from the pantry to add to the table-top model he may have made to assist his drawing. Showing some scepticism about its validity, Sir Joshua Reynolds provides one of the contemporary accounts of this practice: "He [Gainsborough] even framed a kind of model of landskips, on his table; composed of broken stone, dried herbs, and pieces of looking glass, which he magnified and improved into rocks, trees and water".[2]

When creamers would not do, Gainsborough added his own modest sculptures to the natural objects to enliven his table-top models. One of these survives: a old nag which John Constable found in a Suffolk junk shop. It is presently on loan to Gainsborough's House.[3]

NOTES
1. Hayes 1971, pp. 49–51, repr. The copper plate is one of the eleven in Tate Britain.
2. Reynolds, p. 250.
3. Woodall 1956, *passim*.

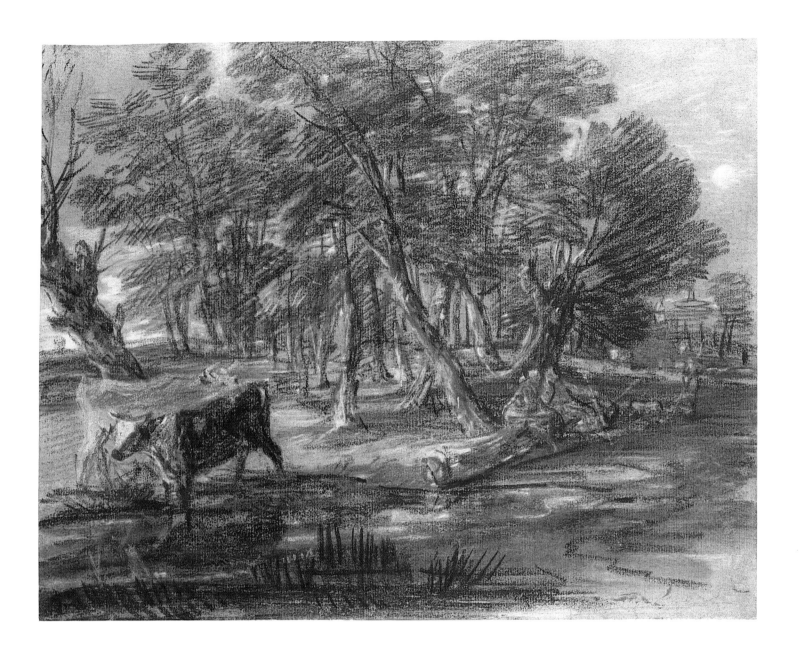

THOMAS GAINSBOROUGH

Wooded landscape with packhorses, ca. 1778

Black chalk and stump with white chalk on grey-blue paper, 27.1 × 33 cm (10⅝ × 13 in.)

PROVENANCE H.B. Milling; by descent to his wife, Mrs W.W. Spooner;[1] with Anthony Reed; presented anonymously in December 1998 (1998.130)

LITERATURE Hayes 1970a, no. 398

EXHIBITED Reed 1978, no. 8, repr.

This extraordinarily free drawing, which only hints at the forms of the group of packhorses on the right, uses the full tonal range of the black chalk to provide the effect. The play with perspective is unusual in Gainsborough's work; over the head of the herdsman (centre left), the gap between the branches of two trees provides a witty contradiction of the perspectival depth.

NOTES

1. Mrs Spooner was H.B. Milling's first wife. The collection formed by Mr Milling and his wife, which includes this drawing, remained in her possession. Those collected by Mr Spooner before his marriage and, later, with his wife were bequeathed in 1967 to the Courtauld Institute Galleries (*The William Spooner Collection and Bequest*, Courtauld Institute of Art, 1967).

THOMAS GAINSBOROUGH

Study of a wooded landscape with country lane, ca. 1782

Black and white chalk on blue paper,
15.5 × 20.5 cm (6⅛ × 8 in.)

ENGRAVED in reverse in soft-ground etching by
William Frederick Wells and published on
1 March 1804 (fig. 28)

PROVENANCE Mrs Gainsborough's
posthumous sale, Christie's, 11 May 1799, lot 82,
84 or 88, bt George Hibbert; by descent to Hon.
A.H. Holland-Hibbert; his sale, Christie's,
30 June 1913; Sir John Witt; given to his son,
Christopher; his anonymous sale, Sotheby's,
14 November 1991, lot 7, repr., bought by the
Society (1991.039)

LITERATURE Woodall 1939, no. 354; Hayes
1970a, no. 545

EXHIBITED Arts Council 1960, no. 31

In this vigorous sketch Gainsborough uses
white chalk to delineate the forms in the
background, rather than just strengthen
them.

W.F. Wells and John Laporte produced
seventy-two soft-ground etchings between
1802 and 1805 from a variety of drawings in
a number of collections. Groups of them
were assembled and published together as *A
Collection of Prints, illustrative of English
Scenery …* by H.R. Young in 1819. Some
of the plates were revised and re-published
by Louis Francia in his book *Studies of
Landscapes* (1810).[1] These publications
did much to maintain an interest in
Gainsborough's drawings in the early
nineteenth century.

NOTES
1. Aldeburgh 1988, nos. 37–41.

Fig. 28
WILLIAM FREDERICK WELLS (1762–1836)
after THOMAS GAINSBOROUGH
Study of a wooded landscape with country lane,
published 1 March 1804
Soft-ground etching, 24.2 × 31.4 cm
(9⅝ × 12⅜ in.)
Gainsborough's House, Sudbury (1991.040)

From the Original in the Collection of Geo. Hibbert Esq.
Published Mar.ᵗ 1, 1804, by W.F.Wells & J.Laporte.

THOMAS GAINSBOROUGH

Upland landscape with shepherd, sheep and cattle, ca. 1783

Black and white chalk on brown paper,
26.1 × 36.3 cm (10¼ × 14¼ in.)

PROVENANCE perhaps George Frost ...; with
Knoedler, 1923; Museum of Art, Ponce Puerto
Rico (Luis A. Ferré Foundation) by 1962;
deaccessioned and sold to Spink-Leger in 2000;
purchased from them by the Society in
September 2001 with contributions from
Re:source/V&A Purchase Grant Fund and the
National Art Collections Fund (2001.152)

LITERATURE Park 1962, pp. 143–46, repr.;
Hayes 1970a, pp. 12–13, 18, 33, 39, 45–46, 73,
no. 590, pl. 181; Hayes 1975, p. 62, repr.; Hayes
1982, II, p. 516, repr.; Vaughan 2002, pp. 188–89,
repr.

EXHIBITED: New York, Knoedler 1923; Tate
1980, no. 34, repr.; IEF 1983, no. 64, repr.

In a letter to his friend William Pearce,
Gainsborough talks of "going along with a
Suffolk Friend [Samuel Kilderbee] to visit
the Lakes in Cumberland & Westmoreland",[1]
and two landscape drawings exist, rushed off
as an *aide-mémoire*, that were, in all
probability, drawn during his trip. They both
include in the background the hump-back
profile of Langdale Pikes.[2]

In the letter to Pearce Gainsborough
intends "when I come back to show you that
your [Thomas] Gray and Dr [John] Brownes
were tawdry fan-painters" (both Gray and
Brown wrote poems about mountainous
scenery). He achieved this in many later
landscape paintings, which often refer to the
mountainous landscape of the Lake District;
however, only one composition, known in
two versions, features the profile of the
Langdale Pikes in the background. Henry
Bate-Dudley described the relationship of
the larger painting to the topography in a
review which appeared in the *Morning Post*
on 6 April 1789: "... though not a portrait of
any particular spot, the picture is highly
characteristic of that country".

The larger of the two canvases was
bought by the Prince of Wales and is now in

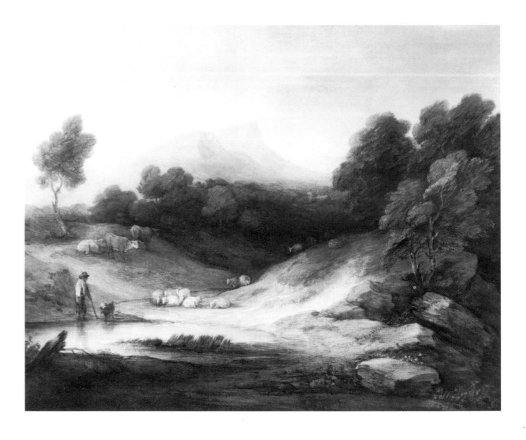

Fig. 29
THOMAS GAINSBOROUGH
Upland Landscape with a Shepherd, 1784
Oil on canvas, 120 × 148.6 cm (47¼ × 58½ in.)
Bayerische Landsbank, on loan to the Neue Pinacothek, Munich

the collection of the Bayerische Landesbank,
Munich, and on loan to the Neue Pinakothek
(fig. 29). A smaller, slightly later, version is
part of the Pennington-Mellor Charity's
collection at Southside House in Wimbledon.[3]
There are minor differences between the two
canvases and the drawing is closer to the
canvas in Munich. The main differences
between the drawing and the landscape are
the addition of cows on the left and of some
indistinct buildings to the centre of the canvas.

The technique of the drawing is dissimilar
from many others made in the 1780s and
one has the impression that it was developed
from a series of sketches that have since been

lost. It may therefore have been conceived as
a presentation drawing, to be used to
encourage the Prince of Wales to commission
the painting. The painting was left
undelivered and was kept in the artist's
studio until 1793, when the Prince finally
paid Gainsborough's widow for it. George
Frost made a rather insensitive copy of the
drawing, perhaps when it was in his possession.[4]

NOTES

1. Hayes 2001, pp. 153–54.
2. Hayes 1970a, nos. 577 and 578.
3. Hayes 1982, nos. 146 and 147.
4. Hayes 1970a, p. 245, pl. 380.

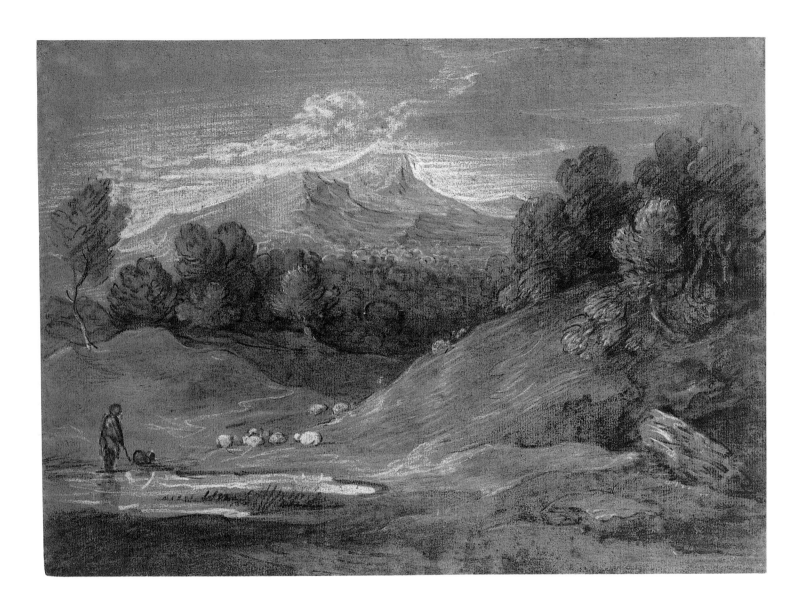

THOMAS GAINSBOROUGH

Study for Diana and Actaeon, ca. 1784

Black and white chalk with grey and grey-black washes and gouache with (perhaps) oil paint on buff paper, 27.4 × 36.4 cm (10⅞ × 14¼ in.)

PROVENANCE probably Sir Richard Wallace; bequeathed to Sir John Murray Scott; given by him to Josephine, 3rd Lady Sackville; bequeathed to her grandson, Nigel Nicholson; given by him to the Marchioness of Angelsey as a wedding gift in 1952; given by her to her son, Lord Rupert Paget; his anonymous sale, Sotheby's, 3 April 1996, lot 101, repr. col., withdrawn; purchased by the Society in March 1996 through Hazlitt Gooden & Fox Ltd with contributions from the National Heritage Memorial Fund, the National Art Collections Fund and the MGC/V&A Purchase Grant Fund through Suffolk County Council (1996.038)

LITERATURE Woodall 1939, p. 123, no. 242; Millar 1969, p. 43, repr. fig. 11; Hayes 1970a, pp. 19, 40, 45–46, 51, 62, 295, no. 810, repr. pl. 343; Hayes 1975, p. 225, repr. pl. 165; Hayes 1982, pp. 174, 538, repr. pl. 160a; Rosenthal 1992, pp. 167–94; BM 1997, p. 76; Rosenthal 1999, pp. 269–70, repr. col. pl. 277; Asfour and Williamson 1999, pp. 226–27, repr. col. pl. 137

EXHIBITED Bath 1951, no. 53; Arts Council 1960, no. 58, repr.; Tate 1980, no. 40, repr.; Paris 1981, no. 105, repr.; IEF 1983, no. 66, repr.; on loan to the National Trust (Plâs Newydd); Ferrara 1998, no. 85, repr. col.; Tate 2002, no. 175, repr. col.

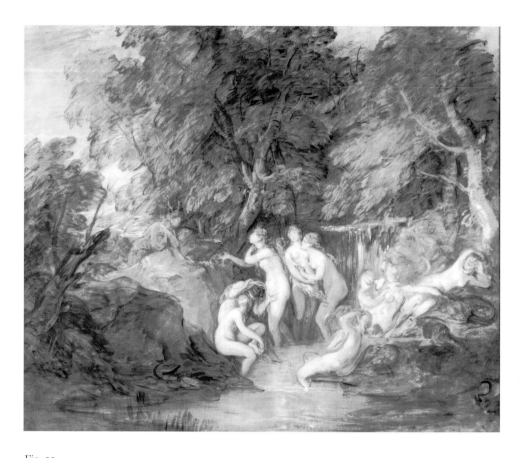

Fig. 30
THOMAS GAINSBOROUGH
Diana and Actaeon, ca. 1785
Oil on canvas, 158.1 × 188 cm (62¼ × 74 in.)
The Royal Collection © 2002, Her Majesty Queen Elizabeth II

The subject comes from Ovid's *Metamorphoses*, Book III: Actaeon is hunting in the sacred valley of Gargaphe when he comes across a woodland pool. There he surprises Diana bathing with her nymphs. Horrified that a mortal has seen her naked, she throws water into his face, transforming him into a stag. He is then set upon and killed by his own hounds. This is an uncommon subject, to which Gainsborough may have been introduced by a Francis Hayman painting of the 1760s.[1] The inspiration for his composition, as Michael Rosenthal has convincingly suggested, comes

from a painting by Filippo Lauri which he would have known through William Woollett's engraving of 1764.[2]

The Sudbury drawing is the first of three extant studies which show the development of the composition in the Royal Collection (fig. 30). The other studies are in the Henry E. Huntington Library and Art Gallery (fig. 31) and the Cecil Higgins Museum and Art Gallery in Bedford (fig. 32). John Hayes suggested at first that the present drawing was second in the series and that it was later than the Huntington drawing.[3] Subsequently Sir Oliver Millar established the order which

has been universally accepted by later writers.[4] Preparatory drawings by Gainsborough are rare and the survival of three which show the development of a single composition late in his career is unique.

The Sudbury drawing is the most dramatic of the three. It is darker and more energetic than the others, with the figures variously crouching to protect themselves from Actaeon's gaze as they gesticulate in horror at his interruption. No other work by Gainsborough takes such agitated activity as the central theme of its composition, and perhaps this new departure required

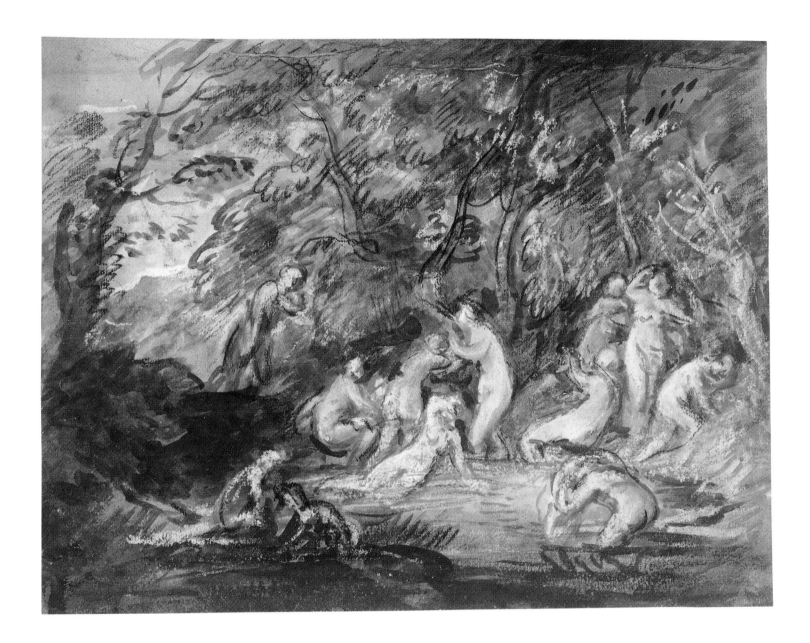

particularly careful preparation with drawings before he felt able to embark on the painting itself. The survival of three such drawings may be no accident: it suggests that their subject was especially valued by the artist, and may have represented a theme that was particularly close to his mood in the 1780s. It is interesting to speculate whether Actaeon, an outsider, represents a development from the woodman made to work hard to fend for the growing demands of his family which is such a central theme of his *Cottage Door* subjects (see cat. 10). The contrast between the figure of Actaeon and

Diana and her attendants is investigated in the three studies and eventually in the painting, where, in an idea first proposed in the Sudbury drawing, Actaeon diminishes in importance and is made to blend with the arboraceous background.

It may be telling that the painting appears to have been made for the artist's own amusement, as it is not mentioned in contemporary press notices and remained unrecorded until it was included in the artist's posthumous sale at Christie's on 10 April 1797. There it was bought by Hammond for the Prince Regent. Michael

Rosenthal has suggested that the sketchy finish of the canvas is a deliberate antithesis to the accepted canons of history painting and that, rather than show a single moment in Ovid's story, Gainsborough chose to encompass in his picture both its beginning and its tragic end, by showing Actaeon already sprouting horns.

NOTES

1. Allen 1987, pp. 72–73, repr.
2. Rosenthal 1992, pp. 174–75, repr.
3. J. Hayes in Arts Council 1960, under no. 58.
4. Millar 1969, p. 43.

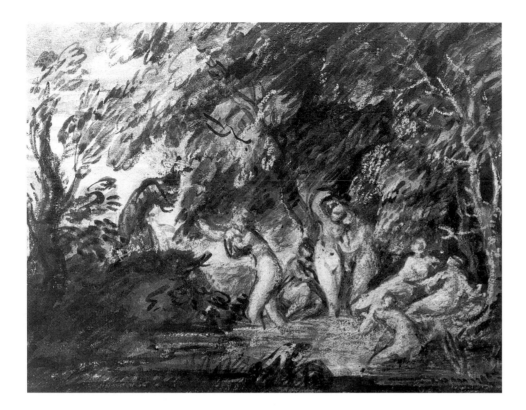

Fig. 31
THOMAS GAINSBOROUGH
Study for Diana and Actaeon, ca. 1785
Grey and grey-black washes and white chalk on
buff paper, 27.9 × 36.7 cm (11 × 14⅜ in.)
Henry E. Huntington Art Collections, San
Marino, California

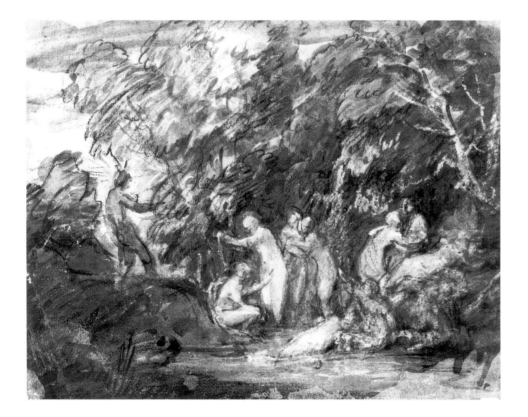

Fig. 32
THOMAS GAINSBOROUGH
Study for Diana and Actaeon, ca. 1785
Black chalk with grey, grey-black and brown
washes and bodycolour, 27.5 × 35.6 cm
(10¾ × 14 in.)
The Trustees, Cecil Higgins Art Gallery, Bedford

THOMAS GAINSBOROUGH

Wooded landscape with a cowman herding four cows, ca. 1785

Sepia wash and possibly an off-set line,
18.5 × 23.2 cm (7¼ × 9⅛ in.)

PROVENANCE with Barbara Davies Gallery
ca. 1950; purchased by Miss Barbara Davis-
Colley; by descent to her son, Andrew Howard;
his anonymous sale, Phillip's, 11 November 1991,
lot 108, purchased by the Society (1991.038)

This slight drawing is similar in design,
though in reverse, to one of the aquatints
which Gainsborough produced at the end of
his life (cat. 38). Many of his drawings in a
similar technique are framed with a tooled
gold arabesque border produced with a
bookbinder's rouleau, and this group of
drawings is frequently stamped with the

artist's initials or signature. It seems likely
that this particular kind of presentation was
reserved for drawings that were to be given
away or sold,[1] even if, judging by their
present condition, any such gift would be
less generous than that of a drawing using an
alternative technique. Lindsay Stainton has
suggested that the technique was imitative of
Old Master drawings and, as in his later
landscape paintings (for example, cat. 10),
Gainsborough was trying to compete with
his forebears. Nonetheless, it is perhaps right
to assume that, for whatever reason, sepia
drawings such as this have lost much of their
definition.

The waxy sepia lines on the drawings
have given rise to some discussion and it has
been suggested that some printing technique,

perhaps on glass, or offset directly on to a
second sheet of paper, may have been used.
The offset technique was frequently adopted
by Gainsborough's contemporaries to
duplicate their designs but, if he used this
method, it is strange that there are no
duplicates in his work. Furthermore,
microscopic examination has revealed that
the hatch lines go from right to left (the trait
of a right-handed artist) and have not been
reversed. Hopefully, further research by
conservators will reveal the true nature of
these marks.

NOTES
1. Hayes 1970a, pp. 25–26.
2. IEF 1983, under no. 75.

THOMAS GAINSBOROUGH

Landscape with cattle and a horse in windy weather, ca. 1785

Black, brown, red and white chalks with stump and possibly off-set on buff wove paper, 15.2 × 24.8 cm (6 × 9¾ in.)

PROVENANCE with Gregory 1974; Stanhope Shelton; bequeathed to his daughter, Victoria Byers; lent to the Society from January 1991 and purchased by the Society in June 1996 (1996.068)

LITERATURE Hayes 1983, no. 971; Asfour and Williamson 1999, pp. 160–62, repr. col. pl. 89

In this drawing the rough-textured paper breaks the strong-coloured chalk lines, which adds to the energy of the piece. The certainty of line and minimalist approach to the drawing, for instance of the tired horse on the right, are an indication of the extraordinary facility of the artist.

Wooded landscape with buildings, lake and rowing boat, ca. 1786

Black chalk and stump with touches of white chalk, 27.8 × 37 cm (10⅞ × 14⁹⁄₁₆ in.)

INSCRIBED [bottom left] *27 ×*; [bottom right] *WE*; [on reverse] *1833 WE 27 × Dr Monro's sale / Gainsborough*

ENGRAVED in soft-ground etching and acquatint by Thomas Rowlandson and included in *Imitations to Modern Drawings, ca.* 1788 (fig. 34; see cat. 45)

PROVENANCE Dr Thomas Monro; his sale, Christie's, 26 June 1833, lot 27, bt William Esdaile; his sale, Christie's, 21 March 1838, lot 816 with another, bt Cavendish; by descent to Richard Cavendish; his sale, Christie's, 8 November 1994, lot 12, bought by Hazlitt, Gooden & Fox Ltd for the Society with contributions from the MGC/V&A Purchase Grant Fund and the National Art Collections Fund (1994.161)

LITERATURE Hayes 1964, pp. 2–3; Hayes 1970a, p. 62, no. 627, pl. 294; Hayes 1970b, p. 311; Hayes 1982, p. 132, repr.

EXHIBITED Kenwood 1980, no. 80, repr.; IEF 1983, no. 70, repr.; Ferrara 1998, no. 77, repr. col.; Tate 2002, no. 147, repr. col.

This drawing has been linked to John Hoppner's remark about "the studies he [Gainsborough] made at this period of his life, in chalks, from the works of the more learned painters of Landscape, but particularly from Gaspard Poussin".[1] Parallels have been drawn between this sheet and a landscape painting by Gaspard in the National Gallery of Scotland (no. 2318) which shows a similar relationship between the buildings and the hillside, while the boat in the foreground is reminiscent of Bolognese painting.[2] However, an engraving by John Mason after Filippo Lauri's landscape painting from the collection of the Earl of Burlington (fig. 33), a popular print which was first published in 1744, provides a closer visual precedent. The similarities of the *repoussoir* bank in the lower left-hand corner, its relationship to the lake, the sweep

Fig. 33
JAMES MASON (1710– *ca.* 1780) after FILIPPO LAURI (1623–1694) *Landscape with fishermen,* published 1744 Engraving, plate size 31.5 × 40.4 cm (12⅜ × 15⅞ in.) Gainsborough's House, Sudbury (2002.070)

Fig. 34
THOMAS ROWLANDSON after THOMAS GAINSBOROUGH *Wooded landscape with buildings, lake and rowing boat,* from *Imitations from Modern Drawings, ca.* 1788 Soft-ground etching and aquatint, plate size 27.6 × 36.8 cm (10⅞ × 14½ in.) Gainsborough's House, Sudbury (1987.021)

of the water and the trees in front of the rocky outcrop in the distance are so close that there can be little doubt that Gainsborough knew the image.

 John Hayes records a copy of the drawing formerly in the collection of L.G. Duke.[3]

NOTES
1. *Quarterly Review,* 1 February 1809, p. 48.
2. Anne French in Kenwood 1980, no. 80, and Lindsay Stainton in IEF 1983, no. 70.
3. Hayes 1970a, no. 627.

Study of a woodman, ca. 1787

Black chalk and stump with white chalk on buff-coloured paper, 48.2 × 32 cm (18⅞ × 12⅝ in.)

PROVENANCE the artist's posthumous sale, Christie's, 11 May 1799, part of lots 1 or 6, bt Morris; ... Thomas Winstanley, Liverpool; George Fardo by 1903; anonymous sale, Christie's, 3 March 1970, lot 84, bt Mrs Albert Broccoli; unidentified New York sale, bt Stanhope Shelton; Donald Harrison; his posthumous sale, Christie's, 8 June 1999, lot 7, bought by Agnew for the Society with contributions from the MGC/V&A Purchase Grant Fund and the National Art Collections Fund (1999.083)

LITERATURE Hayes 1970a, no. 853

EXHIBITED Bath 1903, no. 174

In the *Morning Herald* on 14 July 1787, Henry Bate-Dudley (see cat. 41, 42) wrote of *The Woodman*, a canvas that Gainsborough had been working on during the summer:

"This wonderful memorial of genius is a portrait, the original being a poor smith worn out by labour, and now a pensioner upon accidental charity. Mr. Gainsborough was struck with his careworn aspect and took him home; he enabled the needy wanderer by his generosity to live – and made him immortal by his art! He painted him in the character of a woodman; and to account for his dejected visage introduced a violent storm. He appears sheltering under a tree; at a small distance in the background his cottage is seen. The action of his dog, who is starting with his head reversed, is well expressive of a momentary burst of thunder. A brilliancy of colour on the woodman's rustic weeds is also descriptive of the lightening's flash."[1]

John Hayes interpreted the Sudbury drawing, and four others that relate to it, as compositional alternatives which were eventually rejected before Gainsborough started work on the painting. However, it seems more likely, especially given their obvious speed of execution, that these drawings were made to research the artist's understanding of a man "worn out by labour" and empathize with his situation. Similar studies of the same model in different poses are in the Chicago Art Institute, the Mackenzie Art Gallery, Regina, Canada and a private collection in Canada; another, now lost, is known from a lithograph by R.J. Lane (see cat. 78 and 79).[2] In addition he made a sculpted bust of the man, now lost, which "exhibited all the vigour of Vandyck".[3]

As he was dying Gainsborough wrote to Reynolds to ask him to "come once under my Roof and look at my things, my Woodman you never saw", and it seems as though Reynolds responded, though his opinion of the painting is not recorded.[4] It was clearly a painting that Gainsborough held very dear and he was annoyed that his

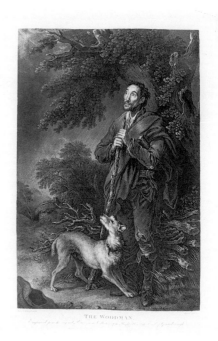

Fig. 35
PETER SIMON after
THOMAS GAINSBOROUGH
The Woodman, published by J. & J. Boydell on 1 August 1791
Stipple, plate size 63.5 × 43.2 cm (25 × 17 in.)
Gainsborough's House, Sudbury (1990.028)

nephew chose another painting from his studio rather than *The Woodman*. It was eventually sold by Mrs Gainsborough to the Earl of Gainsborough for the large sum of 500 guineas in 1789.[5] It was destroyed with several other works by Gainsborough (see cat. 39) in the fire at Exton Hall on 23 May 1810. Its appearance is known through Peter Simon's print (fig. 35).

NOTES
1. Transcribed by Whitley 1915, p. 285.
2. Hayes 1970a, nos. 849–51.
3. Whitley 1915, p. 371.
4. Hayes 2001, p. 176.
5. Whitley 1915, pp. 323, 330.

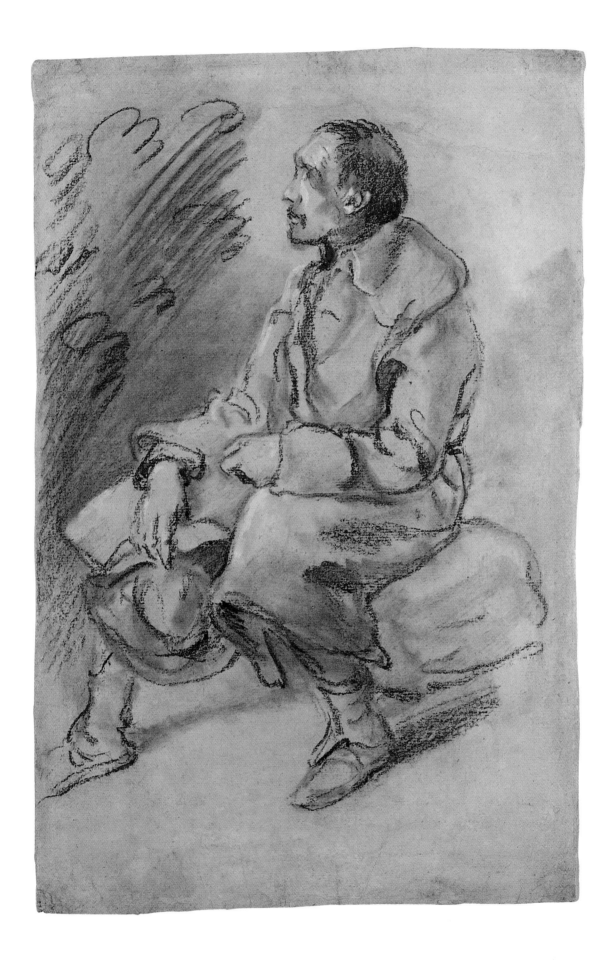

The Suffolk Plough, ca. 1753

Etching, plate size 35.5 × 40.5 cm (13 × 15¹⁵⁄₁₆ in.)

INSCRIBED in pencil *Begun to be Etched by Mr Gainsborough from a Picture of his own but spoil'd & never finished / The plate was never used*

PROVENANCE perhaps Edward Edwards; ...; unidentified sale at Phillip's, bt Andrew Edmunds; purchased by Cavendish Morton in 1978; by whom presented to the Society in October 1987 (1987.022)

LITERATURE Edwards 1808, p. 142; Woodall 1939, pp. 94–95; Hayes 1971, pp. 104–05; Belsey 1990, pp. 40–41, repr.; Hayes 1982, pp. 371–72, repr.; Asfour and Williamson 1999, pp. 45–46, repr.

EXHIBITED Paris 1981, no. 115, repr.; Aldeburgh 1988, no. 3, repr.; Hove 1993, no. 10, repr.; Ferrara 1988, no. 34, repr.; Colchester 2000; Tate 2002, no. 11, repr. col.

This unfinished etching reproduces, in reverse and with slight variations, a painting which was well known in the nineteenth century and was bought by an American collector whose descendants lent it to the Boston Museum of Fine Arts in the late 1980s (fig. 36). One other print from the plate has recently been identified in the collections of the Royal Academy. The Sudbury print bears an inscription, perhaps in the hand of Edward Edwards, who is the only authority to describe the print and explain its fate: "It is extremely scarce, for he [Gainsborough] spoiled the plate by impatiently attempting to apply the acqua fortis, before his friend, Mr. Grignion, could assist him, as was agreed".[1] Presumably Gainsborough kept the plate in the acid too long and the darker areas – the trees behind the horse – were bitten too deeply. Gainsborough, who was indeed impatient by nature, must have found the process laborious and given up the plate in the same way that he abandoned his print of *The Gipsies* (cat. 34) but, in contrast to *The Gipsies*, no other engraver completed the plate. As Gainsborough was taking advice from the London-based artist Charles

Fig. 36
THOMAS GAINSBOROUGH
The Suffolk Plough
Oil on canvas, 50 × 60.5 cm (19¼ × 23¾ in.)
Sotheby's, 14 November 1990, lot 101

Grignion at the time he was etching *The Suffolk Plough*, it is interesting to speculate why Grignion did not take up the plate and publish the print. Once he was working on *The Gipsies* Gainsborough turned to Joseph Wood, a close associate of his friend Joshua Kirby (see cat. 63) to help. He completed the print and published it with great success.[2]

NOTES
1. Edwards 1808, p. 142. For Grignion see cat. 60.
2. Bensusan-Butt 1993, pp. 50–51.

Begun to be Etched by Mr Gainsborough from a Picture of his own but spoild u never finished. The Plate

81

THOMAS GAINSBOROUGH AND JOSEPH WOOD (DIED 1763)

The Gipsies, ca. 1754

Etching on laid paper, trimmed 47.1 × 41.9 cm (18⁹⁄₁₆ × 16½ in.)

INSCRIBED in ink [lower left] *Etch'd by Mr Gainsborrough*

PROVENANCE with Andrew Edmunds 1989; purchased by the Society in December 1989 (1989.098)repr.

EXHIBITED Tate 2002, no. 28, repr. col.

The biographer of J.M.W. Turner, Walter Thornbury, records, in digression from his subject, a conversation he had with Revd Kirby Trimmer, a great-grandson of Gainsborough friend's Joshua Kirby: "He [Gainsborough] had a commission from a gentleman near Ipswich to paint a group of gipsies. When about two-thirds of it were finished – for Gainsborough in his early works, owing to his great execution, finished as he went on – he came to see it, and was not pleased with it; he said he did not like it. Then, said Gainsborough, 'You shall not have it;' and taking up his penknife he drew it directly across it. In this state Joshua Kirby begged it, my father had it mended, and it was sold at his death. It was a terrific gash, and Gainsborough must have been in a flaming passion when he did it. After this, he painted for the same person the picture from which the engraving is taken."[1] The damaged painting, which is a less ambitious design, eventually entered the collections of Tate Britain (fig. 37), while the painting from which the engraving was taken remains lost.[2]

The print is known in a variety of states. John Hayes lists two states before the first publication in 1759 and the present author has identified two earlier states: the first is represented by an impression formerly with Andrew Edmunds and was similar in finish to the print of *The Suffolk Plough* (cat. 33) – and perhaps was the impression that Kirby described as "first-rate"; the second state strengthened the design;[3] the third (Hayes's first state) shows further strengthening of the modelling; and the fourth (Hayes's second

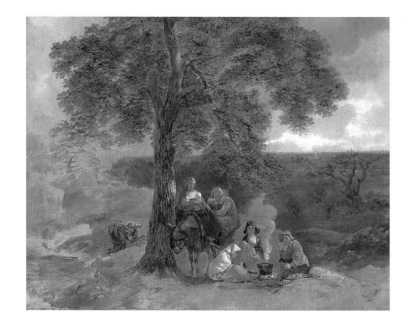

Fig. 37 THOMAS GAINSBOROUGH
The Gipsies, ca. 1754
Oil on canvas, 48.3 × 62.2 cm (19 × 24½ in.)
Tate Britain

state) adds further clouds in the sky and closes the composition on the right with a group of trees. The Sudbury etching under discussion provides yet another state, the fifth, which includes all the features of the finished plate but lacks a printed inscription.

The print was published in March 1759 with the inscription *Painted & Etch'd by T: Gainsborough | Engrav'd & Finish'd by J: Wood*. But at what stage was Joseph Wood involved in the production of the plate? Presumably the first, second and third states were Gainsborough's work; the four state seems most likely to have involved Joseph Wood. It is the earliest state to include the copse of trees on the right, which negates the compositional daring of the younger artist. Perhaps they were added by Wood after Gainsborough had moved to Bath.[4]

Wood died in 1763 and the plate was purchased from his widow and re-published by Joseph Boydell in 1764 as a pendant to

Wood's engraving of *Lake Nemi* after Richard Wilson.[5] The print remained popular and appeared in Boydell's catalogue until the early nineteenth century. The plate was eventually sold in the Boydell sale at Robert H. Evans in June 1818.

NOTES
1. Thornbury 1859, II, pp. 59–60.
2. The Tate canvas is Hayes 1982, pp. 375–76, but the damaged painting that appeared at Sotheby's on 4 July 2001 as lot 70 cannot be considered autograph; it is a copy of the lost painting.
3. See Aldeburgh 1988, fig. 7. Another impression of this state was with Artemis in March 2001.
4. Antony Griffiths (British Museum 1978, no. 10) felt there "is no trace of any such reworking" with a graver in the third (Hayes's first) state.
5. The Society owns a copy of the 1759 publication (1984.009) and the Boydell publication of 1764 (1991.026).

Etch'd by M.ʳ Gainsborough

83

Wooded landscape with country cart and figures, ca. 1778

Soft-ground etching and aquatint, trimmed to
plate mark, 27.7 × 34.5 cm (10$^{15}/_{16}$ × 13$^{9}/_{16}$ in.)

INSCRIBED [outside the margin top left] *9;*
[below] *Designed & Engraved by Thos
Gainsborough./ Pubd. as the Act directs Augt. 1st.
1797, by J. & J. Boydell N$^{o.}$ 90. Cheapside; & at the
Shakespeare Gallery, Pall Mall.*

PROVENANCE with Army & Navy Stores;
purchased by Major E.G. Thompson; his
posthumous sale by W.S. Bagshaw & Sons at
Far Fillimore, Hanbury, Burton-on-Trent,
28 February 1969, lot 115, bt R.H. Edwards;
purchased from him by the Society with a
contribution from the MGC/V&A Purchase
Grant Fund, March 1997 (1997.027)

LITERATURE Woodall 1939, no. 11; Hayes
1971, pp. 52–55

Gainsborough was fascinated with
printmaking techniques which resembled
drawings. Soft-ground etching, which
imitates chalk lines, had been used in Italy in
the 1760s and was adopted by the English
etcher Benjamin Green soon afterwards. It is
not clear whether Gainsborough was taught
the process or whether he discovered it for
himself.

The use of aquatint to reproduce wash is
more complicated and it is unlikely that
Gainsborough discovered the technique by
chance. Although the technique of acquatint
was protected jealously, the secret seems to
have become more widely known in the late
1770s, when Gainsborough began to use it.[1]
Interestingly, an earlier state of this print,
taken before the aquatint was added, is in
Christchurch Mansion, Ipswich.[2] The

Ipswich sheet was formerly mistaken for a
drawing and, instead of being presented by
Henry Joseph Pfungst to the Kupferstich-
kabinett in Berlin together with other early
impressions of Gainsborough's prints, it was
included in his sale of drawings at Christie's
on 15 June 1917.[3]

The print reproduces a drawing of similar
size which is now in the Whitworth Art
Gallery in Manchester.[4]

NOTES
1. Belsey 2002a, pp. 303–08.
2. Hayes 1971, pp. 53–54.
3. See Hayes 1970a, p. 100, and here cat. 18.
4. Hayes 1970a, no. 407.

THOMAS GAINSBOROUGH

Wooded landscape with peasant reading tombstone, 1780

Soft-ground etching with some aquatint,
trimmed 29.7 × 39.3 cm (11⅝ × 15½ in.);
presented on a contemporary wash mount

INSCRIBED [in ink on the mount] *Gainsborough
fecit on soft copper with his own hand*; [on reverse]
*The drawings of Gainsborough are executed by his
hand on soft copper ground - Colnaghi*[1]

PROVENANCE with P. & D. Colnaghi; ... ; with Christopher Mendez in 1968, bt Christopher Lennox-Boyd; his sale, Christie's, 16 May 1989, lot 133, repr., bt Garton & Cooke; purchased by Grosvenor Prints for the Society with contributions from the MGC/V&A Purchase Grant Fund and the Gainsborough Festival Fund, August 1989 (1989.057)

LITERATURE Woodall 1939, p. 96, no. 3; Hayes 1971, pp. 18, 69, no. 10; Belsey 1990, pp. 42–43, repr.; Belsey 1991, p. 114; Clayton 1997, pl. 241; Vaughan 2002, p. 199, repr.; Belsey 2002a, pp. 307–08, repr.

EXHIBITED Mendez 1968, no. 10, repr.

Fig. 38

RICHARD BENTLEY (died 1782)

Frontispiece to *Elegy Written in a Country Church-yard*, from *Designs by Mr. R. Bentley for Six Poems by Mr. T. Gray*, published by Dodsley, London, 1753

Engraving, plate size 29 × 22 cm (11⅜ × 8⅝ in.)

Gainsborough's House, Sudbury (2002.050)

Early in 1780 Gainsborough intended to publish three etchings to publicize the range of his work as a landscape artist. Each was a soft-ground etching, a technique he had started to use in the mid-1770s, with touches of aquatint to darken the denser areas of the print.[2] It is not known why Gainsborough aborted the publication, though these three prints, the largest in his oeuvre, are known through a limited number of copies. Apart from the print shown, there are others of the same design in the Henry E. Huntington Library and, on blue paper, in the Yale Center for British Art.[3]

The other two prints in the group show respectively a pair of empty carts, in a composition which Gainsborough had developed from an earlier print (cat. 35), and a peasant herding cows over a bridge with lovers looking on. The former reprises the theme of peasants going (or coming) from market, a recurrent subject in Gainsborough's imagination during the previous decade. The subject derives from Rubens, and one example is the large drawing in Sudbury (cat. 20). The second, on a more original theme, is, like the 1782 landscape (cat. 10), reminiscent of Claude and was developed into a full-size oval painting shortly after the print was made.[4]

All three prints were re-published by Boydell in 1797. The present print reappeared with the figure *2* on the top left-hand corner (Birmingham City Art Gallery and Yale Center for British Art, New Haven).[5] An earlier state of the print, from the important group of prints in the Kupferstichkabinett, Berlin, shows an incomplete donkey's muzzle and the peasant reading the inscription of a single tombstone rather than two stones as in the final impression.[6]

The image is inspired by Richard Bentley's illustration (fig. 38) to Thomas Gray's poem *Elegy Written in a Country Church-yard*, which appeared in the edition published by Robert Dodsley in 1753. The idea originates in the Poussinesque theme of *Et in Arcadia Ego*, which Sir Joshua Reynolds had also adapted for his double portrait of *Mrs Crewe and Mrs Bouverie* in 1769. Rather than elevate the theme as Reynolds had done, Gainsborough gave a peasant the central rôle. The figure poses beneath a

Gothic church,[7] which, to judge from the dead tree growing from inside, must have been ruined for many years. Beyond the churchyard wall the trees, now verdant, lead the eye to a courting couple who look over a flock of sheep towards their cottage, into the setting sun. Michael Levey suggested that the figure had travelled to the ruined church and its burial ground to contemplate memorials to his parents.[8] In the Bentley illustration the setting sun casts the shadow of the traveller over the grave, making the piece an explicit *memento mori*, a theme which is further emphasized by the skull framed by the older man's hand. With greater subtlety, but maintaining the clear quotation from Bentley, Gainsborough's tombstones are also shadowed by the peasant. Both the strong profile of the figure, very like the pose of Reynolds's Mrs Crewe, and his contemplative air, leaning on a staff, echo the earlier prototypes. It was a pose Gainsborough would use again in *The Woodman* (fig. 35).

At about the same time Gainsborough was painting a more elaborate version of the design with a peasant couple kneeling before the tombstones like reverential shepherds at a nativity. The canvas was long ago mutilated but the whole composition is shown in the aquatint by Maria Catherine Prestel which was published with the first sixteen lines from Gray's *Elegy* in 1790.[9]

NOTES

1. An impression of a *Landscape with two country carts* (Hayes 1971, no. 9), which has the same provenance, has exactly the same inscription and is at Yale (White 1977, no. 27, repr.).

2. Antony Griffiths was the first to observe that Gainsborough had added aquatint (Griffiths 1987, p. 268). For a discussion of how Gainsborough came to use these techniques see Belsey 2002a, pp. 306–08.

3. The version in San Marino (Hayes 1971, pl. 59) has margins and, like the two other designs, bore the inscription *Thos Gainsborough fecit | Publish'd as the Act directs, Feb^y 1^st 1780*. The one at Yale (White 1977, no. 29, repr., and Rosenthal 1999, pl. 269) is trimmed.

4. Hayes 1982, no. 128, repr.

5. In addition to those listed by Hayes (1971, p. 69) there is also a print on blue paper heightened with white chalk, on loan to Gainsborough's House from a private collection (Belsey 1988, no. 20, repr.).

6. Hayes 1971, pl. 58. A chalk copy at Yale, with slight variations, is no longer considered to be by Gainsborough (White 1977, no. 28, repr.; Hayes 1983, no. 936).

7. The church is reproduced in a curious panel painting which appeared at Sotheby's on 21 July 1982, lot 49.

8. In a lecture at Christie's on 3 July 1990.

9. Hayes 1982, no. 125, repr.

Wooded landscape with country cart and figures, ca. 1786

Aquatint, plate size 27.5 × 34.5 cm
(10⅞ × 13⅝ in.)

INSCRIBED [with the image top left] 7; [on a separate plate] *Designed & Engraved by Thos Gainsborough. | Pubd. as the Act directs Aug*[t]*. 1*[st]*. 1797 by J. & J. Boydell N*[o.]*90. Cheapside; & at the Shakespeare Gallery, Pall Mall.*

PROVENANCE with Colnaghi 1972; purchased by the Society with public donations and a grant from the Museums Association (Beecroft Bequest), July 1973 (1973.001)

LITERATURE Woodall 1939, no. 12; Hayes 1971, pp. 92, 96–97

EXHIBITED Colnaghi 1972, no. 60

Like cat. 35 and 38, this print is in grey ink (some were printed in sepia). All three were published as part of a set of twelve by John Boydell on 1 August 1797 from plates that Gainsborough had made in London during the 1770s and 1780s. Eleven of the twelve plates are extant and are now in the collections of Tate Britain.[1] The plates remained the property of the artist's widow and, after her death in December 1798, they were inherited by her daughters. A letter from Margaret Gainsborough, dated Brook Green, 6 April 1802, indicates that the venture with Boydell was designed to provide some income but that it was less successful than they had hoped. Indeed the prints are amongst the rarest of eighteenth century prints, which indicates the relative failure of the publication. The letter asks for the return of the plates as they "are to be sold by Auction by Mr Christie" and Margaret also requests that "the Prints from those Plates be sent to the Shakspear, and give an order for them to be delivered to her when call'd for".[2] She adds that she "will call and settle with Mr Harrison [Boydell's manager] very soon". No Christie's auction sale has been found and it seems likely that Miss Gainsborough was contriving an excuse rather than setting out her real plans. An unrecorded bound but incomplete set of nine

prints is in the Fitzwilliam Museum, Cambridge.[3]

This particular print reproduces a drawing of similar size now in the Yale Center for British Art.[4] There are very minor differences between the drawing and the print: the dog on the left of the drawing and a shepherd and sheep on the horizon and omitted in the print. It is also worth noting that this print is almost a mirror image of an earlier soft-ground etching (cat. 35) and it seems likely that the Yale drawing was developed from the print. Technically it would have been easy for Gainsborough to have used the earlier print to make a new print in reverse, but in this case it seems that he preferred to use a drawing as the intermediary stage.[5]

NOTES

1. The plate for the print under discussion is illustrated in Aldeburgh 1988, p. 8.
2. Suffolk Record Office (Ipswich Branch), HD 276/1/1, quoted by Hayes 1971, p. 26.
3. Fairfax Murray gift, 1917. I am grateful to Craig Hartley for bringing the volume to my attention. Details of this group will be published at a later date.
4. Hayes 1970a, no. 754, and White 1977, no. 31, repr.
5. I am grateful to Andrew Hunter for discussing this likelihood with me.

THOMAS GAINSBOROUGH

Wooded landscape with herdsman and cows, ca. 1786

Aquatint with soft-ground etching, trimmed to plate mark, 27.4 × 34.2 cm (10⅞ × 13½ in.)

INSCRIBED [outside the image top left] *10; Designed & Engraved by Tho.ˢ Gainsborough. | Pub.ᵈ as the Act directs Aug.ᵗ 1ˢᵗ. 1797 by J. & J. Boydell Nº.90. Cheapside; & at the Shakespeare Gallery, Pall Mall.*

PROVENANCE as cat. 35 (1997.027)

LITERATURE Woodall 1939, no. 4; Hayes 1971, pp. 98–101

After the production of the three prints which he intended to publish on 1 February 1780 (cat. 36), Gainsborough returned to printmaking in the mid 1780s and started to experiment with aquatint. Using the sugar-lift method, he could reproduce the effects of wash brushstrokes with increasing complexity and then enliven the texture of the print with the addition of soft-ground etching.

An early state of this print in Berlin, with some of Gainsborough's corrections added in wash, shows the effect of the aquatint before the artist added the soft-ground etching.[1] A transitional print, with some of the soft-ground etching added, is in the Yale Center.[2] The theme of cows and herdsman repeatedly recurs in Gainsborough's work; this design is worth comparing with two of the drawings in the exhibition (cat. 21 and 29). A related drawing in reverse from the print, now in an American private collection, is quite schematic in its handling. The sheet comes from the collection of the Earl of Arran and has only recently been accepted as by Gainsborough.[3]

NOTES

1. Hayes 1971, pl. 87.
2. Hayes 1971, pl. 88; White 1977, no. 32.
3. J. Hayes, *Gainsborough and Rowlandson: A New York Collection*, privately printed 1998, pp. 45–46.

RICHARD EARLOM (1743–1822) AFTER THOMAS GAINSBOROUGH

A shepherd, 1781

Mezzotint, plate size 40.5 × 28.1 cm (16 × 11 in.)

PROVENANCE with Frederick B. Daniell & Son; with Grosvenor Prints; purchased by the Society with public donations and a grant from the Museums Association (Beecroft Bequest), December 1988 (1988.023)

LITERATURE Horne 1891, no. 86i; Clayton 1997, p. 253, repr.; Asfour and Williamson 1999, pp. 261–62; Rosenthal 1999, pl. 230

EXHIBITED Nottingham 1998, no. 6, repr.; Ferrara 1998, no. 48, repr. col.

The print reproduces a painting shown at the Royal Academy in 1781 to considerable acclaim. A critic writing for *The London Chronicle* considered the painting "equal to any picture produced by any modern artist, and superior to most".[1] It is amongst Gainsborough's first 'fancy pictures', a genre which he clearly wanted to bring to a wider public and consequently commissioned Earlom to scrape in mezzotint. The canvas was sold to the Earl of Gainsborough shortly after the Royal Academy exhibition. It was destroyed in the fire at Exton Hall in 1810 (see fig. 35).

NOTES
1. *The London Chronicle,* 28 April –1 May 1781, XLIX, p. 416.

RICHARD EARLOM AND THOMAS GAINSBOROUGH

A shepherd, 1781

Mezzotint worked over with black and white
chalk, some scraping, 36.1 × 28.1cm
(14¼ × 11 in.)

INSCRIBED [on an eighteenth-century label]
Retouch'd by Mr. Gainsborough 1781

PROVENANCE … ; anonymous sale, Sotheby's,
9 December 1982, lot 869, repr., bt Christopher
Lennox-Boyd; with Nicholas Stogdon and
Artemis Fine Arts Ltd; purchased by the Society
with a contribution from Re:source/V&A
Purchase Grant Fund, March 2001 (2001.016)

LITERATURE Horne 1891, no. 86i

EXHIBITED New York, Boerner 2002, no. 56,
repr.

There is no reason to doubt the inscription
on the accompanying label. This piece is the
proof copy provided by Earlom for
Gainsborough to correct. Although there are
corrected proofs recorded of Gainsborough's
own prints,[1] no other proof supplied by
another printmaker is known. Indeed, other
than Dupont, there are relatively few early
engravers who copied work by Gainsborough.
His personal handling of paint was unsuited
to conversion into print and the large
number of corrections in this proof indicate
a certain dissatisfaction with the medium.[2]

Despite Gainsborough's corrections,
Earlom does not seem to have changed the
plate, and the print was published by Joseph
Boydell on 1 October 1781.[3] It was a very
successful publication and remained in
Boydell's catalogue for some time: in his
catalogue of 1803 it is listed at 5s 0d.[4]

NOTES
1. Two proofs are in the Kupferstichkabinett in
Berlin, both corrected with grey wash (Hayes
1971, pp. 87–88 (no. 15i), 98–101 (no. 19i))
and another is at Yale (see cat. 38).
2. For Gainsborough's relationship with specialist
engravers see Clayton 1991, pp. 38–48.
3. The cataloguer for the Boerner exhibition
noted a number of alterations to the plate
following Gainsborough's corrections; these,
however, seem to the present author to be

dissimilarities in the impressions rather than
variations in the plate.
4. *An Alphabetical Catalogue of Plates … which
compose the stock of John and Josiah Boydell*,
London 1803, p. 14; a copy is at Gainsborough's
House (1996.103).

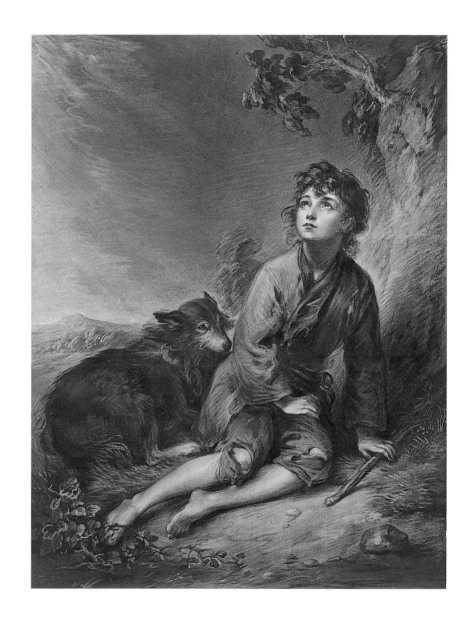

Portrait of the Revd Sir Henry Bate-Dudley, Bt, ca. 1780

Black chalk heightened with white on brown paper, 58.8 × 38.1 cm (23⅛ × 15 in.)

PROVENANCE E.M. Hodgkins by 1909; ... ; John Wentworth-Smith; his posthumous sale, Christie's, 19 March 1968, lot 149, repr., bt Christopher Lennox-Boyd; with Nicholas Stogdon and Artemis Fine Arts Ltd; purchased by the Society with a contribution from Re:source/V&A Purchase Grant Fund, March 2001 (2001.017)

LITERATURE Menpes and Grieg 1909, p. 170; Hayes 1970a, p. 370

The drawing is copied from Gainsborough's portrait and squared up for Dupont to convert into a mezzotint. The corrected proof, signed with Dupont's initials, is now in the collection at Gainsborough's House

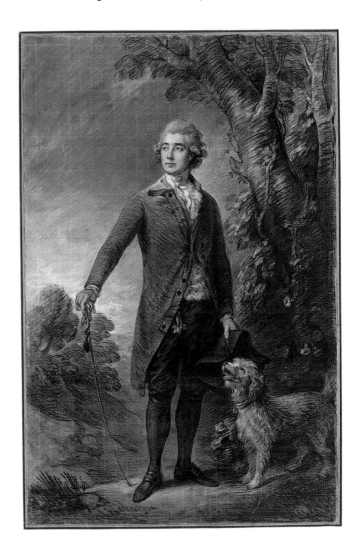

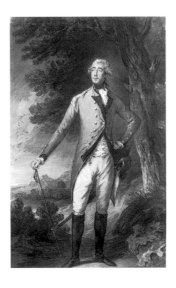

Fig. 39
GAINSBOROUGH DUPONT after
THOMAS GAINSBOROUGH
Portrait of the Marquis of Hastings,
ca. 1784
Black chalk and stump, white chalk and grey wash on buff paper,
62.2 × 41.7 cm (24½ × 16¼ in.)
Worcester Art Museum

(cat. 42). The drawing was presumably made shortly after Gainsborough painted the portrait in 1780.

Comparable drawings after Gainsborough's portraits of the Marquess of Hastings[1] (fig. 39) and Lord Rodney are also recorded.[2] The portrait of Hastings was intended to hang in the Royal Academy exhibition in 1784 but was withdrawn shortly before the exhibition opened; in pose and composition it is very similar to the portrait of Bate-Dudley. The portrait of Rodney dates from the same time.

While there is no record of Dupont scraping a mezzotint of Lord Hastings, one of Lord Rodney was published on 1 May 1788.[3] Both drawings are more finished than the drawing of Bate-Dudley, though both lack the ruled squaring.

NOTES
1. Hayes 1965b, p. 251, pl. 9.
2. Both drawings were in the Daren Brown sale, Christie's, 23 May 1924, lots 58 and 59, where both were attributed to Gainsborough himself. The original paintings are in São Paulo and the Rosebery collection at Dalmeny (Waterhouse 1958, nos. 353 and 583 respectively).
3. Horne 1891, p. 21, no. 57.

GAINSBOROUGH DUPONT AFTER THOMAS GAINSBOROUGH

Portrait of the Revd Sir Henry Bate-Dudley, Bt, ca. 1780

Mezzotint and soft-ground etching on laid paper, perhaps strengthened with black wash, plate mark 62.3 × 38.7 cm (24½ × 15¼ in.)

INSCRIBED in wash *G - D*; in pencil *Painted by Thomas Gainsborough / Engraved by Gainsborough Dupont / The Revd Sir Henry Bate Dudley / The only finished impression known. Originally the property of Gainsborough Dupont & bequeathed / by him to his nurse from whose descendents it was purchased.*

PROVENANCE given by Dupont to his nurse; ... ; The Marquesses of Bute; their sale, Christie's, 26 June 1997, lot 208, bought by Grosvenor Prints for the Society with a contribution from MGC/V&A Purchase Grant Fund, June 1997 (1997.119)

LITERATURE Russell 1926, p. 64

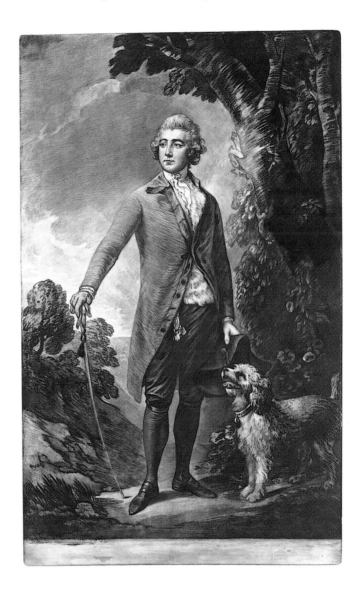

The mezzotinter's initials indicate that this print is a corrected proof; there are others in the collection, notably that by John Dean of Mrs Dalrymple Elliot, which is also signed by the artist.[1] The print, which was never published, is remarkably rare and was not included by Horne or by Chaloner Smith in their extensive catalogues of mezzotints.[2]

The mezzotint reproduces Gainsborough's portrait of the newspaper proprietor Sir Henry Bate-Dudley, who did much to support Gainsborough's activities in the 1780s. The painting was shown at the Royal Academy in 1780, when the reviewer in the *Candid Review* thought, "... perhaps there never was a more perfect resemblance. The modest style of the drapery, and the genteel figure of the person, assisting the painter, he has produced a most admirable picture. The dog is very fine."[3]

NOTES

1. 1997.118. Another was with Grosvenor Prints in 2002.
2. Horne 1891 and Chaloner Smith 1883.
3. Transcribed by Whitley 1915, p. 168.

VALENTINE GREEN (1739–1813) AND RICHARD EARLOM
AFTER THOMAS GAINSBOROUGH

Girl with pigs, 1783

Mezzotint on laid paper,

40.1 × 46.8 cm (15¾ × 18⅜ in.)

PROVENANCE The Marquesses of Bute; their
sale, Christie's, 26 June 1997, lot 208, bought by
Grosvenor Prints for the Society with a
contribution from MGC/V&A Purchase Grant
Fund, June 1997 (1997.089)

EXHIBITED Nottingham 1998, no. 85, repr.;
Ferrara 1998, no. 49, repr.; Carlisle 2002, no. 13,
repr.

LITERATURE Horne 1891, no. 84 (unrecorded
state)

W.T. Parke saw "at his house in Pall Mall the
three little pigs (who did not, in the common
phrase, sit for their likenesses) gamboling
about his painting room, whilst he was
catching an attitude or a leer from them at
his easel".[1] Gainsborough's painting was
exhibited at the Royal Academy in 1782,
where it was purchased by Sir Joshua
Reynolds for one hundred guineas. In the
letter acknowledging the payment
Gainsborough says that he is pleased that he
has "brought his Piggs to a fine market".[2]
Reynolds was satisfied, too: he felt
Gainsborough's painting was "by far the best
Picture he ever Painted or perhaps ever
will".[3] The canvas is now at Castle Howard.

Presumably the print was commissioned
by the painting's new owner. Valentine Green
had frequently worked for Reynolds but
quarrelled with him over the engraving of his
great portrait of *Mrs Siddons as the Tragic
Muse*, and this may explain why Earlom
finished the plate.[4] The print in Sudbury is a
proof before letters – a state that has not
previously been recorded.

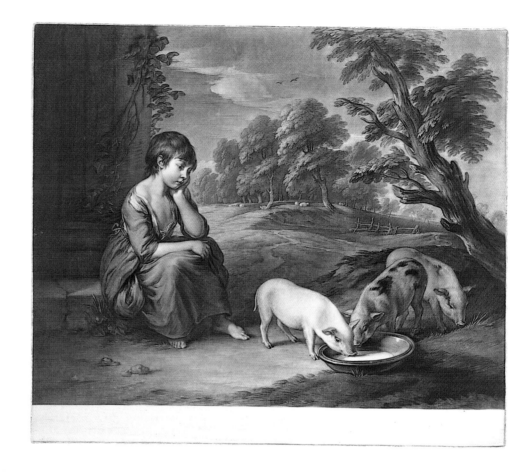

NOTES
1. W.T. Parke, *Musical Memories*, London 1830,
II, p. 108.
2. Hayes 2001, p. 147.
3. *The Letters of Sir Joshua Reynolds*, ed.
J. Ingamells and S. Edgcumbe, New Haven and
London 2001, p. 162.
4. Antony Griffiths in British Museum 1978,
pp. 36–37; cf. Whitley 1928, II, pp. 9–10.

GAINSBOROUGH DUPONT AFTER THOMAS GAINSBOROUGH

Sir John Skynner, ca. 1785

Mezzotint on laid paper,
50.2 × 35.6 cm (19¾ × 14 in.)

INSCRIBED in pencil [in margin] *The Rt Honble.*
Charles Wolfman Cornwall | Painted by Thomas
Gainsborough | Engraved by Gainsborough Dupont ||
Undescribed – probably unique | This print was
bequeathed by Dupont to his old nurse from whose
descendants it was directly purchased.

PROVENANCE as cat. 43 (1997.130)

A manuscript inscription wrongly identifies
this print as copying Gainsborough's portrait
of the Rt Honourable Wolfran Cornwall, the
Speaker of the House of Commons, who sat
to Gainsborough in April 1785. Judge
Skynner (born 1723) sat for his portrait the
following October and both canvases were
shown at Schomberg House in
Gainsborough's annual exhibition the
following May.

After a legal training at Oxford, Sir John
Skynner was appointed attorney general for
the Duchy of Lancaster and served as the
Member for Woodstock from 1771 until
1777. He became Chief Baron of the
Exchequer in 1777 and a Privy Councillor in
1787. He died in 1805.

This mezzotint is unrecorded and, like
the portrait of Bate-Dudley (cat. 42), was
unpublished.

THOMAS ROWLANDSON (1756–1827)

Imitations of Modern Drawings, 1784–88

Royal folio, 55.9 × 42.5 cm (22 × 16¾ in.);
21 pp. with two prints in soft-ground etching and
aquatint on each page, three of which have been
removed, in plain grey-green wrappers with the
trade card of H. Brookes, Coventry Street,
London

PROVENANCE with Grosvenor Prints;
purchased by the Society with a contribution
from the MGC/V&A Purchase Grant Fund
(1994.083)

The volume originally comprised forty-two
prints set on twenty-one pages – two prints
to a page. Three prints have been removed
and those that remain are as follows: two
after George Barrett, four after Gainsborough,[1]
one after Sawrey Gilpin, seven after Samuel
Howitt, three after John Hamilton Mortimer,
three after Francis Wheatley, one after
Antonio Zucchi, two after paintings by
George Barrett and Sawrey Gilpin and a
total of fifteen after Rowlandson's own
drawings. *Imitations of Modern Drawings*, as
the volume has come to be called, appears to
be a compilation of prints that Rowlandson
had produced in the mid 1780s. A number of
copies of the book are recorded, and the
order and the number of prints they contain
varies. The variations in the content of the

volumes and the scarcity of copies of the
book indicate that the volume was designed
to be split up. As the prints omit the
printmaker's name and only supply that of
the originating artist, a number of the prints,
especially those by Gainsborough, have been
misattributed.[2]

Joseph Grego catalogued a folio volume
that contained twenty-four prints with one
print per page.[3] Similar folio copies,
containing thirty-one plates, are recorded in
an exhibition in November 1916 at the
Grolier Club, New York,[4] and others are
preserved in the Metropolitan Museum of
Art, New York, and the British Museum
(both with thirty-six plates) and the Boston
Public Library (thirty-three plates). The only
other Royal folio copy is in the Philadelphia
Museum of Art, which has thirty-four plates
on twenty-three sheets. This is likely to have
been the copy which was on exhibition at
Ernest Gee & Co in New York in 1920, when
it was claimed to be unique.[5]

At least one of Rowlandson's drawings
exists for the volume. It copies a landscape
by George Barrett (with horses added by
Sawrey Gilpin) which was eventually

Fig. 40
THOMAS ROWLANDSON after GEORGE
BARRATT and SAWREY GILPIN
Mares and foals, ca. 1784
Pen, ink and grey, red and bistre washes,
11.2 × 17.8 cm (4 ⅛ × 7 ⅛ in.)
Gainsborough's House, Sudbury (1999.084)

reproduced in *Imitations* (see page 97 and
fig. 40).

NOTES
1. There is a total of seven prints by
Gainsborough in the series and the copy of
Imitations in Boston appears to be the only one
that includes all of them (Toronto 1987, no. 30,
n. 1). The drawings from which the prints are
taken are Hayes 1970a, nos. 326, 511, 627, 636,
667, 728 and 729.
2. Hayes 1971, p. 27.
3. Grego 1880, I, p. 151.
4. Falk 1949, p. 209.
5. Toronto 1987, p. 14 n. 34.

Trade card of H. Brookes, on the wrapper of
cat. 45

Folio 9
above THOMAS
ROWLANDSON after
SAMUEL HOWITT
Deer grazing in an
open landscape
Soft-ground etching
and aquatint,
19.3 × 24.8 cm
(7 ⅝ × 9 ¾ in.)

below THOMAS
ROWLANDSON after
GEORGE BARRATT
and SAWREY GILPIN
Mares and foals
grazing
Soft-ground etching
and aquatint,
14 × 21.3 cm
(5 ½ × 8 ⅜ in.)

Gainsborough.

Gainsborough.

Folio 13
above THOMAS
ROWLANDSON
after THOMAS
GAINSBOROUGH
*Wooded landscape with
cottage, figures and boat*
Soft-ground etching and
aquatint, 27.7 × 37.5 cm
(10⅞ × 14¾ in.)

below THOMAS
ROWLANDSON
after THOMAS
GAINSBOROUGH
Open landscape with cows
Soft-ground etching and
aquatint, 18.4 × 27.7 cm
(7¾ × 10⅞ in.)

Gainsborough's swordstick, with scabbard, ca. 1780

Cane and tempered steel, 83 cm (32⅝ in.) long; scabbard 73.5 cm (28⅞ in.) long

PROVENANCE by descent through the Dupont family to Gainsborough Dupont's great nephew, Richard Gainsborough Dupont (1789–1874); passed to his grandson, Kenneth Malcolm Waring (1887–1968), who gave it to the Society in April 1961 (1961.005)

EXHIBITED Sudbury 1988, no. 36

Following Gainsborough's practice during his life, a selling exhibition of the major works that remained in his studio opened on 30 March 1789. It was visited by the Queen and her eldest daughters, who "expressed very distinguished approbation of the pictures", which "operated to suspend for a time the resort of gay carriages to these Rooms".[1] In the nine months since Gainsborough's death there must have been considerable reorganization of his effects; much paperwork must have been destroyed, and only a handful of objects which belonged to him have come down to us. Some, including this swordstick, a snuff box and a notebook, were saved by his nephew and assistant Gainsborough Dupont.[2]

NOTES
1. *Morning Post*, 18 April 1789, p. 2, col. 2. For the catalogue, a copy of which is at Gainsborough's House (1990.022), see Hayes 1982, p. 302 and references.
2. Sudbury 1988, nos. 38, repr., and 40, repr.

47 *Gainsborough's studio cabinet, ca.* 1780

Mahogany, 99 cm high × 120.5 cm wide × 72.5 cm deep (39 × 47¾ × 28½ in.)

PROVENANCE bequeathed by the artist to Charles Cranmer, porter at the Royal Academy;[1] given by his son, the artist Charles Cranmer, to John Whitehead Walton; his sale, Sotheby's, 24 March 1897, lot 57, bt Glen; Hon. Mrs Francis Bridgeman; William Hollins, Mansfield, Nottinghamshire; given to his brother-in-law T. Blake Wirgman; bequeathed to his niece, Lena Thevenard, who sold it to the Victoria and Albert Museum, June 1935 (W.34–1935); transferred to the Society, May 1967 (1967.001)

LITERATURE Menpes and Greig 1909, p. 181; Leonard 1969, p. 40, repr.; Belsey 2002a, p. 301

The cabinet has a marble slab under the lid on which to grind colours and a large drawer beneath to hold large sheets of paper. They are supported by two pedestals with four drawers each. The top right-hand drawer is divided into a grid, perhaps to store dry colours.

The cabinet was altered extensively during the nineteenth century. Originally there were swan-necked handles on all the drawers, which have been replaced by knobs; the front section of the lid probably lifted in a scissor shape from the front rail of the cabinet, but the two dowel holes on the front rail, beneath the lid, remain difficult to explain. The brass threaded hole on the top may have supported a candlestick. The most radical change was the addition of five small cupboards with two drawers beneath, which were made to fit on the top (not exhibited).[2]

The changes to the cabinet are probably even more extensive than those described. A library table by Gillows (fig. 41), recently on the art market, may give the best available impression of its original appearance.[3]

NOTES
1. Hutchinson 1968, p. 96.
2. The cupboards are shown in Leonard 1969, p. 40.
3. See also L. Boynton, *Gillows Furniture Designs 1760–1800*, Royston 1995, pls. 20 and 24.

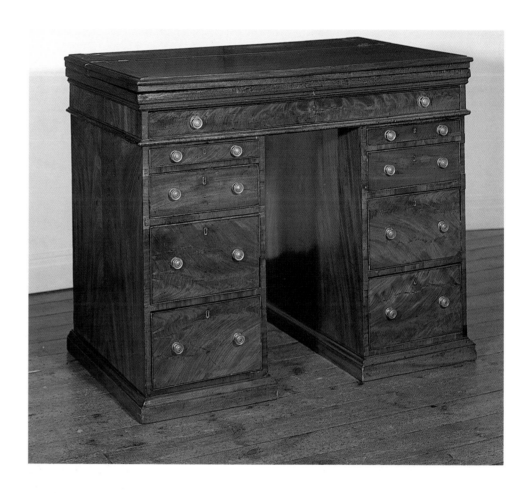

Fig. 41
WILLIAM BROWNRIGG (of GILLOWS of Lancaster and London) and THOMAS GIBBONS (1730–1813)
Library table, *ca.* 1785
Mahogany
With Simon Wingett Ltd, Wrexham, 2002

Fragment of a letter to James Hatley, containing satirical sketches of John Wood and Captain Abraham Clerke, 1750s

PROVENANCE private collection, England; with Historical Portraits Ltd; purchased by the Society in May 1994 (1994.070)

LITERATURE Hayes 2001, p. 7, no. 3, repr.; Belsey 2002a, pp. 297–301, repr.

This fragment from a letter shows two portraits rapidly sketched in pen and ink. It was cut, perhaps as early as the late eighteenth century, from one of Gainsborough's letters addressed to James Hatley of Ipswich. Hatley was a "highly cultivated [gentleman] with a very thorough knowledge of the polite arts" and, as both the portraits show amateur musicians, it is tempting to assume that the letter discussed musical events in Ipswich.[1] The tiny fragment was framed and on the back was pasted an inscription which identifies the two heads. On the left is John Wood, a dancing master who was portrayed by Gainsborough with an equally flamboyant a wig in the mid 1750s (fig. 42), and, on the right, Captain Clerke.

Wood followed his father into the business and by 1750 he was giving dancing classes in Dedham and Colchester as well as Ipswich. Seven years later he abandoned his commitments in Essex to take classes in Norwich and, after his father's death, Bury St Edmunds. Clerke was a captain of the 7th Marines, a company that was disbanded in 1748, though he continued his military career in the Eastern Battalion of the Suffolk Militia. Both figures were also portrayed by Gainsborough in a group portrait of the Ipswich Musical Society, which is now lost.

NOTES

1. *GM*, LVII, August 1787, p. 742.

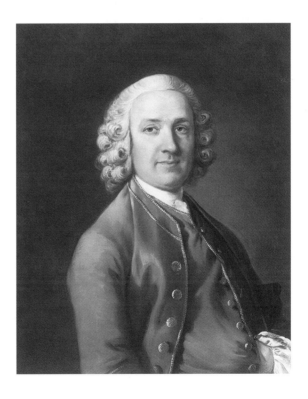

Fig. 42
THOMAS GAINSBOROUGH
Portrait of John Wood, ca. 1756
Oil on canvas, 76.2 × 63.5 cm (30 × 25 in.)
Yale Center for British Art, Paul Mellon Collection

Letter to William, 2nd Earl of Dartmouth, 18 April 1771

Gainsborough's correspondence with Lord Dartmouth was prompted by the patron's disappointment with the artist's portrait of his wife. Gainsborough's three letters, written within a fortnight, provide the best available insight into his attitude to portraiture. Lord Dartmouth felt that fancy dress would assist the likeness and give the portrait of his wife a timeless quality, and asked Gainsborough his opinion. Gainsborough had obviously suppressed his real thoughts but eventually, after much goading, replied in none too pleased a tone, in a letter full of self-justification and finger-wagging: "Here it is then – Nothing can be more absurd than the foolish custom of Painters dressing people like scaramouches and expecting the likeness to appear."

This letter has always been interpreted as one that accompanied a replacement portrait. However, although Gainsborough painted quickly, it seems unlikely that he would have responded with a completely new composition within the period of the correspondence. The letter reads better as an explosive outpouring of his thoughts on portraiture and, in particular, in response to Reynolds's recent portraits exhibited at the Royal Academy. The extant portraits bear out this interpretation. The portrait of Lord Dartmouth faces left; he stands hands crossed over a cane, tricorn hat in hand. One of the two portraits of Lady Dartmouth shows the sitter also facing left, in wrap-over dress, seated beneath a tree, with hair piled up; the other, now cut down to head-and-shoulder size, shows the sitter facing right, in crimson Van Dyck dress trimmed with ermine, holding a rose. She is wearing a lower coiffeur, decorated with a string of pearls, and a fragment of green curtain, like that in her husband's portrait, frames the composition on the left.[2] Which of the two was intended as a pendant to the portrait of Dartmouth? Visually the cut-down portrait seems the more likely.[3]

It should be noted that the receipt of 25 May 1769 is for £126, the price of three three-quarter-length portraits.

Presently the Society owns six other letters by Gainsborough and two receipts from him.[4]

NOTES

1. Hayes 2001, nos. 52, 53 and 138. The other two letters and the receipt are with the Dartmouth correspondence in Staffordshire Record Office (D (W) 1778/III/257).
2. All three portraits are illustrated in Hayes 2001, pp. 86, 87 and 89.
3. See Kenwood 1988, pp. 34–35, and Ribeiro 1995, p. 26.
4. Hayes 2001, nos. 3 [cat. 48], 25, 26, 34, 92. 102 and 143. A receipt to Thompson Scott, dated 9 May 1759, has appeared since John Hayes's publication (2001.021).

Articles of Apprenticeship of Gainsborough Dupont to Thomas Gainsborough, 12 January 1772

PROVENANCE with Maggs in 1924; with Frost & Reed in 1958; with Bennett & Marshall, Los Angeles; anonymous sale, Christie's, 24 October 1979, lot 90, bt John Wilson; purchased from him by the Society with donations and a grant from the Victoria and Albert Museum, November 1979 (1979.003)

LITERATURE Whitley 1915, p. 336; *Morning Post*, 15 April 1924; Woodall 1963, repr. opp. p. 89; Hayes 1982, p. 234 n. 2

EXHIBITED Bath 1958, no. 373; Sudbury 1988, no. 34

Gainsborough Dupont was baptized at St Peter's Church, Sudbury, on 28 April 1754, the second son of Thomas Gainsborough's sister Sarah, who, on 6 May 1745, had married Philip Dupont at St Gregory's, Sudbury. They had three sons and two daughters. Dupont moved to Bath to be apprenticed to his uncle and after he moved to Schomberg House in Pall Mall in 1774 continued his studies at the Royal Academy Schools.

Gainsborough was temperamentally unsuited to teaching and it is difficult to determine Dupont's activities during the sixteen years he served in Gainsborough's studio. During the time he was in the studio he appears to have made a number of copies of Gainsborough's work (cat. 65), scraped a number of mezzotints (cat. 42, 44), and painted with a considerable degree of competence.[1] After Thomas's death Dupont continued to paint portraits and landscapes in a Gainsboroughesque style. With the passing of time, as the memory of his uncle faded, the canvases became increasingly brittle in handling and acidic in colouring. Dupont died in Fitzroy Square, London, on 20 January 1797.

NOTES
1. The portrait of *Mrs Hatchett* in the Frick Collection, although it is signed with Dupont's initials, has only recently been attributed to him (Rosenthal 1998, pp. 80–81, repr.).

51 *The New Bath Guide, published by R. Cruttwell, Bath* [1770], *with manuscript notes by Dorothy Richardson*

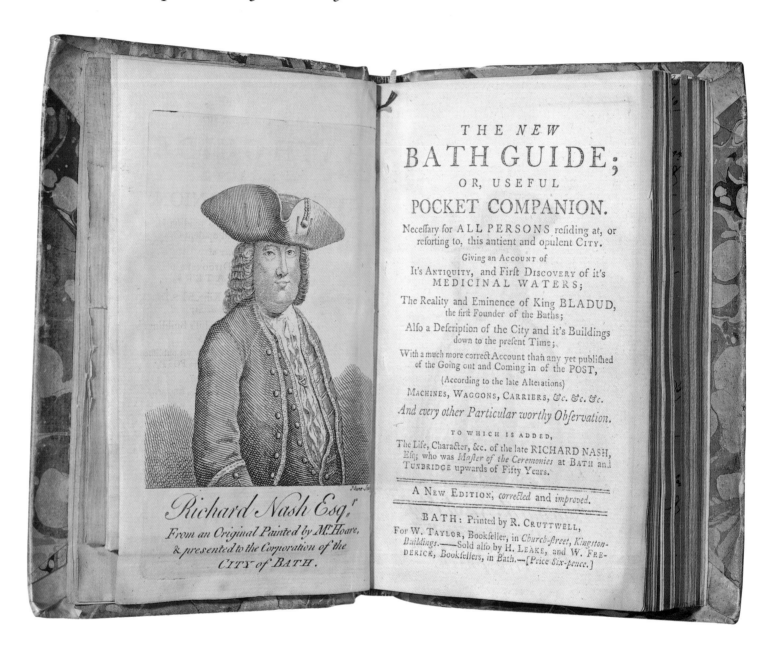

PROVENANCE with Bernard Quaritch Ltd; purchased by Cavendish Morton in about 1976; presented by him to the Society in May 1987 (1987.003)

LITERATURE Belsey 1987, pp. 107–09; Belsey 1991, p. 112

EXHIBITED Bath 1990, no. 44

Dorothy Richardson (born 1748) was brought up at Bierley Hall near Bradford and travelled with her uncle, John, from Oxford to Bath in May 1770. It was the first of several trips they took together, many of which she recorded in neat handwriting sometimes illustrated with naive, though charming, drawings.[1] In Bath she recorded her impressions of the city on blank pages at the back of the guide book to the city published annually by R. Cruttwell of Bath. There are a total of thirty-one pages of manuscript notes.

She begins, "This City stands low, Surrounded by Hills, it is very large, & all the New parts are most elegantly Built, of a

white kind of stone". She visited the usual sights: the Pump Room, the Abbey, Spring Gardens, the Bath Hospital and the Circus, "one of the Grandest things of the kind in Europe", and the new Assembly Rooms. Her descriptions are lively, and she showed particular enthusiasm for Mrs Smith's "Artifical Auricula, by which she got a Prize at the Florists Feast [which was] extremely beautiful & is purple streak'd with white & a Meal [presumably a caterpillar] upon it".

After the Richardsons' visit to the Circus they "call'd at Mr. Gainsborough's the Painters, to see his Pictures". Dorothy remarked that "Gainsborough Paints only in Oil, & excells most in Landscape; his Portraits are painted in a harsh manner, but said to be strong likeness's, his landscapes are very fine". They then continued "to see Mr: Hoares Crayon Pictures", from which she could "form no higher Idea of that Art, either as to Delicacy Colouring, or expression ... which if they do not reach perfection, I am sure they are very near it".[2]

NOTES

1. Marcia Pointon identified Dorothy Richardson and examined the five manuscript travel diaries in the John Rylands University Library in Manchester (Pointon 1997, pp. 89–130).
2. The section dealing with the visit to the two studios was examined by Belsey 1987, pp. 107–09.

Works by Other Artists

JOHANN THEODORE HEINS (1697–1756)

Portrait of Thomas Gainsborough, 1731

Oil on canvas, 76.2 × 63.5 cm (30 × 25 in.)

INSCRIBED [lower left] *D Heins Fec 1731*

PROVENANCE by descent to the granddaughter of John Gainsborough (1711–1772), Martha Gainsborough (born 1783), who, in 1803, married William Hurrell of Brundon; by descent to Reymes Hurrell; his widow's sale, Christie's, 22 February 1929, lot 32, bt Walters; … ; with Leger Galleries, London, in 1967; private collection, London; with Leger Galleries 1971, bt David Levin; purchased through Leger Galleries by the Society with contributions from the Victoria and Albert Museum (Purchase Grant Fund), Sudbury Town Council, the National Art Collections Fund (Reginald Jones Bequest) and a private donor, June 1984 (1984.003)

LITERATURE Bensusan-Butt 1985, pp. 460, 478, repr.; Vaughan 2002, p. 19, repr.

EXHIBITED Sudbury 1988, no. 1, repr.

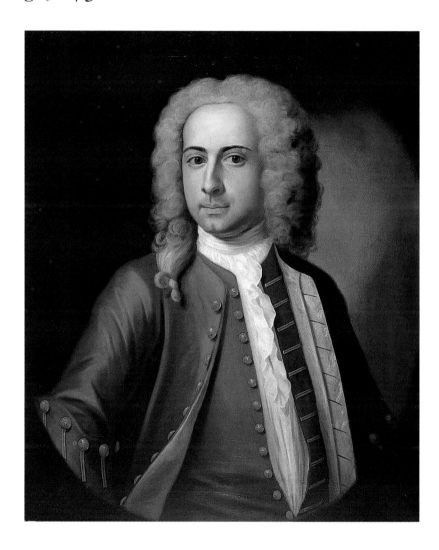

Heins was a German émigré who settled in Norwich in about 1720 and painted portraits of East Anglian sitters. In the year after he painted the Gainsborough family, Heins was was commissioned to paint a series of civic portraits for St Andrew's Hall in Norwich. Before his death in 1756 he had contributed a total of nineteen portraits.[1]

In 1731 Heins presumably travelled to Sudbury expressly to paint a series of portraits for the artist's paternal uncle, Thomas Gainsborough (1678–1739). The series comprised two three-quarter-length portraits of his patron and his second wife, Elizabeth Fenn (*ca.* 1676–1753), and four half-lengths of his three sons – Thomas (the present picture), John (cat. 53) and Samuel (1717–1780), who was to become a London haberdasher – and his daughter, Margaret (died 1748), who, in 1735, married William Shepherd.[2] The portraits of the parents are known only through the descriptions in the sale catalogue; that of Samuel is in a private collection in Canada and the likeness of Margaret, using a pose which Heins often repeated, is known through a photograph.[3]

The sitter built on his father's success as a entrepreneur. In 1725 he was apprenticed to James Ball, a merchant tailor in London, at a cost of £400, and by 1734 he had diversified the business and become the London partner of Samuel Storke, a West Indies merchant based in New York. Two years later he moved the business to Ayliffe Street near Goodman's Fields in London. There, in 1738, he took on an apprentice, Thomas de le Fontaine, for £500. Despite his premature death, in 1739, the association with Storke seems to have continued and Gainsborough money may well have stayed in the firm.[4]

NOTES

1. Moore in Norwich 1992, pp. 47–48, 203–09.
2. The parents were lot 29 in the Reymes Hurrell sale, Christie's, 29 February 1929, and Samuel and Margaret lots 31 and 30 respectively. For illustrations of the latter see Belsey 1988, pp. 12–13.
3. Lot 30 in the 1929 sale catalogue comprised the portraits of John Gainsborough (see cat. 53) and "his wife, Mary English" (*ca.* 1723–1764). However, the couple were not married until 1747, so a more plausible identification is Margaret, John Gainsborough's sister.
4. Bensusan-Butt 1985, p. 460.

JOHANN THEODORE HEINS

Portrait of John Gainsborough, 1731

Oil on canvas, 76.2 × 63.5 cm (30 × 25 in.)

INSCRIBED [lower left] *D Heins Fec 1731*

PROVENANCE as cat. 52 except in the Hurrell sale, Christie's, 22 February 1929, lot 30, bt Spiller (1984.004)

LITERATURE Bensusan-Butt 1985, p. 460; Vaughan 2002, p. 19, repr.

EXHIBITED Sudbury 1988, pp. 12–13, no. 2, repr.

The sitter, John (1711–1772), was the second son of Thomas Gainsborough and Elizabeth Fenn. Unlike his brother Thomas (see cat. 52) he remained in Sudbury, becoming a successful weaver of funerary crape. By 1735 he was rich enough to buy 46 Gainsborough Street for £500 and allow the artist's family to remain in the house (see cat. 13). After the death of the artist's mother in 1755 the property was rented and eventually passed to the sitter's son, John (1752–1791). After his death it was sold by auction to the tenant, Peter James Bennett, a silk manufacturer.

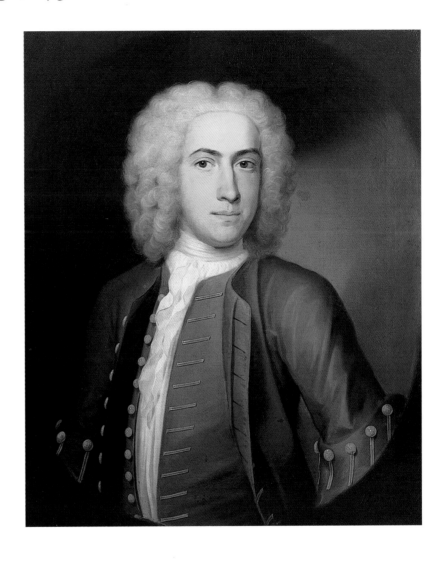

HUBERT-FRANÇOIS BOURGIGNON D'ANVILLE, CALLED GRAVELOT (1699–1773)

Design for the title page of John Pine's The Tapestry Hangings of the House of Lords, ca. 1739

Pen and ink with grey washes,
47 × 34.3 cm (18½ × 13½ in.)

PROVENANCE with William Drummond; with Historical Portraits Ltd; purchased from them by the Society with a contribution from the MGC/V&A Purchase Grant Fund, May 1993 (1993.015)

Before their destruction in the fire of 1837, the House of Lords was decorated with a series of seventeenth-century tapestries showing the progress and destruction of the Spanish Armada in 1588. In 1739 John Pine, a distinguished engraver, published a book describing the tapestries which was illustrated with eighteen large fold-out prints. In the book the reproductions were "ornamented with a curious border, wherein is engraved the portraits of the lord high admiral and other great commanders who signalized themselves in that glorious defence of their country".[1] The borders are occasionally printed in a contrasting colour of ink; nine of the border designs were by Gravelot, the others, by C. Lemprière, were very much in his style. Gravelot's drawing for the surround for the general chart is in New York (fig. 44).[2]

The Sudbury drawing is Gravelot's design for the title page (fig. 43): at the top are the arms of Queen Elizabeth I, flanked by cherubs blowing trumpets of fame, and, at the bottom, the arms of Charles Howard, 2nd Baron Howard of Effingham (later 1st Earl of Nottingham; *ca.* 1536–1624), who was Lord High Admiral and supreme commander of the navy at the time of the Armada.[3] Either side, between sails and halbards, shields and breastplates are two Rococo corbels, which support figures dressed as Elizabethan sailors. The one on the left smokes a pipe and brandishes an axe; the one on the right gathers weapons together.

Another similar cartouche, perhaps celebrating the postal service under George II, formed part of an exhibition of drawings organized by Thomas Williams and Luter Riester in New York in 1991.

NOTES
1. John Bowles & Son, *A Catalogue of Maps, Prints, Copy-Books &c from off Copper-plates*, London 1753, p. 78, no. 23. This advertisement presumably describes the second edition that was published that year.

2. See *Rococo: Art and Design in Hogarth's England*, Victoria and Albert Museum, May–September 1984, no. D5, repr.
3. I am grateful to John Martin Robinson for identifying the arms.

above Fig. 43
HUBERT-FRANÇOIS GRAVELOT
Frontispiece to John Pine's *Tapestry Hangings of the House of Lords*, London 1739
Board of the British Library, London

left Fig. 44
HUBERT-FRANÇOIS GRAVELOT
Design for the border for the General Chart in John Pine's *Tapestry Hangings of the House of Lords*, 1739
Sepia and grey wash, 37.5 × 60.9 cm (14¾ × 24 in.)
Cooper-Hewitt National Design Museum, Smithsonian Institution, New York, Purchase in memory of Annie Schermerhorn Kane (Mrs John Innes Kane)

HUBERT-FRANÇOIS GRAVELOT

Design for The Funeral of Faction, 1741

Pen and brown ink with wash, 19.4 × 31.7 cm
(7⅝ × 12½ in.)

ENGRAVED in reverse anonymously (perhaps
Charles Mosley) and published by Thomas
Cooper on 21 March 1741[1]

PROVENANCE anonymous sale, Sotheby's,
18 April 1994, lot 233, repr.; purchased by
Stephen Somerville for the Society (1994.051)

Sir Robert Walpole's popularity was charted
in a number of prints. On 13 February 1741
a vote of confidence was placed before the
two Houses of Parliament; Walpole was
triumphant, gaining votes of 290 against 106
in the Commons and 108 against 59 in the
Lords. The print, which was published with

twelve verses of doggerel, shows a funeral
procession headed by Caleb d'Anvers and
other anti-Whigs bearing the coffin of
'Faction' to 'the Family Vault' on the extreme
left. Members of the procession utter
sentiments such as *We're all Undone* and *All
our hopes are fled,* , which have been added to
the engraving. In the foreground the rotund
figure of Walpole stands with his companions,
arms akimbo, laughing heartily at the
procession of his opponents. To the left is
a street seller of a pamphlet engraved *The
Last Dying Speeches*; the figures of the
Parliamentary vote are inscribed at her feet.

Walpole's administration, by then known
as much for its corrupt practices as his

ministerial virtues, resigned the following
year. He was raised to the peerage and died
three years later.

A more elaborate drawing, engraved as
The European Race in 1739, is in the British
Museum[2] and another is in the Metropolitan
Museum of Art in New York.[3]

NOTES

1. *Satires* 2487.
2. Purchased at Christie's, New York, 9 January
1991, lot 46A. The engraving of the drawing is
Satires 2431.
3. J. Bean, *15th–18th Century French Drawings in
the Metropolitan Museum of Art*, New York 1986,
pp. 116–17, no. 122, repr.

Five winged cherubs supporting a cartouche, ca. 1741

Pencil with some pen and ink, indented for
transfer, 26 × 22 cm (10¼ × 9⅝ in.)

PROVENANCE anonymous sale, Christie's,
10 July 2001, lot 126, bought by Stephen
Somerville for the Society (2001.085)

Gravelot's designs for his own engravings are
less resolved than those he produced for
others to engrave (see cat. 55). In this
drawing, for instance, he provided several
alternatives for the feet of the lower cherubs
but chose only one to indent for transfer to
the engraving plate. The lower three cherubs,
detailed with pen and ink, were adjusted and
given suitable attributes to become figures

Fig. 45
HUBERT-FRANÇOIS GRAVELOT
Title page of George Bickham's *The Universal
Penman, or the Art of Writing made useful*,
H. Overton, London 1743
Gainsborough's House, Sudbury (2000.058)

representing wisdom and learning and to
support the motto *Delectando Monemus* on
the title page of George Bickham's *The
Universal Penman*, which was published in
1743 (fig. 45). The group of cherubs at the
top of the design are not indented for
transfer in preparation for an engraving.

This drawing is part of a cache of over
seventy which also includes ten sketches for

Gravelot's headpieces to the 1753 Paris
edition of Terence's comedies, *Publii Terentii
afri Comediæ Sex.*[1]

NOTES
1. 2001.111, 2001.118-23, 2001.125-6, 2001.128
(V. Salomons, *XVIIIth Century French Book-
illustrators: Gravelot*, London 1911, pp. 75–76, 80,
repr. pl. 3).

Surround for the Portrait of Katharine of Aragon for The Heads of Illustrious Persons in Great Britain, ca. 1743

Pen and black ink with sepia wash and touches of red chalk, incised for transfer with a blackened back, 35.7 × 22.2 cm (14⅛ × 8¾ in.)

PROVENANCE with Sidney Sabin; presented by him to the Society, March 1972 (1972.001)

LITERATURE Hayes 1969, pp. 1–3; Brown 1982, p. 500; Whiteley 2000, p. 234

In 1737 Arthur Pond was commissioned by John and Paul Knapton to travel to country house collections and make copies of portraits of famous historical figures to illustrate Nicholas Tindal's translation and continuation of Rapin de Thoyras's *History of England* (five volumes, 1743–47). The Knaptons appear to have approached Gravelot to make ornamental surrounds for the portraits, each of which included a panel at the bottom illustrating an event in the life of sitter. The designs were then sent to Jacobus Houbraken of Amsterdam to be engraved. The prints, which proved to be extremely popular, were republished, with biographies by Thomas Birch, in *The Heads of Illustrious Persons of Great Britain*, first published in a set of four volumes in 1747 and re-published five years later in a set of two. By this time Pond complained of the involvement of so many "by artifice".[1] The bandwagon continued to roll, and many years later, in an obituary, Gainsborough was credited as drawing, under Gravelot's instructions, "most of the ornaments which decorate the illustrious heads" – although, as John Hayes has demonstrated, this attribution cannot be substantiated.[2]

The largest group of designs are in the Sutherland collection in the Ashmolean Museum. Of the twenty-seven in Oxford, David Blayney Brown attributes sixteen to Gravelot himself and gives another nine to an artist working under his direction; John Whiteley, however, favours Gravelot for most of the group, though he considers that some

were executed more speedily than others.[3] Excepting those in Oxford and the drawing under discussion, four others are in the British Museum, one more in the Victoria and Albert Museum and another appeared at Christie's on 5 March 1974, lot 70.

The vignette in the Sudbury drawing shows Katharine of Aragon attending a hearing to discuss her divorce. She is seated

before her husband Henry VIII, who is being advised by Cardinal Wolsey.

NOTES

1. Lippincott 1983, pp. 36–37, 150.
2. *Morning Chronicle*, 8 August 1788, and Hayes 1969, *passim*.
3. Whiteley 2000, pp. 233–34.

JACOBUS HOUBRACKEN (1698–1780) AFTER ARTHUR POND (1701–1758)
AND HUBERT-FRANÇOIS GRAVELOT

Portrait of Katherine of Aragon, 1743

ENGRAVED by J. Houbracken in Amsterdam in
1743 and published by J. & P. Knapton in
London in 1744

PROVENANCE with Sidney Sabin; presented by
him to the Society, March 1972 (1972.002)

LITERATURE see cat. 57

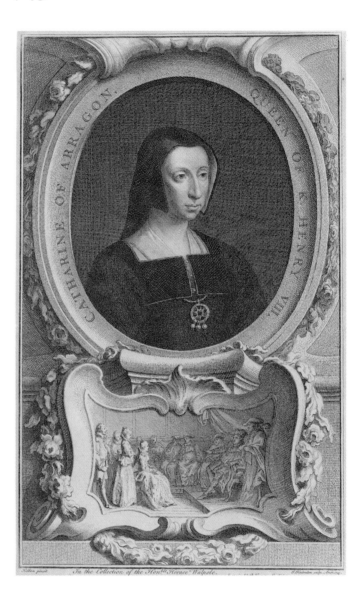

Study of a woman's costume, ca. 1744

Black chalk and stump heightened with white on buff paper, 32.5 × 25.5 cm (12¾ × 10 in.)

PROVENANCE E. Rodrigues; his sale, Paris, 28–29 November 1928, lot 130, repr.; … ; unidentified Paris sale, bt Kate de Rothschild; her sale, Christie's New York, 9 January 1991, lot 46, repr., bt in; purchased from Kate de Rothschild with a contribution from the MGC/V&A Purchase Grant Fund, May 1993 (1993.014)

LITERATURE Rosenthal 1999, pp. 5–6, repr.; Vaughan 2002, p. 25, repr.

EXHIBITED Didier Aaron 1987, no. 20, repr.; Tate 2002, no. 15, repr. col.

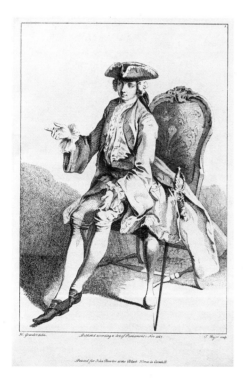

Fig. 46
THOMAS MAJOR after
HUBERT-FRANÇOIS GRAVELOT
Study of a man's costume, published
1 November 1745
Engraving, 28.5 × 18.6 cm (11¼ × 7¼ in.)
Victoria and Albert Museum, London

This drawing comes from a group of sheets, roughly the same size, which are related to a set of costume engravings by Charles Grignion, Louis Truchy and Thomas Major (figs. 6, 46 and 47).[1] The group includes sheets in the British Museum,[2] the Ashmolean Museum,[3] the Yale Center for British Art,[4] and the Forsyth Wickes Collection at the Museum of Fine Arts in Boston;[5] others have recently appeared on the New York art market.[6] Further related drawings, not by Gravelot himself but by a pupil, from the collection of William Younger Ottley, appeared at Christie's on 1 June 1928.[7] A pair of remarkable drawings by Nathaniel Smith dated 1743 and others by Charles Grignion (see cat. 60) reveal how considerable Gravelot's influence was on artists working in the early 1740s.[8]

French figure drawings such as this were executed on a coloured paper of generous size with black, and sometimes red, chalk and white highlights.[9] It was a format that Gainsborough adopted for the figure studies he drew throughout his life. Essentially it apes the approach Gainsborough adopted for his canvases, too, with a coloured ground, a rapid, dark-toned delineation of the composition and the addition of colour highlights to enliven the painting (see cat. 9).

NOTES
1. The largest group of engravings, which may not be complete, is in the Victoria and Albert Museum (see cat. 2, fig. 6). The catalogue of the 1928 sale stated that the Sudbury drawing was a study for one of these engravings; at the time the drawing was on a mount inscribed HUBERT GRAVELOT.
2. Inv. 1853-10-8-24 (Hayes 1970, pl. 244) is very close to one of the prints (fig. 46).
3. Brown 1982, pp. 347–48, no. 762.
4. From the Duke collection (B1977.14.9732).
5. *The Forsyth Wickes Collection in the Museum of Fine Arts in Boston*, Boston 1992, p.120–21, no. 65, repr.
6. Christie's New York, 10 January 1996, lot 207A; 28 January 1999, lot 152, repr., and 24

January 2001, lot 112, repr.
7. Some of these drawings are now at Gainsborough's House (1997.026) and (in 1992) with Wildenstein and at Christie's, 6 July 1999, lot 192. Interestingly, Ottley owned a large number of drawings by Gainsborough Dupont, which he may have aquired at the same time. Some are at Gainsborough's House (1984.010, 1989.058, 1994.171 and 1998.123).
8. The Smith drawings are at Yale (B1979.8.1 and 2). I should like to thank Dr Brian Allen for bringing the Yale drawings to my attention.
9. The Society owns a large drawing of a woman by Mercier using this technique (1998.076).

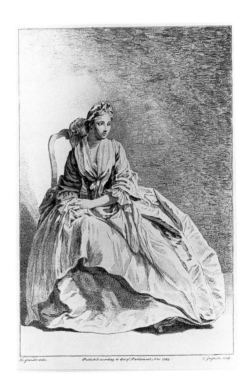

Fig. 47
CHARLES GRIGNION after
HUBERT-FRANÇOIS GRAVELOT
Study of a woman's costume, published
1 November 1745
Engraving, trimmed 27 × 18 cm (10¾ × 7⅛ in.)
Gainsborough's House, Sudbury (1998.134)

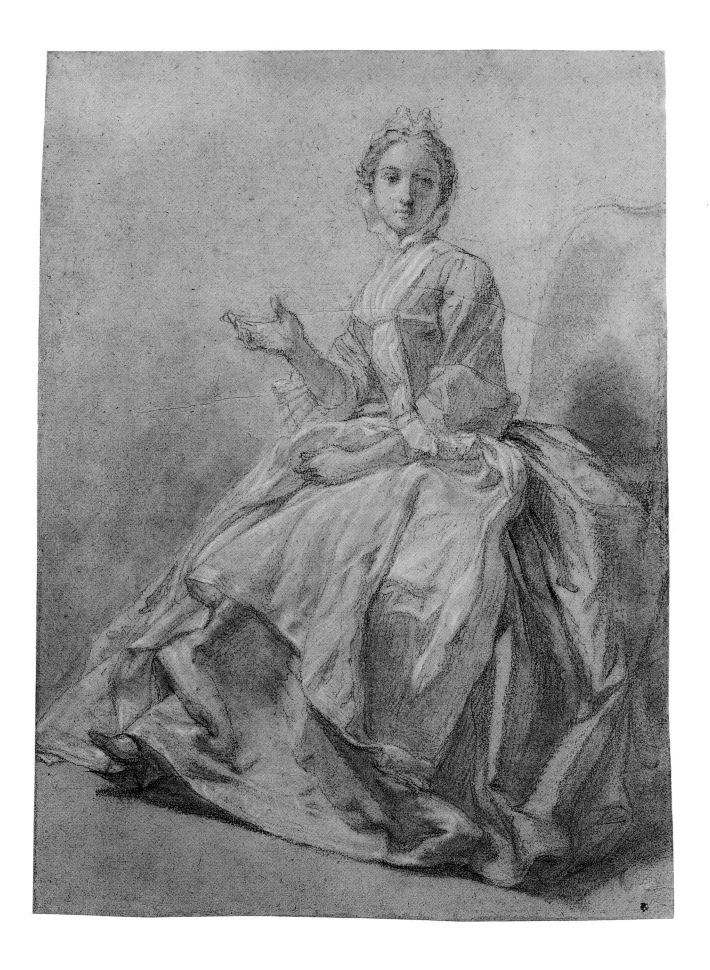

CHARLES GRIGNION (1721–1810)

Study of a young man wearing a tricorn hat, early 1740s

Black chalk, heightened with white chalk, on blue paper, 40.5 × 22.6 cm (16 × 8⅞ in.)

PROVENANCE with Colnaghi in 1979; purchased by Dr Tessa Murdoch in 1980; purchased from her by the Society with contributions from the Museums Association (Beecroft Bequest), December 2000 (2000.099)

EXHIBITED Colnaghi 1979, no. 15; Museum of London 1985, no. 284, repr.

Charles Grignion was the son of Daniel Grignon, a watchmaker, who emigrated from France in 1688. Charles studied with the celebrated engraver Le Bas in Paris and in London, from the age of ten, he continued his studies with Gravelot. Amongst his fellow students was Thomas Gainsborough. The technique of this drawing, black and white chalk with stump on tinted paper, is identical with the figure drawing by Gravelot (cat. 59) and the drawing of the artist's daughters (cat. 18). The Sudbury sheet is very similar to figure drawings in the British Museum and the Ashmolean Museum in Oxford and may have come from the same sketchbook.[1]

Grignion developed a career as an engraver, working for many designers during his long life. His obituary in the *Gentleman's Magazine* assures the reader, "He could *draw* as well as engrave", and continues, "Of the elegant art of English Engraving, he first planted the seed, which has risen to such luxuriance and maturity under the more accomplished hands of our chief Engravers, either of whom he would have equalled".[2] Towards the end of the century his style became old fashioned but his personality appears to have risen above any consequent difficulties. The Society also owns a lively head-and-shoulder sketch of a student by the artist.[3]

NOTES
1. Brown 1982, pp. 361–62, no. 814, and Museum of London 1985, no. 365, repr.
2. *GM*, LXXX, November 1810, p. 499.
3. This drawing (1998.034) has the study of a leg on the verso.

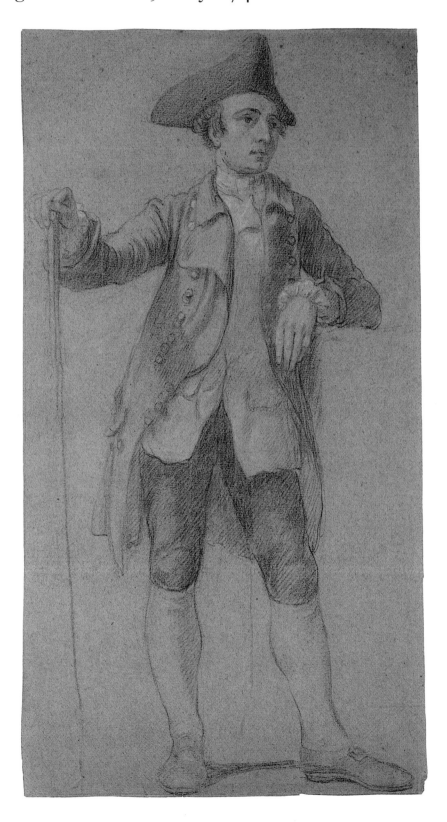

FRANCIS HAYMAN (1708–1776)

Portrait of Two Boys, 1740–42

Oil on canvas, 36.8 × 27.9 cm (14½ × 11 in.)

PROVENANCE perhaps David Garrick; his widow's sale, Christie's, 23 June 1823, lot 25, bt Noseda; … ; Mrs G.B. Smith's sale, Parke Bernet Inc, New York, 15 February 1964, lot 258 [as attributed to William Hogarth]; private collection, USA; anonymous sale, Sotheby's, New York, 11 October 1990, lot 54, repr. col.; with Anthony Mould Ltd; purchased from him with a contribution from the MGC/V&A Purchase Grant Fund, April 1992 (1992.024)

LITERATURE Buck 1996, p. 183, repr.

The two boys, perhaps aged between seven and ten years old, are shown resting from a game of shuttlecock and battledore. One of them sits, legs dangling, on a studio-prop chair that appears in other portrait groups by Hayman. This canvas could be "A Study of two Boys" which appeared in the sale of David Garrick's estate in 1823 in the same lot as a study of *James Quin as Falstaff*, which remains untraced.[1] Mysteriously the Garrick catalogue fails to name the sitters. It is easy to assume they may be Garrick's two beloved nephews, who appear in the famous conversation pieces by Zoffany of 1762, but they were born in the early 1750s and, stylistically, the Sudbury painting is close to *The Gascoigne Family* in the Huntington Library and *The Atkins Brothers* in the Fitzwilliam Museum, Cambridge, both of which date from the early 1740s.[2]

At the time this portrait was painted Gainsborough was assisting Hayman to paint some of the Vauxhall Gardens 'Supper Box' pictures. It was a period when Gainsborough was learning much from the older artist, and as the 1740s progressed there was a close interaction between the work of the two men. Indeed there is documentary evidence to prove that Hayman collaborated with Gainsborough: the younger artist painted the landscape background in Hayman's double portrait of *Elizabeth and Charles Bedford*.[3]

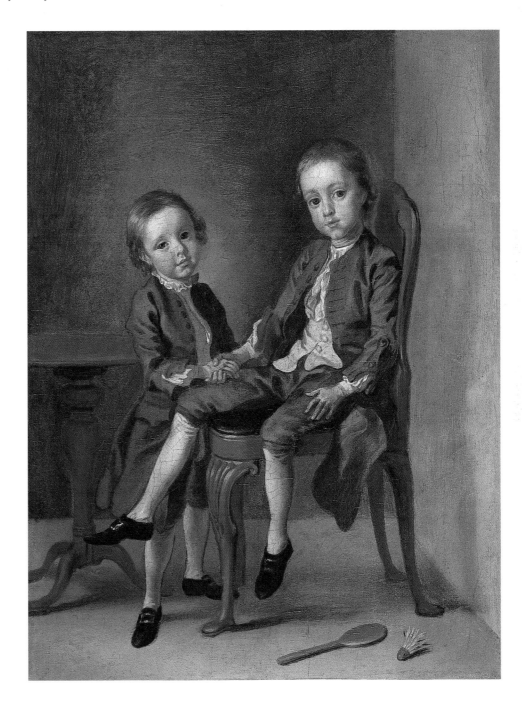

NOTES

1. Allen 1987, pp. 174–75, no. 71 [as untraced] and 179, no. 155.
2. Verbal information from Dr Brian Allen. For the compared paintings see Allen 1987, pp. 28–29, 171, no. 1, 172, no. 19, and Asleson and Bennett 2001, pp. 158–61, repr. col..
3. Allen 1987, pp. 8, 36–37, 92–93, repr. col.

FRANCIS HAYMAN

Seeing (La Vue), 1753

Oil on panel, 30.5 × 24.2 cm (12 × 9½ in.)

ENGRAVED in mezzotint by Richard Houston, published by John Bowles on 1 August 1753

PROVENANCE anonymous sale, Sotheby's, 20 December 1972, lot 31, bt Sidney Sabin Ltd; his sale, Sotheby's, 14 July 1999, lot 40, repr. col., bt Spink-Leger Ltd; purchased from them by the Society with contributions from the National Art Collections Fund and Re:source/V&A Purchase Grant Fund, February 2000 (2000.001)

LITERATURE Allen 1987, pp. 143–44, no. 158

EXHIBITED Spink-Leger 1999, no. 23, repr. col.

In 1753 Hayman produced five small panel paintings illustrating the five senses, but this is the only one to have survived. They were commissioned by the print publisher John Bowles and the Irish mezzotinter Richard Houston. Houston had engraved domestic subjects by the French émigré Philip Mercier, and no doubt he hoped to build on this success with the prints after Hayman's *Senses*. The 1753 prints bear inscriptions in both French and English and were intended to satisfy markets on both sides of the channel.[1] The subject-matter was favoured by France – a famous group of five *Senses* by Mercier is in the Yale Center for British Art[2] – and this beautifully observed design is decidedly French in character.

The image shows a young woman preparing herself for an outing, glancing over her shoulder for the final look in the mirror. The play of light on the brim of the hat and the gentle undulations in the profile of the hat, the falling blue ribbon and the lawn cuff would be the sort of details Gainsborough would have especially enjoyed.

A thumbnail preparatory drawing for the painting, which includes a cat, is in the Yale Center for British Art.[3]

NOTES

1. Allen 1987, no. 73 a–e, repr.

2. Mercier also produced another set (Ingamells and Raines 1976, nos. 264–68 and 269–73).

3. Allen 1987, p. 187, no. 259, illustrated Spink-Leger 1999.

JOSHUA KIRBY (1716–1774)

Classical Landscape with Ruins, 1761

Oil on canvas, 50.5 × 68.5 cm

INSCRIBED [bottom right] *JK* [in monogran] *1761*

PROVENANCE by descent to Mrs G.H. Spurrier, Ollerton Lodge, Cheshire; with Charles A. Jackson, Manchester 1933; … ; anonymous sale, W. & C. Bonham & Sons Ltd, 2 October 1969, lot 46, bt Christopher Lennox-Boyd; his sale, Christie's, 14 October 1988, lot 35, bt in; purchased from him by the Society with a contribution from the Museums Association (Beecroft Bequest), February 1992 (1992.011)

LITERATURE Owen 1995, p. 74 n. 80

EXHIBITED perhaps Society of Artists 1767, no. 86; Sudbury 1980, no. 5, repr.; Sudbury 1991, no. 8, repr.

This is the only known painting by Joshua Kirby. It shows the influence of Gainsborough's early work, especially in the treatment of the plants at the bottom right. According to family tradition Kirby met Gainsborough sketching near Freston Tower near Ipswich in about 1747, at which time he was working on *Twelve Prints of Monasteries, Castles, Ancient Churches and Monuments.*[1] He subsequently provided the specialist draughtsmanship for Gainsborough's painting of Hadleigh Church (private collection).[2] Their friendship remained close after Kirby moved to London in 1755 to teach drawing to the royal children at Kew. However, the political shenanigans surrounding the formation of the Royal Academy in 1768, when Kirby was President of the Society of Artists, must have strained the relationship; their relationship must also have affected Gainsborough's attitude to the fledging academy. Kirby died in 1774 and was buried at Kew; Gainsborough was buried beside him fourteen years later.

According to an old label Kirby's descendants described this painting as an Italian view near Rome. It is close to contemporary prints and drawings of Kew Gardens and may be a pastiche inspired by a landscape much closer to home. This painting may be identical with the canvas exhibited at the Society of Artists in 1767 that is traditionally ascribed to George III.[3] It is worth noting that there is a distinct resemblance between the Sudbury painting and George III's watercolour of *Syon House from Richmond* in the Royal Collection.[4]

NOTES

1. The Society owns one of these plates, that of Lavenham Church (1990.045), and a copy of the text written to explain the plates, which was published in 1748 (1994.149); see Felicity Owen in Sudbury 1980, p. 61.
2. Hayes 1982, no. 28, repr., and Owen 1995, p. 62, repr.
3. See Sudbury 1991, no. 8.
4. Roberts 1987, p. 64, and Sloan 2000, pp. 101–02, repr.

JOHN DOWNMAN (1750–1824)

Portrait of William Jackson of Exeter, 1779

Watercolour, and black chalk over pencil,
19.5 × 16 cm (7¾ × 6¼ in.)

INSCRIBED [right] *J. D.* [in monogram] *1779*

ENGRAVED anonymous mezzotint published by
John Downman on 1 March 1785[1]

PROVENANCE Gillingham collection sale,
Sotheby's, 19 April 2000, lot 352, repr. col., bt
Agnew; purchased from them with contributions
from Re:source/V&A Purchase Grant Fund and
the Lady Charlotte Bonham Carter Charitable
Trust, March 2001 (2001.018)

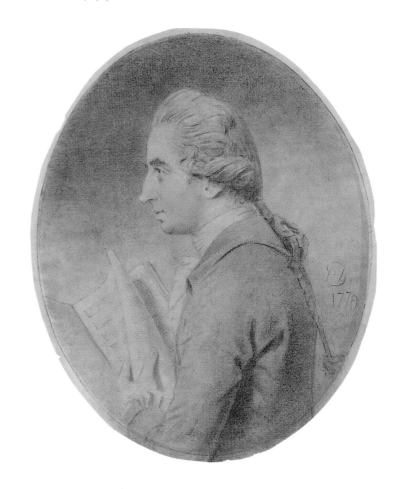

William Jackson, the son of an Exeter grocer,
studied the organ under John Travers at the
Chapel Royal in London between 1745 and
1748. He then returned to Exeter, publishing
Twelve Songs in 1755. In the early 1760s in
Bath he met Thomas Gainsborough, who
persuaded him to take up painting.[2] He
eventually became organist at Exeter
Cathedral in 1777 and in the same year
sketched around Teignmouth with
Gainsborough and John Bampfylde. He
continued to compose; perhaps his most
notable composition, published in 1780, was
the opera *The Lord of the Manor*, with a
libretto by General John Burgoyne. He made
a Continental tour in 1785 and after his
return to Exeter began to write. *Thirty Letters
on Various Subjects* went into three editions
and *The Four Ages* was also successful. He
died in Exeter in 1803.[3]

Between 1778 and 1780 John Downman
visited Exeter and painted members of
Jackson's family. A small oval oil portrait of
William Jackson's daughter Mary dated 1778
is in Tate Britain; the sitter was to marry
Downman in 1806. A portrait of Jackson's
son Thomas holding the neck of a viol da
gamba or 'cello is dated 1780 and may have
been designed as a pendant to the present
drawing.[4] Another 1780 portrait of Jackson
taken from the same sitting as the present
picture but omitting the music and altering
the hand and the costume was offered to the
National Portrait Gallery by Leggatt
Brothers in 1915 but has since disappeared.[5]

Other portraits of Jackson, associated with
Gainsborough, are less convincing likenesses.
A large oil portrait of Jackson playing a harp,
which had been attributed to Gainsborough,
is more likely to be a self-portrait.[6] Another
portrait showing him playing a harp has been
attributed to Downman,[7] but when it was
exhibited in Sudbury in 1997 the identity of
the sitter was questioned and an attribution
to John Raphael Smith proposed.[8]

The Society owns a number of drawings
attributed to Jackson.[9]

NOTES
1. Chaloner Smith 1883, IV, p. 1735, no. 94.
2. See J. Hayes, 'William Jackson of Exeter',
Connoisseur, CLXXIII, 1970, pp.17–24. Works by
Jackson cited by Hayes, and others that have

been identified more recently, were included in
the exhibition *William Jackson of Exeter
(1730–1803)* at Gainsborough's House in 1997,
nos. 14–28. An illustrated file of the exhibition is
in the archives at Gainsborough's House.
3. See *GHR* 1996/97 for the most complete
biographical account of the sitter.
4. Sotheby's, 24 June 1924, lot 51.
5. Heinz Archive, National Portrait Gallery.
6. In the Royal Albert Memorial Museum,
Exeter. The attribution was made in the 1997
Gainsborough's House exhibition notes (see
note 2 above), no. 1.
7. The portrait is reproduced in Hayes 1975,
pp. 14-15, fig. 9.
8. Verbal attribution from Andrew Wilton.
9. 1997.030–034.

GAINSBOROUGH DUPONT (1754–1797)

Portrait of Lady Mendip, ca. 1787

Oil on prepared paper mounted on book board,
15.4 × 11.8 cm (6 1/16 × 4 5/8 in.)

PROVENANCE by descent in the family of the
sitter; with Historical Portraits Ltd; purchased by
the Society in January 1996 (1996.008)

The sitter is Anne Stanley, who, on 20 July
1765, married, as his second wife, Welbore
Ellis, who was created Lord Mendip in 1794.
Gainsborough's portrait of Lady Mendip
was completed late in 1787 and is now in a
private collection.[1]

Examination by a conservator at the
Royal Library established that the support of
this small oil was compacted cardboard
which includes many indigo fibres, perhaps
from recycled naval uniforms. The material
was generally used to make book covers.[2] A
number of copies, on identically sized sheets
of book board, have been attributed to
Gainsborough. Those of Mrs Gainsborough
(cat. 11) and the sketch of Charles, 11th
Duke of Norfolk[3] appear to be the only ones
painted by Gainsborough himself; others,
including the Sudbury portrait of Lady
Mendip, are copies by Dupont of portraits
that Gainsborough painted during the 1780s.
Not surprisingly, and almost without
exception, this group has been passed off as
reduced versions by Gainsborough himself. [4]

The purpose of these duplicates are
difficult to determine. They might represent
an opportunity for Dupont to learn more of
his uncle's technique, or they could be some
form of *liber veritatis* – an opportunity for
Gainsborough to record his output and show
his range to new clients. The suggestion that
the copies were produced for engraving fails,
as only the portrait of Pitt was reproduced.

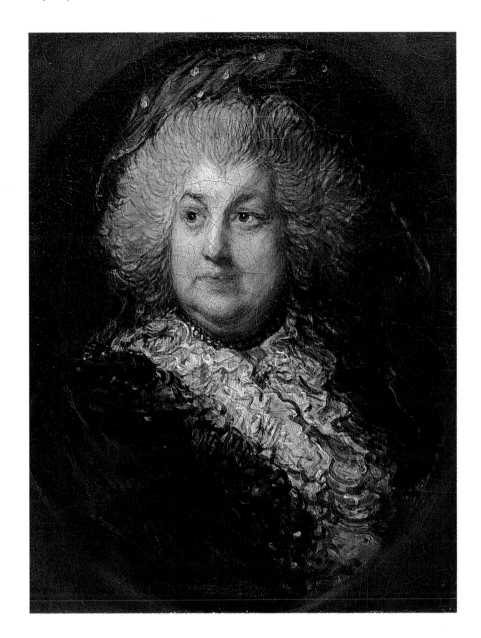

NOTES
1. Whitley 1915, p. 294.
2. This suggestion was first made by Anthony Reed.
3. Mistakenly called James Bentall by Waterhouse,
who is the earliest recorded owner (1958, no. 64).
4. Waterhouse 1953, pp. 59, 79, 89, 129; for the
unknown man in the Taft Museum, Cincinnati,
see Sullivan 1995, p. 183, repr.; for Lord

Mulgrave in the Metropolitan Museum and Lady
Mulgrave in Cincinnati Art Museum see
Cincinnati 1931, no. 37, repr.; for Princes William
and Octavius in the Royal Collection see Millar
1969, nos. 813 and 814; for William Pitt see
Hayes 1992, pp. 68–69, repr. A miniature portrait
of Mrs John Puget (Metropolitan), although the
same size, is painted on the reverse of a disused
etching plate. In December 1998 Viola

Pemberton-Piggot, Rica Jones, John Hayes,
Lindsay Stainton, Anthony Mould and Hugh
Belsey met to examine cat. 11 and 65, the Royal
Collection pair and the portrait of the Prince of
Wales in a private collection. The opinion here
expressed was agreed by John Hayes, though
Lindsay Stainton and Anthony Mould felt that
possibly all the paintings were by Gainsborough
himself.

Wooded Landscape with Milkmaid and Woodman ('Rural Courtship'), ca. 1792

Oil on canvas, 126 × 101 cm (49⅝ × 39¾ in.)

ENGRAVED in aquatint by T. Whessell and J.C. Sadler, published by R. Bowyer on 1 December 1800 (fig. 48)

PROVENANCE the artist's posthumous sale, 10–11 April 1797, lot 77, bt Caswell; Revd Edward Gardiner; by descent to Edward Netherton Haward; his widow's sale, Christie's, 11 May 1923, lot 102, repr.;[1] with Knoedler, New York; Percy R. Pyne II, New York, by 1926; with Ehrich-Newhouse Galleries, New York, by 1937; with Agnew's, London, by 1957; Mr and Mrs Leigh Battson, Beverley Hills; bequeathed to the Los Angeles Museum of Art (M.64.18.1); deaccessioned in 1996; their sale, Christie's New York, 15 May 1996, lot 68, repr. col., bt Raphael Valls; purchased from him by the Society with a contribution from the MGC/V&A Purchase Grant Fund, December 1996 (1996.259)

LITERATURE Fulcher 1856, p. 233; Armstrong 1898, p. 205; Whitley 1923, p. 66, repr.; Woodall 1939, pp. 72–73, pl. 99; Waterhouse 1958, no. 904; Hayes 1982, pp. 190–91, 194, 207, repr.

EXHIBITED Grosvenor Gallery 1885, no. 73; New York, Knoedler 1923, no. 23; Fort Worth 1937, no. 4, repr.; Pittsburgh 1938, no. 47

Fig. 48
T. WHESSELL and
J.C. STADLER after
GAINSBOROUGH
DUPONT
Rural Courtship,
published by R. Bowyer
1 December 1800
Stipple and aquatint
with etching, trimmed
67 × 49.7 cm
(26⅜ × 19½ in.)
Gainsborough's House,
Sudbury (1991.047)

Despite Whessell and Sadler's aquatint (fig. 48), which clearly states the true authorship of the landscape, the painting had erroneously been attributed to Thomas Gainsborough since it was first published by Fulcher in 1856,[2] and it was only in 1973 that Waterhouse revised the attribution. John Hayes has convincingly linked the painting to "The woodman and girl, milking cows, a beautiful picture" in Dupont's posthumous sale; the canvas was designed to hang with another landscape "of equal merit", which was also bought by Caswell but is now lost. A drawing in the Metropolitan Museum of Art, New York, first linked to the painting by Mary Woodall, shows a dog on the left.

Recent cleaning of the canvas shows that the painting originally followed the drawing and included the dog, which was painted out by the artist.

With those from the Brooklyn Museum and the Lady Lever Art Gallery, Port Sunlight, the Sudbury canvas ranks with the best of Dupont's landscape paintings.[3] Another painting from the 1797 sale is in the Sudbury collection: a 'fancy picture' of a boy and girl outside a cottage, formerly in the Kimbell Art Museum in Fort Worth.[4]

NOTES

1. For the line of descent see Harris 1991, pp. 45–49.
2. Waterhouse's letter dated 5 November 1973 is in the files of the Los Angeles Museum of Art.
3. Hayes 1982, pp. 192, 194, 199, repr., 213, repr., and Kidson 1999, pp. 55–56, repr.
4. 1987.002 (Hayes 1982, pp. 193, no. 7, 230, repr.).

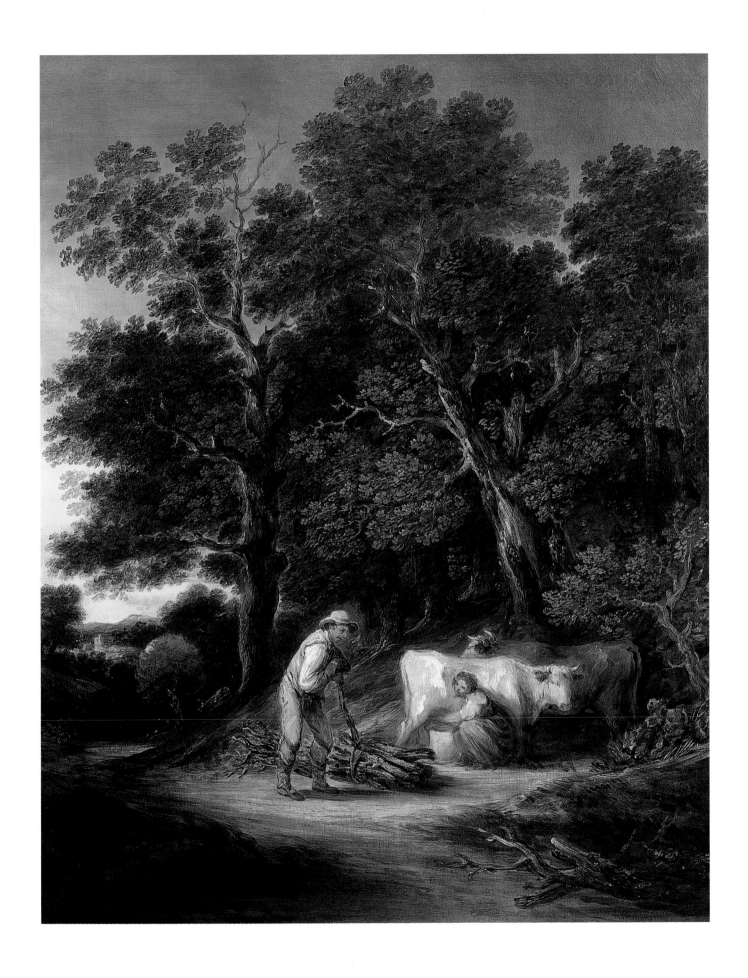

Portrait of John Clementson, exhibited 1792

Oil on canvas, 126 × 100.5 cm (49⅝ × 39⅝ in.)

PROVENANCE passed to the sitter's daughter
Mary Ann, the wife of Edward Boodle
(1751–1828); by descent until 1990; purchased
by a private collector; his anonymous sale,
Sotheby's, 9 July 1997, lot 38, repr. col., bt by
Historical Portraits Ltd for the Society with a
contribution by the MGC/V&A Purchase Grant
Fund (1997.134)

EXHIBITED RA 1792, no. 122

John Clementson (1735–1805) was a solicitor
who became the Deputy Serjeant at Arms at
the House of Commons in 1770, a position
he filled with distinction until his retirement
in 1804, when the office passed to his son.
Clementson served under two Serjeants,
Nicholas Beaufoy, who had been appointed
in 1762 and served until his death in 1775,
and his successor Edward Coleman, who
retired in 1805. As with many similar
eighteenth-century appointments, the
Deputy Serjeant did much of the work.

The post relied on fees and emoluments
though, from 1800, the House ensured that
this was never less than £500 per annum,
and from at least 1794 the Deputy Serjeant
was able to act as a Parliamentary agent for
private bills. After Clementson's retirement
the King was asked to make some provision
for him "on account of his long and
laborious services and advanced time of
life".[1] He died on 24 April 1805 "at his
house in the country", which was probably
the one he had owned since 1803 at Copthall
in Bedfordshire.

The portrait shows Clementson touching
the mace before the Speaker's Chair. It is one
of the few representations of the chamber
before the destruction of the House by fire in
1837. The portrait appears to have remained
in the artist's studio; family tradition states
that it was painted to thank the sitter for the
many introductions he had arranged for the
painter. An entry dated 15 February 1797 in
Clementson's diary mentions "Mr Dupont's
Bro^r. [presumably Richard Dupont] sent me
my Portrait done by Gainsboro' Dupont w^th
a Letter"; sadly, the letter is lost. On 11
March 1797 the same volume, which has
accounts on the right-hand page, notes:
"Paid for Frame for my Portrait given me by
the Ext [executors] of ye late Mr Gainsborough
Dupont £3.8.0d".[2] The frame was, however,
replaced in the nineteenth century and the
Society purchased a contemporary frame for
it at acquisition.

Perhaps remembering this picture, the
critic of the St James's Chronicle found that

Dupont's work revealed "Gainsborough's
clumsy unfinished manner [rather than] his
chiaroscuro, and his clearness and beauty of
colouring".[3]

The Society owns a number of other
portraits by Dupont.[4]

NOTES

1. *Commons Journals*, LIX, p. 326, quoted by
P.D.G. Thomas, 'The Parliamentary Diary of
John Clementson, 1770–1802', *Camden
Miscellany*, XXV, 1974, p. 144.
2. A photocopy of the diary extracts are in the
Museum files.
3. 10–12 May 1792, quoted Hayes 1982, pp. 189,
191.
4. *Miss Caroline Horde* (1991.022), *Revd Robert
Heron* (1993.083) and *William Townshend*
(1997.023).

Landscape with Cow and Sheep, ca. 1795

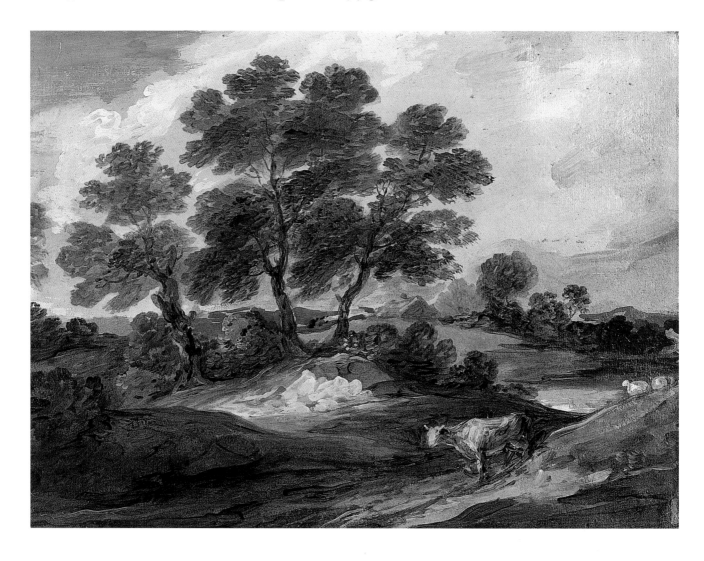

Oil on paper, 30.4 × 39.6 cm (12 × 15⁹⁄₁₆ in.)

PROVENANCE perhaps William Pitt the Younger; given to his secretary John Mayheux (died 1839); ... General Arthur Easton (1863–1949); bequeathed to his godson, Major C.G. Carew Hunt (died 1980); with Michael Harvard in 1959; with Edward Speelman; Brian Jenks; his anonymous sale, Sotheby's 27 June 1973, lot 43, bt Baskett & Day; purchased by Dudley Snelgrove; his posthumous sale, Sotheby's, 19 November 1992, lot 300, bought by William Drummond for the Society (1992.099)

LITERATURE Woodall 1951, pp. 266, 268, repr.; Hayes 1982, pp. 196, 224, repr.

EXHIBITED Bath 1951, no. 34

This oil sketch and cat. 69 come from a group of fourteen that are amongst the liveliest works painted by the artist. When the group was exhibited in 1951 Mary Woodall attributed them to Thomas Gainsborough, though Ellis Waterhouse appears to have revised the attribution soon afterwards, as they are not included in his monograph of 1958. While the sketches retain the vocabulary of Thomas Gainsborough's

wooded landscapes with cows, tracks, pools and cottages, their raw boldness and energy make an attribution to Dupont acceptable. Nonetheless they show greater confidence, stronger colour and stronger compositions than many of Dupont's larger compositions.

Five paintings from the group are in the Yale Center for British Art. Apart from the two in Sudbury, of the eight that were sold at Sotheby's in 1973 two are in the Henry E. Huntington Library and Art Gallery and four in English private collections. One other has been kept by the Carew Hunt family.

GAINSBOROUGH DUPONT

Wooded Landscape with Cows, ca. 1795

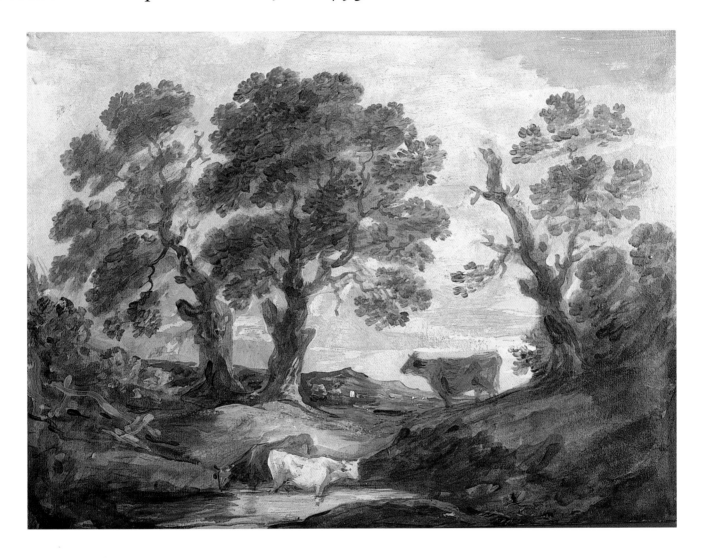

Oil on paper, 29.2 × 39.4 cm (11¾ × 15⁹⁄₁₆ in.)

PROVENANCE as cat. 68 until Baskett & Day; purchased by Dr John Hayes; purchased from him by the Society by private treaty sale with a grant from the MGC/V&A Purchase Grant Fund through Suffolk County Council, February 1992 (1992.028)

LITERATURE Woodall 1951, p. 266; Hayes 1982, pp. 196, 230, repr.

EXHIBITED Bath 1951, no. 34; Sudbury 1991, no. 32, repr.

HENRY WILLIAM BUNBURY (1750–1811)

Patience in a Punt, 1780s

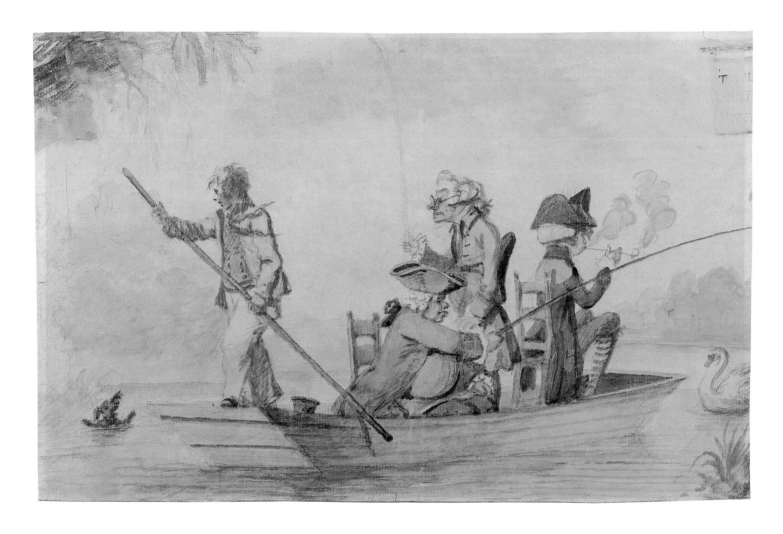

Watercolour over pencil,
20.4 × 32.3 cm (8 × 12⅝ in.)

ENGRAVED by William Dickinson in stipple,
published by him on 1 May 1792[1]

PROVENANCE with Squire Gallery; purchased
in 1948 by Cornish Torbock; his posthumous
sale, Sotheby's, 14 April 1994, lot 31, repr.;
purchased by Hazlitt, Gooden & Fox Ltd for the
Society (1994.050)

EXHIBITED Kendal 1982, no. 10; Sudbury
1983, no. 65, repr.; Ludlow 1992

The watercolour shows three characters in a
punt fishing off Eel Pie Island in the Thames
at Twickenham. They are being attended by a
lad who wields the punt pole at the bow of
the boat. The figure in the centre, who
resembles Sir Joshua Reynolds, has just
caught a distraught dog to the left, and a
portly figure, Dr Samuel Johnson, has cast
his line on the other side of the boat. In the
stern, James Boswell ruefully smokes a clay
pipe.

To accompany the stipple engraving after
the Sudbury drawing, another print by
William Dickinson was published on the
same day after a drawing which is now at

Yale. This shows a group of four frustrated
anglers who have had even less success
fishing.[2] The design was very probably
inspired by the fishing party painted by
George Morland which was published as a
print by George Keating in 1789.[3]

NOTES
1. *Satires* 8206. The Society owns a copy
(2000.104).
2. *Satires* 8207.
3. New Haven 1977, no. 170, repr. This
connection was first suggested by John Riely
(Sudbury 1983, pp. 5, 8 n. 34).

1

Twenty Prints Illustrative of Various Interesting Scenes in the Plays of Shakespeare (London: Published originally by the late T. Macklin), [1803]

PROVENANCE Senator W. Murray Crane; by descent to Louise Crane of Sugar Hill, Dalton, Massachusetts; her sale, Skinner, Boston, 19 November 1994, lot 102, bt Grosvenor Prints; purchased from them by the Society with a contribution from the Museums Association (Beecroft Bequest) in December 1995 (1995.100)

Between 1792 and 1796 Thomas Macklin published twenty engravings after Henry William Bunbury's watercolours of scenes from Shakespeare's plays (see cat. 72). The publication is embossed with the title *Bunbury's Shakespeare Gallery*, parallelling that of John Boydell's publication of the prints for his famous Shakespeare Gallery. The prints after Bunbury were published individually – the earliest is 1791 – and eventually in book form in 1803.

In contrast to the copy of the book in the British Library (3 Table 45), the Sudbury copy uses one of the plates as a frontispiece and has two additional unidentified plates added at the end.

HENRY WILLIAM BUNBURY

Falstaff's Escape, from The Merry Wives of Windsor, Act IV Scene 2, 1791

Watercolour and pen and ink over pencil,
35.9 × 46.3 cm (14⅛ × 18¼ in.)

ENGRAVED by J. Chapman in stipple and line
engraving, published as by T. Macklin on 30
November 1792

PROVENANCE with Ruskin Gallery, Stratford-
upon-Avon; Brian Northington; purchased from
him through William Drummond by the Society,
September 1993 (1993.044)

Bunbury first acted in the theatricals at
Wynnstay, the seat of Sir Watkin Williams
Wynn in Denbighshire, in January 1778. He
appeared there every year until 1787. Not
only did he employ his considerable acting
skills but he also produced admission tickets
to the performances[1] and, perhaps most
notably, commemorated the 1785 production
of *Twelfth Night* in a watercolour of the duel
scene and costume studies of Miss Wynne as
Viola and Mr Horneck (Bunbury's brother-
in-law) as Sebastian.[2] After the death of Sir
Watkin in 1787 Bunbury's association with
Wynnstay came to an end, but the
watercolours he produced for Thomas
Macklin may well include echoes of his
performances in North Wales.

This drawing is one of three in the
Society's collection.[3] They form part of the
group of twenty-two that Macklin
commissioned from Bunbury for a book of
prints which was eventually published in
1803 (cat. 71). Other drawings from the
series are in the Garrick Club,[4] the
Cavendish collection at Holker Hall,[5] the
Lewis-Walpole Library at Farmington,
Connecticut,[6] and at the Yale Center for
British Art.[7] Some of the subjects from the
series are duplicated in red chalk (fig. 49).
Although these drawings carry attributions to
Bunbury, they appear to have been made by
the engravers in preparation for the prints.[8]

This particular drawing shows Sir John
Falstaff with Mistress Ford and Mistress
Page examining the possibility of hiding in
the chimney to avoid William Page. All three
figures appear, with less animation, in a

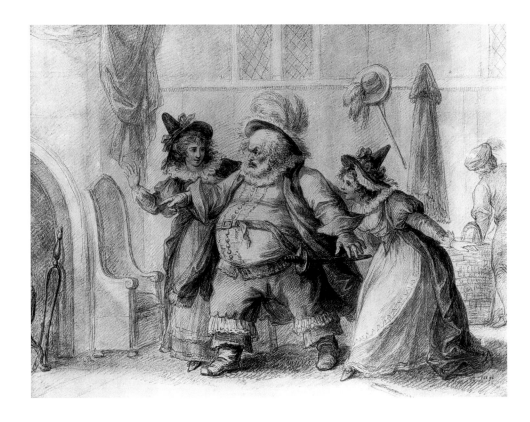

Fig. 49
Unidentified artist after HENRY WILLIAM BUNBURY
Falstaff's Escape, ca. 1792
Red chalk, 35.3 × 45.9 cm (13⅞ × 18⅛ in.)
Victoria and Albert Museum, London

circular watercolour on the London art
market in 1940.[9]

NOTES

1. *Satires* 7068; Rosenfeld 1978, p. 83, pl. 112a-b;
Sudbury 1983, nos. 50–51. The Society owns a
total of four Wynnstay tickets, one dated 1781
(1993.029 and 1999.002).
2. Sudbury 1983, nos. 28, 32 and 33; Rosenfeld
1978, p. 87, pl. 11. All three watercolours are now
in the National Museum of Wales, Cardiff.
3. The others are *Aguecheek, Belch and the Clown*
(*Twelfth Night*, Act II, Scene 3; 1993.042) and

Katherine and Petruchio (*Taming of the Shrew*, Act
IV, Scene 1; 1993.043).
4. *Fluellen making Pistol eat the Leek* (*Henry V*, Act
V, Scene 1; Ashton 1997, no. 885, repr.); *Dick the
Butcher and Smith the Weaver seizing the Clerk of
Chatham* (*Henry IV, Part II*, Act IV, Scene 2;
Ashton 1997, no. 886, repr.).
5. *Helena in the Dress of a Pilgrim* (*All's Well that
Ends Well*, Act III, Scene 5).
6. *Macbeth and the Murderers* (*Macbeth*, Act III,
Scene 1; New Haven 1981, no. 26); *The Supposed
Death of Imogen* (*Cymbeline*, Act IV, Scene 2; New
Haven 1981, no. 27; *Falstaff reproved by King*

Henry (*Henry IV, Part II*, Act V, Scene 5; New Haven 1981, no. 24); *Jaques discovered by the Duke* (*As You Like It*, Act II, Scene 1; New Haven 1981, no. 22, repr.) and *Falstaff at Justice Shallow's mustering his Recruits* (*Henry IV, Part II*, Act III, Scene 2; New Haven 1981, no. 23).

7. *Henry V before Harfleur* (*Henry V*, Act III, Scene 1; New Haven 1981, no. 25).

8. Other engravers' copies are: *Romeo and Juliet with Friar Laurence* (*Romeo and Juliet*, Act II, Scene 6; Isetan 1992, no. 17) and *The Supposed Death of Imogen* (*Cymbeline*, Act IV, Scene 2; Isetan 1992, no. 18 repr.), both in the

Shakespeare Birthplace Trust (they appeared at Sotheby's, 16 March 1978, lot 27, the former repr.); *Falstaff with Hotspur on his Back* (*Henry IV, Part I*, Act V, Scene 4; New Haven 1981, no. 21, repr.) and *Launce Teaching his Dog Crab to behave as a Dog* (*Two Gentlemen of Verona*, Act IV, Scene 4; New Haven 1981, no. 20), both at Yale Center for British Art; *Florizel and Autolycus changing Garments* (*Winter's Tale*, Act IV, Scene 3; Sudbury 1983, no. 70; Lambourne and Hamilton 1980, p. 44, repr.), at the Victoria and Albert Museum, London; *Prospero disarming Ferdinand* (*The Tempest*, Act 1, Scene 2; Brown 1982,

no. 410, repr.), at the Ashmolean Museum, Oxford; and *Falstaff reproved by King Henry* (*Henry IV Part II*, Act V, Scene 8), at the Folger Library in Washington, D.C.

9. Catalogue produced by F.C. Meatyard, the dealer in drawings, in 1940; a mount in the Witt Library, Courtauld Institute of Art.

HENRY WILLIAM BUNBURY

Rustics in a Landscape, ca. 1806

Oil on canvas, 39.4 × 57.2 cm (15½ × 22½ in.)

PROVENANCE purchased by the Revd Henry
Hasted (1771–1852); by descent to Revd Canon
J.A.O. Hasted; his sale at the Vicarage, Yoxford,
Suffolk, by Flick & Son, Saxmundham, 26 June
1979, lot 325, bt Martyn Gregory; purchased
from him by the Society with a contribution from
Miss M.A. Tapper in memory of her mother Mrs
M.C. Tapper and grants from the Victoria and
Albert Museum (Purchase Grant Fund) and the
Scarfe Charitable Trust, August 1985 (1985.002)

EXHIBITED Sudbury 1983, no. 81[1]

In about 1804, after the death of his wife,
Bunbury settled in Kendal, where he seemed
to abandon humorous subjects, preferring to
paint peasant scenes. The subject for this oil
painting is very similar to a large watercolour
dated 1804 which was formerly in the
collection of L.G. Duke.[2]

 In a letter of 1806 to the comic actor John
Bannister Bunbury notes his unexpected
success with "painting in Oils … & being a
very *young* hand at it, without any knowledge
of the art whatever, I am rather surprised at
having Painted a Picture or two, which I
think really tolerably good, considering too
that a twelvemonth past I could not make out
a *Figure* in oils for the soul of me".[3] Besides
this canvas, only four others have been
recorded.[3]

NOTES
1. The painting was unavailable for the exhibition
and was represented by a photograph.
2. According to an inscription on the back, the
watercolour was given by the artist to James
Holland. It was in the Arts Council exhibition
British Country Life, 1937, no. 60, and a
photograph of it is in the Witt Library, Courtauld
Institute of Art.
3. Hyde collection, Somerville, New Jersey,
quoted by J. Riely (Sudbury 1983, pp. 5–6).
4. Three, entitled *Armathwaite House, Lake Scene*
and *View of Keswick Lake*, were lent to an *ad hoc*
exhibition at the Atheneum in Bury St Edmunds
in July 1950 by Miss M. South Phillips of
Ixworth Abbey. One other one was sold at
Sotheby's, 21 November 1979, lot 31.

GEORGE FROST (1745–1821)

Country scene with stile, ca. 1800–05

Black chalk and stump,
21.8 × 18.6 cm (8⁹⁄₁₆ × 7⅜ in.)

PROVENANCE perhaps purchased from the
artist's widow by William Esdaile (1759–1837);
his posthumous sale, Christie's, 20–21 March
1838, lot 543 or 723; … ; with Colnaghi in 1966;
with Stanhope Shelton in 1971; given in memory
of Stanhope Shelton, Vice-Chairman of
Gainsborough's House Society, by a group of
friends, February 1984 (1984.001)

LITERATURE Hayes 1966, p. 164, pl. 26; Hayes
1970a, p. 73, pl. 382

EXHIBITED Colchester 1971, no. 12, repr.;
Sudbury 1974, no. 14, repr.; Sudbury 1991,
no. 64, repr.

George Frost, a clerk in the Blue Coach
Office at Ipswich, spent his free time
sketching around the town. It is known that
for a short time he was John Constable's
mentor and there is at least one example of
the two artists drawing together.[1] His other
passion was for the work of Gainsborough.
He collected many of the older artist's
drawings and owned his late painting *The
Mall* (now Frick Collection, New York).
Frost's drawings are sometimes a pastiche of
Gainsborough's work[2] and frequently, when
Frost did sketch outdoors, the environs of
Ipswich are drawn in a Gainsboroughesque
manner.

This chalk drawing is very similar to
Gainsborough's handling in the late 1750s.
The composition echoes, somewhat naively,
Gainsborough's etching *The Gipsies* (cat. 34).

NOTES
1. See Sudbury 1991, no. 64.
2. The Society owns a drawing (1999.180),
which, but for one alteration, is copied from a
Gainsborough drawing (1990.051; Sudbury
1991, no. 5, repr.). There are other drawings by
Frost which are copied from known
Gainsboroughs, and drawings that are so close to
the older artist's work that they must have been
copied from lost examples of his work.

GEORGE FROST

Assembly Rooms, Tavern Street, Ipswich, ca. 1800

Pen and ink with grey and buff washes over pencil, 27 × 28.5 cm (10¾ × 11¼ in.)

PROVENANCE posthumous sale of the artist's widow, Robert Garrod, Ipswich, 7 June 1839, lot 41, bt Ranson; … ; Starkie Bence family; by descent to C.D.B. Starkie Bence; his posthumous sale, Boardman & Oliver at Kentwell Hall, 7–9 September 1970, lot 603, bt Harold Day; with John Day, Eastbourne Fine Art; purchased from him by the Society with a contribution by the MGC/V&A Purchase Grant Fund, July 1995 (1995.028)

EXHIBITED Colchester 1971, no. 5, repr.

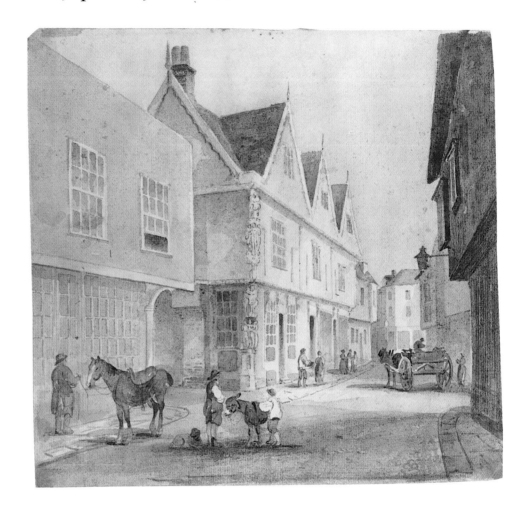

Besides chalk and pencil sketches of views around the town (see cat. 74), Frost made more formal topographical views of Ipswich. This watercolour shows the north side of Tavern Street looking eastwards. The gabled building on the left was originally built by Henry and Dorcas Buckenham in about 1600 and stood between Tower Street and Hatton Garden. In the eighteenth century the first bay was Gooding's Coffee House and the next two the Assembly Rooms. New Assembly Rooms were built in Northgate Street in 1809, and in about 1815 the street was widened and the front rooms of the old building partly demolished.

Some of the sculptures on the corner post (the lowest were Faith, Hope and Charity) were taken to decorate the Cobbold family house beside their brewery at the Cliff, which is now the Brewery Tap freehouse. The architect John Shewell Corder used drawings by Frost and Trent to produce Plate 10, *The Coffee House*, in *Ye Olde Corner Posts of Ipswiche* in 1890. When in the later nineteenth century the building became the Working Men's College some of its rooms retained the elaborate plaster ceilings, wall decorations and fireplaces of the former Assembly Rooms.[1]

NOTES
1. I am grateful to Dr John Blatchly for providing the topographical information.

JOHN CONSTABLE (1775–1837)

St Peter's Church, Sudbury, from the south-east, ca. 1814

Pencil and wash, 16.3 × 14.3 cm (6⅜ × 5⅝ in.)

PROVENANCE by descent to Capt. Charles Golding Constable; …; with Beaux Art Gallery 1951; purchased by Miss S.G. Lister on 14 December 1951; thence by descent; anonymous sale, Sotheby's, 19 November 1992, lot 41, repr., bt John Hilary Travel and lent to Gainsborough's House; purchased by the Society with a contribution from the Sudbury Freemen's Trust in October 1994 (1994.146)

LITERATURE Reynolds 1996, p. 203, repr.; Lyles 1999, p. 183

The subject of this small pencil sketch was identified by Charles Hind. It is a view looking westwards up Borehamgate Street (now King Street) towards St Peter's Church, with the sign of the Rose and Crown on the left and a house, pressed hard against the east end of the church, on the right. The spirelet was added to the fifteenth-century tower in 1810 and it was removed, together with the statues on the corners, in 1968. Surprisingly it is the only known view of Sudbury by Constable, which lies just fourteen miles upstream on the river Stour from Constable's birthplace at East Bergholt.

Although the drawing was accepted by Graham Reynolds, Anne Lyles, finding the handling crude, has proposed an attribution to George Frost. The certainty of the draughtsmanship and the variations in the strength of chalk marks, however, are surely more subtle than anything attempted by Frost. The wash, however, may have been added by another hand.

THOMAS CHURCHYARD (1798–1865)

Coastal landscape with beached fishing boats, 1820

Watercolour over pencil on grey paper,
17.5 × 26.3 cm (6⅞ × 10⅜ in.)

INSCRIBED *TC 1820*

PROVENANCE given to the Society by
Dr Charles Warren, November 1974 (1974.001)

EXHIBITED Colchester 2000

Thomas Churchyard was a Woodbridge
solicitor when John Constable, Edward
Fitzgerald and other luminaries – the
'Woodbridge Wits' – made the town a centre
of intellectual activity.[1] He was an avid
draughtsman producing many thousands of
drawings and watercolours in sketchbooks
which were hardly known until they were
sold by the last of his children in 1927. His
work is often confused with that of his
offspring, Ellen, Laura and Charles
Churchyard, whose artistic personalities
have yet to be definitively distinguished and
set apart from that of their father.[2]

Not only is the Sudbury drawing one of
the livelier studies Thomas Churchyard made
of boats on the River Deben, it is also
unusual in being an early example and on
coloured paper. It is amongst the few that are
signed with his initials and dated.

NOTES
1. See Notehelfer 1999, *passim.*
2. Best efforts are made in Ipswich 1998 and
Messum 1998.

RICHARD JAMES LANE (1800–1872)

Two Portraits of Edward Theophilus Lane, 1836 and 1850

Pencil, 8 × 6.4 and 20.2 × 17.2 cm
(3¼ × 2½ and 8 × 6¾ in.)

PROVENANCE given by Emily Lane, the artist's daughter, to Sir Sydney H. Nicholson; thence by descent to Mrs Jane Coper (née Nicholson); given by her to the Society in August 1996 (1996.109)

Richard James Lane was the son of Revd Theophilus Lane and Sophia Gardiner, the daughter of Susan Gainsborough, a sister of the artist Thomas, and Richard Gardiner. His brother Edward William Lane was the distinguished Arabic scholar.

As early as 1825 Lane demonstrated his exceptional ability to make lithographs in his publication *Studies of Figures by Gainsborough.* He became an Associate of the Royal Academy in 1827 and campaigned for engravers to be given full membership, at last agreed in 1865. Queen Victoria enjoyed her sittings with him, especially when he discussed his artist friends. She remarked, "He draws beautifully … the best lithographer in this country. He is besides a very modest, gentle, pleasing, clever and nice looking man."[1]

The portrait is of Ned – Edward Theophilus Lane – the artist's son, who died of typhus at the age of nineteen on 18 January 1850. He seems to have inherited his family's considerable abilities and have been an exceptional draughtsman; there is a collection of drawings of steam engines by him preserved in the Science Museum, London.[2] Another profile portrait of him dressed in a mortar board, dated 1847, is with the sitter's decendants. Presumably it was used as the basis of the later portrait at Sudbury, which was drawn posthumously.

NOTES

1. Royal Library 13878, quoted in *Kings and Queens*, exh. cat., Queen's Gallery, London, 1982–83, under no. 94.
2. Inv. 1923.436 and 1936.54. The latter includes another portrait of Ned Lane as a frontispiece (see J. Simmons, *The Victorian Railway*, London 1991, pp. 125–26, 385 n. 26, repr.).

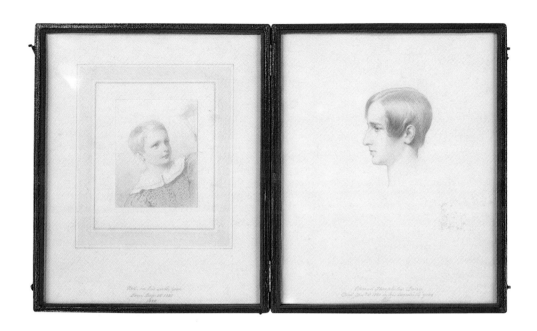

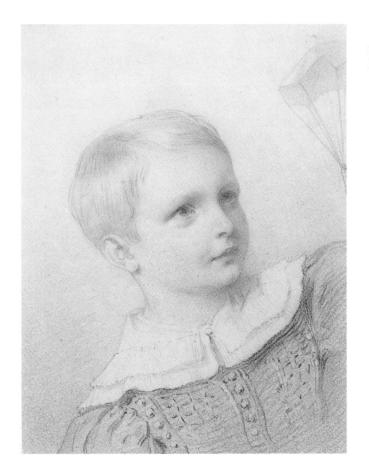

Grangerized and annotated copy of *Notes on so much of the Catalogue of the Present Exhibition of the Royal Academy,* privately printed 1855

PROVENANCE as cat. 78 (1996.107)

On 15 December 1855 Richard James Lane, Gainsborough's great nephew, invited friends to his house in Regent's Park for "a reading of Notes on so-much of the Catalogue of this year's exhibition of the Royal Academy … with a report of the private view and the dinner". The 'Notes' were in verse, written presumably by Lane himself, and printed copies were distributed to his guests. This copy, owned by Lane, includes a number of photographs of paintings included in the exhibition, a supplement on the portraits in the show, and letters of thanks from some of his correspondents who had received a copy of the booklet by post. One of them, the aged painter Thomas Uwins, wrote, "Many thanks my dear friend for the *jus d'espirit* which came to hand today and was read immediately. I can imagine the amusement it would have occasioned at your house." He continues, "Ruskin is a man of mischief. He has a giants strength and he uses it like a giant. I wish all critics to resemble you: We should not be called on to admire the mental abberations of Mr Millais. Nor the [illegible] emblems by Hunt. But unhappily in this writing age, we are called upon to judge by their ears and not their eyes."

The photographic portrait was taken by Herbert Watkins of Chancery Lane. Another portrait from the same photographic session is in the National Portrait Gallery, London (P301 (167)), and a third provided the basis for an engraving reproduced in the *Illustrated London News* to accompany an obituary notice of the sitter.[1]

NOTES

1. LXI, 7 December 1872, p. 548.

Self-portrait, 1936

Oil on board, 29.4 × 29.6 cm (11½ × 11¼ in.)

INSCRIBED *R. Suddaby | 36*

PROVENANCE Montpelier Gallery; Austin Desmond; purchased from them by the Society in December 1994 (1994.175)

EXHIBITED Austin Desmond 1988, no. 16, repr. col.

Rowland Suddaby was born in South Yorkshire and moved to London in 1931. There he worked in film and sold the odd painting. Rex Nan Kivell, the owner of the Redfern Gallery, spotted his work and offered him a solo exhibition. In 1943 he was taken up by Leger Galleries, where he continued to exhibit until 1967.

In 1937 he moved to East Anglia. There the relative gentleness of the landscape eroded the edge to his work and it became formulaic; his popularity waned and London exhibitions became fewer. He first became associated with Gainsborough's House in the 1960s, becoming Curator in 1970. Although his Curatorship was short-lived, his work with schools was especially noteworthy, and he died in post in 1972.

The Society has built up a collection of works by Suddaby. They show his variety of subject-matter and date from all stages of his career; this is the earliest of them, painted when he was twenty-six.

BIBLIOGRAPHY

Allen 1987
B. Allen, *Francis Hayman*, exh. cat., London and New Haven 1987

Armstrong 1898
Sir W. Armstrong, *Gainsborough and his Place in English Art*, London and New York 1898

Asfour, Williamson and Jackson 1997
A. Asfour, P. Williamson and G. Jackson, '"A Second Sentimental Journey": Gainsborough abroad', *Apollo*, CXLVI, August 1997, pp. 27–30

Asfour and Williamson 1999
A. Asfour and P. Williamson, *Gainsborough's Vision*, Liverpool 1999

Ashton 1997
G. Ashton, ed. K.A. Burnim and A. Wilton, *Pictures in the Garrick Club*, privately printed 1997

Asleson and Bennett 2001
R. Asleson and S.M. Bennett, *British Paintings at the Huntington*, San Marino 2001

Bell 1999
E. Bell, 'The Life and Work of Henry Walton', *GHR* 1998/99, pp. 39–101

Belsey 1987
H. Belsey, 'A Visit to the Studios of Gainsborough and Hoare', *BM*, CXXLX, February 1987, pp. 107–09

Belsey 1988
H. Belsey, 'A Gainsborough Landscape for Sudbury', *National Art Collection Fund Review*, 1988, pp. 103–05

Belsey 1990
H. Belsey, 'Two Prints by Gainsborough', *GHR* 1989/90, pp. 40–44

Belsey 1991
H. Belsey, 'The Gainsborough's House Collection: Starting from Scratch', *Apollo*, CXXXIV, August 1991, pp. 112–15

Belsey 1992
H. Belsey, 'Two Works by Gainsborough', *National Art Collections Fund Review*, 1992, pp. 6–12

Belsey 1997
H. Belsey, 'The Gainsborough's House Collection: A progress Report', *Apollo*, CXLVI, August 1997, pp. 55–59

Belsey 2001
H. Belsey, *Love's Prospect: Gainsborough's Byam Family and the Eighteenth-Century Marriage Portrait*, exh. cat., Holburne Museum of Art, Bath 2001

Belsey 2002a
H. Belsey, 'Thomas Gainsborough as an Ipswich Musician, a Collector of Prints and a Caricaturist', in *East Anglia's History: Studies in Honour of Norman Scarfe*, ed. C. Harper-Bill, C. Rawcliffe and R.G. Wilson, Woodbridge 2002

Belsey 2002b
H. Belsey, *Thomas Gainsborough: A country life*, Munich, Berlin, London and New York 2002

Bensusan-Butt 1985
J. Bensusan-Butt, 'The Young Gainsborough', *BM*, CXXVII, July 1985, pp. 454, 459–60, 478

Bensusan-Butt 1993
J. Bensusan-Butt, *Thomas Gainsborough in his Twenties*, privately printed 1993

Bermingham 1986
A. Bermingham, *Landscape and Ideology: The English rustic tradition 1740–1860*, London 1986

BM *Burlington Magazine*
BM 1991
'Recent Acquisitions by East Anglian Museums: Norwich, Sudbury, Ipswich', *BM*, CXXXIII, August 1991, pp. 579–84

BM 1997
'Acquisitions in British Museums and Galleries made with the help of the Heritage Lottery Fund and the National Heritage Memorial Fund since January 1995', *BM*, CXXXIX, January 1997, pp. 74–80

Bond 1956
L. Bond, *Tyneham: A Lost Heritage*, London 1956

Braham and Bruce-Gardner 1988
H. Braham and R. Bruce-Gardner, 'Rubens's "Landscape by Moonlight"', *BM*, CXXX, August 1988, pp. 579–96

Brenneman 1996
D.A. Brenneman, 'Thomas Gainsborough's "Wooded Landscape with Cattle by a Pool", Art Criticism and the Royal Academy', *GHR* 1995/96, pp. 37–46

Brown 1982
D.B. Brown, *Ashmolean Museum: Catalogue of the Collection of Drawings – IV: British School*, Oxford 1982

Buck 1996
A. Buck, *Clothes and the Child*, Bedford 1996

Chaloner Smith 1883
J. Chaloner Smith, *British Portrait Mezzotinto* …, 4 vols., London 1883

Chapel 1986
J. Chapel, 'The Turner Collector: Joseph Gillott, 1799–1872', *Turner Studies*, VI, no. 2, Winter 1986, pp. 43–50

Clayton 1991
T. Clayton, 'Gainsborough and his Engravers', *GHR* 1990/91, pp. 38–48

Clayton 1997
T. Clayton, *English Prints 1688–1802*, New Haven and London 1997

Coats 1904
Catalogue of the Collection of Pictures of the French, Dutch, British and other Schools collected by W.A. Coats Esq., Glasgow 1904

Comstock 1956
H. Comstock, 'Gainsborough's Daughters', *Connoisseur*, CXXXIV, March 1956, p. 141

Cormack 1991a
M. Cormack, 'An Early Landscape by Gainsborough for Gainsborough's House', *GHR* 1990/91, pp. 30–37

Cormack 1991b
M. Cormack, *The Paintings of Thomas Gainsborough*, Cambridge 1991

Crisp 1881
F.A. Crisp, *Some Account of the Parish of Stutton, Suffolk*, privately printed 1881

Derow 1988
J. Derow, 'Thomas Gainsborough's Varnished Drawings', *Master Drawings*, XXVI, no. 3, Autumn 1988, pp. 259–71

Dewar 1965
H.S.L. Dewar, 'The Thomas Rackett Papers, 17th to 19th centuries', *Dorset Record Society*, 1965

EADT *East Anglian Daily Times*
Edwards 1808
E. Edwards, *Anecdotes of Painting* …, London 1808

Egerton 1998
J. Egerton, *National Gallery Catalogues: The British School*, London 1998

Einberg 1987
E. Einberg, *Manners and Morals: Hogarth and British Painting 1700–1760*, exh. cat., Tate Gallery, London, 1988

Falk 1949
B. Falk, *Thomas Rowlandson: His Life and Art*, London [1949]

Farington
J. Farington, *Diary* …, ed. K. Garlick, A. MacIntyre and K. Cave, New Haven and London 1978–98

Farrer 1908
Revd E. Farrer, *Portraits in Suffolk Houses (West)*, London 1908

Farson 1990
D. Farson, *Gallery: A personal guide to British galleries and their unexpected treasures*, London 1990

Foster 1891
J. Foster, *Alumni Oxonienses … 1500–1714 and 1715–1886*, 8 vols., Oxford 1891

Fulcher 1856
G.W. Fulcher, *Life of Thomas Gainsborough, R.A.*, London 1856

GHR *Gainsborough's House Review*
GM *Gentleman's Magazine*
Gordon 1981
D. Gordon, *Second Sight: Rubens and Gainsborough*, exh. cat., National Gallery, London, 1981

Gore 1974
R. St John Gore, ed. L. Dresser, *European Paintings in the Collection of the Worcester Art Museum*, Worcester 1974

Grego 1880
J. Grego, *Rowlandson the Caricaturist*, 2 vols., London 1880

Griffiths 1987
A. Griffiths, 'Notes on Early Aquatint in England and France', *Print Quarterly*, IV, no. 3, 1987, pp. 256–70

Harris 1991
J. Harris, 'The Harward Family and the 1923 sale', *GHR* 1991/92, pp. 45–49

Hayes 1963
J. Hayes, 'Gainsborough and Rubens', *Apollo*, LXXVIII, August 1963, pp. 89–97

Hayes 1964
J. Hayes, 'The Holker Gainsboroughs' (Notes on British Art), *Apollo*, LXXIX, June 1964, pp. 2–3

Hayes 1965a
J. Hayes, 'Gainsborough', *Journal of the Royal Society of Arts*, April 1965

Hayes 1965b
J. Hayes, 'The Drawings of Gainsborough Dupont', *Master Drawings*, Autumn 1965, III, no. 3, pp. 243–56

Hayes 1966
J. Hayes, 'The Gainsborough Drawings from Barton Grange', *Connoisseur*, CLXI, February 1966, pp. 86–93

Hayes 1969
J. Hayes, 'The Ornamental Surrounds for Houbracken's "Illustrious Heads"' (Notes on British Art), *Apollo*, LXXIX, January 1969, pp. 1–3

Hayes 1970a
J. Hayes, *The Drawings of Thomas Gainsborough*, 2 vols., London 1970

Hayes 1970b
J. Hayes, 'Gainsborough and the Gaspardesque', *BM*, CXII, May 1970, p. 311

Hayes 1971
J. Hayes, *Gainsborough as Printmaker*, London 1971

Hayes 1975
J. Hayes, *Gainsborough*, London 1975

Hayes 1982
J. Hayes, *The Landscape Paintings of Thomas Gainsborough*, 2 vols., London and Ithaca 1982

Hayes 1983
J. Hayes, 'Gainsborough Drawings: A Supplement to the Catalogue Raisonné', *Master Drawings*, XXI, no. 4, Winter 1983, pp. 367–91

Hayes 1991
J. Hayes, *The Portrait in British Art*, exh. cat., National Portrait Gallery, London, 1991–92

Hayes 1992
J. Hayes, *The Collections of the National Gallery of Art Systematic Catalogue: British Paintings …*, Cambridge 1992

Hayes 2001
J. Hayes, *The Letters of Thomas Gainsborough*, New Haven and London 2001

Horne 1891
H.P. Horne, *An Illustrated Catalogue of Engraved Portraits and Family Pictures painted by Thomas Gainsborough … and by George Romney*, London 1891

Hussey 1953
C. Hussey, 'Shrubland Park, Suffolk, I and II', *Country Life*, CXIV, 19 and 26 November 1953, pp. 1654–57 and 1734–38

Hutchinson 1968
S.C. Hutchinson, *The History of the Royal Academy 1768–1968*, London 1968

IJ Ipswich Journal

Ingamells and Raines 1976
J. Ingamells and R. Raines, 'A Catalogue of the Paintings, Drawings and Etchings of Philip Mercier', *Walpole Society*, XLVI, 1976–78, pp. 1–70

Jones 1997
R. Jones, 'Gainsborough's materials and methods: a "remarkable ability to make paint sparkle"', *Apollo*, CXLVI, August 1997, pp. 19–26

Judson 2000
J.R. Judson, *Corpus Rubensianum Ludwig Burchard: Rubens, The Passion of Christ*, London 2000

Kidson 1999
A. Kidson, *Earlier British Paintings in the Lady Lever Art Gallery*, Liverpool 1999

Kinross 1995
F. Kinross, 'A History of Gainsborough's House Society 1958–72', *GHR* 1994/95, pp. 38–49

Lambourne and Hamilton 1980
L. Lambourne and J. Hamilton, *British Watercolours in the Victoria and Albert Museum*, London 1980

Leonard 1969
J.N. Leonard, *The World of Gainsborough 1727–1788*, London 1969

Lewin 1990
P.I. Lewin, 'The Revd Tobias Rustat of Stutton and his family', *GHR* 1989/90, pp. 35–39

Lippincott 1983
L. Lippincott, *Selling Art in Georgian London*, New Haven and London 1983

Lyles 1999
Review of G. Reynolds, *The Earlier Paintings and Drawings of John Constable*, *BM*, CXLI, March 1999, pp. 181–83

Menpes and Grieg 1909
M. Menpes and J. Greig, *Gainsborough*, London 1909

Millar 1969
O. Millar, *Pictures in the Royal Collection: Later Georgian Pictures* 2 vols., London 1969

Millar 1982
Oliver Millar, *Van Dyck in England*, exh. cat., National Portrait Gallery, London, 1982

Morant 1768
P. Morant, *The History … of Essex*, 2 vols., London 1768

Mould 1995
P. Mould, *Sleepers: In search of lost old masters*, London 1995

Neale 2000
F.D. Neale, *Eminent Talents: A History of the Reverend Thomas Rackett 1756–1840 Rector of Spetisbury, Dorset*, privately printed 2000

Notehelfer 1999
F.G. Notehelfer, 'Constable and the "Woodbridge wits"', *BM*, CXLI, September 1999, pp. 531–39

Owen 1992
F. Owen, 'One of the First and Finest', *Country Life*, 28 May 1992, pp. 106–07

Owen 1995
F. Owen, 'Joshua Kirby (1716–74): a biographical sketch', *GHR* 1995/96, pp. 61–75

Park 1962
M. Park, 'A preparatory Sketch for Gainsborough's "Upland Valley with Shepherd, Sheep and Cattle"', *Art Quarterly*, Summer 1962, pp. 143–46

Pointon 1997
M. Pointon, *Strategies for Showing: Women, possession and representation in English visual culture 1665–1800*, Oxford 1997

Postle 2002
Thomas Gainsborough (British Artists series), forthcoming 2002

Reynolds
Sir Joshua Reynolds, *Discourses on Art*, ed. R.R. Wark, New Haven and London 1959

Reynolds 1996
G. Reynolds, *The Earlier Paintings and Drawings of John Constable*, 2 vols., New Haven and London 1996

Ribeiro 1995
A. Ribeiro, *The Art of Dress: Fashion in England and France 1750–1820*, New Haven and London 1995

Roberts 1987
J. Roberts, *Royal Artists: From Mary Queen of Scots to the present day*, London 1987

Rosenfeld 1978
S. Rosenfeld, *Temples of Thespis: Some Private Theatres and Theatricals in England and Wales, 1700–1820*, London 1978

Rosenthal 1982
M. Rosenthal, *British Landscape Painting*, London 1982

Rosenthal 1992
M. Rosenthal, 'Gainsborough's Diana and Acteon', in *Painting and the Politics of Culture*, ed. J. Barrell, Oxford 1992, pp. 167–94

Rosenthal 1998
M. Rosenthal, 'Thomas Gainsborough's "Ann Ford"', *The Art Bulletin*, LXXX, no. 4, December 1998, pp. 649–65

Rosenthal 1999
M. Rosenthal, *The Art of Thomas Gainsborough*, New Haven and London 1999

Russell 1926
C.E. Russell, *English Mezzotint Portraits …*, 2 vols., London 1926

Satires
F.G. Stephens and M.D. George, *Catalogue of Political and Personal Satires … in the British Museum*, 12 vols., London 1870–1954

Siple 1934
E.S. Siple, 'Gainsborough Drawings: The Schniewind Collection', *Connoisseur*, XCIII, June 1934, pp. 353–58

Sloan 2000
K. Sloan, *'A Noble Art': Amateur Artists and Drawing Masters c. 1600–1800*, London 2000

Sloman 1992
S.L. Sloman, 'Gainsborough and "the lodging-house way"', *GHR* 1991/92, pp. 23–44

Sloman 1996a
S.L. Sloman, 'Artists' Picture Rooms in Eighteenth-century Bath', *Bath History*, VI, 1996, pp. 132–54

Sloman 1996b
S.L. Sloman, 'Mrs Margaret Gainsborough, "A Prince's Daughter"', *GHR* 1995/96, pp. 47–55

Sloman 1998
S.L. Sloman, 'The Holloway Gainsborough: its subject re-examined', *GHR* 1997/98, pp. 47–54

Sloman 2002
S.L. Sloman, *Gainsborough in Bath*, New Haven and London 2002

Stainton 1977
L. Stainton, *Gainsborough and his Musical Friends*, exh. cat., Iveagh Bequest, Kenwood 1977

Stainton 1991
L. Stainton, 'Two Gainsborough Drawings', *GHR* 1990/91, pp. 49–51

Steegman 1962
J. Steegman, *A Survey of Portraits in Welsh Houses*, 2 vols., Cardiff 1962

Stemp 1997
R. Stemp, 'The Artist's Eye', *The Artist*, July 1997, p. 35

Sudeley 1970
Lord Sudeley, 'Toddington and the Tracys', *Transactions of the Bristol and Gloucestershire Archaeological Society*, LXXXVIII, 1970, pp. 127–219

Sullivan 1995
E.J. Sullivan, ed., *The Taft Museum: European and American Paintings*, Cincinnati 1995

Surry 1989
N. Surry, *George Beare*, exh. cat., Pallant House, Chichester, 1989

Thicknesse 1788
P. Thicknesse, *A Sketch of the Life and Paintings of Thomas Gainsborough Esq.*, London 1788

Thornbury 1859
W. Thornbury, *The Life of J.M.W. Turner R.A.*, 2 vols., London 1859

Tyler 1992
D.D. Tyler, ' Thomas Gainsborough's Daughters' , *GHR* 1991/92, pp. 50–66

Vaughan 2002
W. Vaughan, *Gainsborough (World of Art* series), London 2002

VCH Victoria County History

Venn 1922–54
J. & J. A. Venn, *Alumni Cantabridgiensis Part I –1751; Part II 1752–1900*, 10 vols., Cambridge 1922–54

Wallace 1979
R.W. Wallace, *The Etchings of Salvador Rosa*, Princeton 1979

Wark 1974
R.R. Wark, 'A Note on Gainsborough and Van Dyck', *Museum Monographs* III, St Louis Art Museum, 1974, pp. 45–53

Waterhouse 1953
E.K. Waterhouse, 'A Checklist of Portraits by Thomas Gainsborough', *Walpole Society*, XXXIII, 1953

Waterhouse 1958
E.K. Waterhouse, *Gainsborough*, London 1958

Waterhouse 1981
E.K. Waterhouse, *A Dictionary of British 18th Century Painters*, Woodbridge 1981

White 1977
C. White, *English Landscape 1630–1850*, exh. cat., Yale Center for British Art, New Haven, 1977

Whiteley 2000
J.J.L. Whiteley, *Ashmolean Museum: Catalogue of the Collection of Drawings – French School*, Oxford 2000

Whitley 1915
W.T. Whitley, *Gainsborough*, London 1915

Whitley 1923
W.T. Whitley, 'The Gainsborough Family Portraits', *The Studio*, LXXXVI, August 1923, pp. 62–67

Whitley 1928
W.T. Whitley, *Artists and their Friends in England, 1700–1799*, 2 vols., London 1928

Woodall 1939
M. Woodall, *Gainsborough's Landscape Drawings*, London 1939

Woodall 1951
M. Woodall, 'The Gainsborough Exhibition in Bath', *BM*, XCIII, August 1951, pp. 265–68

Woodall 1956
M. Woodall, 'Gainsborough's use of models', *Antiques*, LXX, October 1956, pp. 363–5

Woodall 1963
M. Woodall, *The Letters of Thomas Gainsborough*, London 1963

EXHIBITIONS

Agnew 1980
English Pictures from Suffolk Collections, Thos. Agnew & Sons Ltd, London, 1980

Agnew 1999
English Watercolours and Drawings, Thos. Agnew & Sons Ltd, London, 1999

Aldeburgh 1988
Gainsborough the Printmaker, catalogue by H. Belsey, Peter Pears Gallery, Aldeburgh, 1988

Arts Council 1949
Thomas Gainsborough, catalogue by M. Woodall, Arts Council, 1949

Arts Council 1951
Three Centuries of British Water-Colours and Drawings, catalogue by B. Ford, 4 St James's Square, London, 1951

Arts Council 1953
Thomas Gainsborough, catalogue by E.K. Waterhouse, Arts Council and Tate Gallery, London, 1953

Arts Council 1960
Gainsborough Drawings, catalogue by J. Hayes, Arts Council, 1960–61

Austin Desmond 1988
Rowland Suddaby: paintings, watercolours, gouaches and drawings – a collection of work 1936–1956, Austin/Desmond, London, 1988

Bath 1903
Exhibition of Works by the Old Bath Artists, Victoria Art Gallery, Bath, 1903

Bath 1936
The Arts of Three Centuries, Victoria Art Gallery, Bath, 1936

Bath 1951
An Exhibition of Paintings and Drawings by Thomas Gainsborough 1727–1788, catalogue by M. Woodall, Victoria Art Gallery, Bath, 1951

Bath 1958
Art Treasures Exhibition, Octagon Room, Bath, 1958

Bath 1990
William Hoare of Bath 1707–1792, catalogue by E. Newby, Victoria Art Gallery, Bath, 1990

Birmingham 1842
Catalogue of Pictures by Deceased Masters …, Birmingham Society of Arts, 1842

Birmingham 1995
Thomas Gainsborough: The Harvest Wagon, catalogue by P. Spencer-Longhurst and J.M. Brooke, Birmingham City Art Gallery and Art Gallery of Ontario, Toronto, 1995

British Museum 1978
Gainsborough and Reynolds in the British Museum, catalogue by T. Clifford, A. Griffiths and M. Royalton-Kisch, The British Museum, London, 1978

British Museum 1988
Treasures for the Nation, The British Museum, London, 1988–89

Carlisle 2002
Love, Labour & Loss, Tullie House Museum & Art Gallery, Carlisle, 2002–03

Charleston 1999
In Pursuit of Refinement: Charlestonians Abroad 1740–1860, Gibbes Museum of Art, Charleston, South Carolina, 1999

Cincinnati 1931
Exhibition of Paintings and Drawings by Thomas Gainsborough, R.A., Cincinnati Art Museum, 1931

Colchester 1971
George Frost and Thomas Churchyard, The Minories, Colchester, 1971

Colchester 2000
This Flat Earth, University Gallery, University of Essex, Colchester, 2000

Colnaghi 1972
Original Printmaking in Britain 1600–1900, P. & D. Colnaghi & Co. Ltd, London, 1972

Colnaghi 1979
Exhibition of English Drawings and Watercolours, P. & D. Colnaghi Ltd, London, 1979

Didier Aaron 1987
Exhibition of Old Master Drawings, Kate de Rothschild at Didier Aaron, London, 1987

Ferrara 1998
Thomas Gainsborough, catalogue by J. Hayes, Palazzo dei Diamanti, Ferrara, 1998

Fort Worth 1937
Exhibition of Masterpieces lent by The Newhouse Galleries, New York, Fort Worth Museum of Art, 1937

Glasgow 1901
International Exhibition, Glasgow 1901

Grosvenor Gallery 1885
Exhibition of the Works of Thomas Gainsborough R.A., Grosvenor Gallery, London, 1885

Ham 1954
A Loan Exhibition of Masterpieces of British Art and Craftsmanship in aid of The Church of England Children's Society, Ormeley Lodge, Ham Common, [1954]

Hazlitt 1965
The Tillotson Collection, Hazlitt Gallery, London, 1965

Hazlitt 1990
English Drawings, Hazlitt, Gooden & Fox, London, 1990

Hove 1993
The Romantic Windmill, catalogue by T. Wilcox, Hove Museum and Art Gallery, 1993

IEF 1983
Gainsborough Drawings, catalogue by L. Stainton and J. Hayes, International Exhibitions Foundation, Washington, D.C., 1983

Ipswich 1927
T. Gainsborough, R.A. 1727–1788: Bicentenary Memorial Exhibition, Ipswich Museum, 1927

Ipswich 1998
Thomas Churchyard (1798–1865), catalogue by H. Belsey, Christchurch Mansion, Ipswich, 1998

Isetan 1992
Shakespeare in Western Art, catalogue by J. Christian, Isetan Museum of Art, etc, 1992–93

Kendal 1982
Portraits and Figure Sketches from A to Z, Abbott Hall, Kendal, 1982

Kenwood 1980
Gaspard Dughet: A French Landscape Painter in Seventeenth Century Rome and his Influence on British Art, catalogue by A. French, Iveagh Bequest, Kenwood, 1980

Kenwood 1988
The Earl and Countess of Howe by Gainsborough: a bicentenary exhibition, catalogue by A. French, Iveagh Bequest, Kenwood, 1988

Leger 1946
Exhibition of Water Colour Drawings including an important example by Thomas Gainsborough, Leger Galleries, London, 1946

Leger 1990
English Landscape Painting, Leger Galleries, London, May 1990

Ludlow 1992
An Alphabet of English Watercolours, Dinham House, Ludlow, 1992

Manning 1958
Tenth Exhibition: English and Continental Drawings, Manning Gallery, London, 1958

Mendez 1968
English Prints, Christopher Mendez, London, October 1968

Messum 1998
Thomas Churchyard 1798–1865, catalogue by S. Reiss, Messum, London, 1998

Museum of London 1985
The Quiet Conquest: the Huguenots 1685 to 1985, Museum of London, 1985

New Haven 1977
The Pursuit of Happiness: A view of life in Georgian England, catalogue by J.H. Plumb, Yale Center for British Art, New Haven, 1977

New Haven 1981
Shakespeare and British Art, catalogue by G. Ashton, Yale Center for British Art, New Haven, 1981

New York, Boerner 2002
English Mezzotints from the Lennox-Boyd Collection, C.G. Boerner Inc., New York, 2002

New York, Knoedler 1914
Drawings by Thomas Gainsborough, M. Knoedler & Co., New York, 1914

New York, Knoedler 1923
Exhibition of Pictures by Gainsborough 1727–1788, M. Knoedler & Co., New York, 1923

Norwich 1948
Loan Exhibition of Portraits in the Landscape Park from Norfolk and Suffolk Houses, catalogue by C. Villiers-Stuart, Castle Museum, Norwich, 1948

Norwich 1961
Music and Painting: Loan exhibition, Castle Museum, Norwich, 1961

Norwich 1992
Family and Friends, catalogue by A. Moore, Castle Museum, Norwich, 1992

Nottingham 1962
Landscapes by Thomas Gainsborough, catalogue by J. Hayes, Nottingham University Art Gallery, November 1962

Nottingham 1998
Angels and Urchins: the Fancy Picture in 18th-century British Art, catalogue by M. Postle, Djanogly Art Gallery, University of Nottingham, and Kenwood House, 1998

Paris 1953
Le Paysage Anglais de Gainsborough à Turner, Orangerie, Paris, 1953

Paris 1981
Gainsborough 1727–1788, catalogue by J. Hayes, Grand Palais, Paris, 1981

Park Lane 1936
Gainsborough: Loan Exhibition …, catalogue by P.M. Turner and E.K. Waterhouse, 45 Park Lane, London, 1936

Pittsburgh 1938
Survey of British Paintings, Carnegie Institute, Pittsburgh, 1938

Providence 1975
Rubenism, Bell Gallery, Brown University, Providence, Rhode Island, 1975

RA 1954
European Masters of the Eighteenth Century, Royal Academy, London, 1954–55

RA 1956
British Portraits, Royal Academy of Arts, London, 1956–57

RA 1998
Art Treasures of England, Royal Academy, London, 1998

Reed 1978
English Sketches and Studies, Anthony Reed, London, and David & Long Company, New York, 1978

Schomberg House 1789
A Catalogue of the Pictures and Drawings of the late Mr. Gainsborough … [Schomberg House], Pall Mall, from 30 March 1789

Sotheby's 1988
Childhood, Sotheby's, London, January 1988

Southampton 2001
The Stuart Portrait: Status and Legacy, Southampton City Art Gallery, 2001

Spink-Leger 1999
Head and Shoulders: Portrait drawings and some small oils, Spink-Leger Ltd, London, 1999

Sudbury 1961
Inaugural Exhibition, Gainsborough's House, Sudbury, 1961

Sudbury 1974
George Frost 1745–1821, Gainsborough's House, Sudbury, 1984

Sudbury 1977
The Painter's Eye, catalogue by D. Coke, G. Reynolds, J. Hayes and M. Woodall, Gainsborough's House, Sudbury, 1977

Sudbury 1980
Joshua Kirby and Thomas Gainsborough, catalogue by F. Owen, Gainsborough's House, Sudbury, 1980

Sudbury 1983
Henry William Bunbury 1750–1811, catalogue by J. Riely, Gainsborough's House, Sudbury, 1983

Sudbury 1988
Gainsborough's Family, catalogue by H. Belsey, Gainsborough's House, Sudbury, 1988

Sudbury 1991
From Gainsborough to Constable, catalogue by M. Kitson, F. Owen and H. Belsey, Gainsborough's House, Sudbury, and Leger Galleries, London, 1991

Suffolk Street 1927
Catalogue of Pictures and Drawings being the Entire Collection of the late W.A. Coats Esq exhibited at the Galleries of the Royal Society of British Artists, Suffolk Street, catalogue by W.B. Paterson, Suffolk Street Galleries, London, 1927

Tate 1980
Thomas Gainsborough, catalogue by J. Hayes, Tate Gallery, London, 1980–81

Tate 2002
Gainsborough, catalogue by M. Rosenthal and M. Myrone, Tate Britain, London, 2002

Toronto 1987
Our Old Friend Rolly: Watercolours, Prints and Book Illustrations by Thomas Rowlandson, catalogue by B.A. Rix, Art Gallery of Ontario, Toronto, etc, 1987–88